Solitary Raven:
The Selected
Writings of
Bill Reid

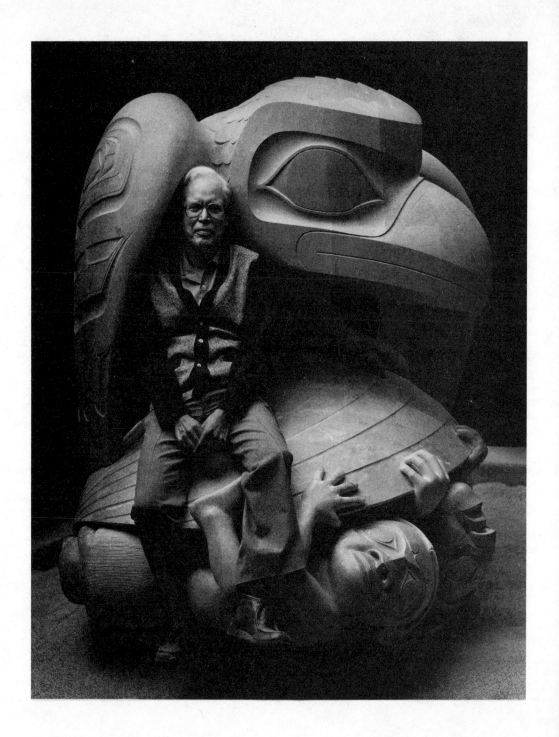

Solitary Raven

The Selected Writings of Bill Reid

With an Afterword by Martine Reid

Douglas & McIntyre
Vancouver/Toronto

University of
Washington Press
Seattle

EDITED WITH AN INTRODUCTION BY ROBERT BRINGHURST

*Canadian Cataloguing
in Publication Data*

Reid, Bill, 1920–1998.
 Solitary raven

Includes biographical
references.
ISBN 1-55054-797-6

1. Reid, Bill, 1920–1998.
2. Haida sculpture.
3. Indian art – Northwest
Coast of North America.
I. Bringhurst, Robert, 1946–
II. Title.

NB249.R44A35 2000
730'.92 C00-910971-4

◄ FRONTISPIECE: Bill Reid
with *The Raven and the First
Men,* 1980. Photograph by
Bill McLennan, Museum of
Anthropology, University
of British Columbia.

DOUGLAS & MCINTYRE LTD
Suite 201 · 2323 Quebec Street · Vancouver, B.C. V5T 4S7

Published simultaneously in the United States of America by

UNIVERSITY OF WASHINGTON PRESS
PO *Box 50096, Seattle, WA 98145-5096.*

*We gratefully acknowledge the financial support of the Canada Council for the Arts, the
British Columbia Ministry of Tourism, Small Business and Culture, and of the Government
of Canada through the Book Publishing Industry Development Program (BPIDP) for our
publishing activities.*

*Illustrations in this book are reproduced courtesy of the American Museum of Natural
History, New York; Royal British Columbia Museum, Victoria; Canadian Museum of
Civilization, Ottawa; United States National Museum, Smithsonian Institution,
Washington, DC; University of British Columbia Museum of Anthropology, Vancouver;
Vancouver Aquarium Marine Science Centre; Douglas Reynolds Gallery; William Reid Ltd
and Martine Reid; George Febiger; Bill McLennan; Adélaïde de Ménil and Edmund
Carpenter; Kenji Nagai; Michel Setboun; Ulli Steltzer; and Robert Bringhurst.*

Printed and bound in Canada by Friesens.
00 01 02 03 04 05 · 5 4 3 2 1

EDITOR'S ACKNOWLEDGEMENTS

I compiled this book as a small act of gratitude and homage to a man who was my teacher and my friend, and who for some years was a stand-in for the father I had earlier disowned. Reid was well acquainted with the hard and brittle silences that form from time to time between child and father, or father and child, and he too took a quizzical delight in the immediate and mutable relationships that now and then replace them.

Gathering and editing the texts would have been impossible without the active help of Martine Reid. With that assistance and encouragement, the work has been a pleasure.

Bill McLennan helped immensely in providing illustrations and locating some that had proven especially elusive. A number of others have also gone out of their way to help make this a better book. They include Karen Duffek and Krisztina Laszlo at the University of British Columbia Museum of Anthropology; Dan Savard at the Royal British Columbia Museum; Colin Preston at the CBC Television Archives; Treva Ricou at the Vancouver Aquarium Marine Science Centre; Toni Cavelti, Bill Holm, Elizabeth McLean, Kenji Nagai, Douglas Reynolds, and Ulli Steltzer.

Gudrun Dreher and Louise Mercer both took time from their own important tasks to help with mine, and Joe Moore, an expert on the voluminous work of Buckminster Fuller, located a passage important to Reid which I was unable to find. I am grateful to them, and I am grateful to Kay Amert and Valerie Hennell, who provided me two perfect spots to work, in the sixth arrondissement and on Protection Island.

— RB

Contents

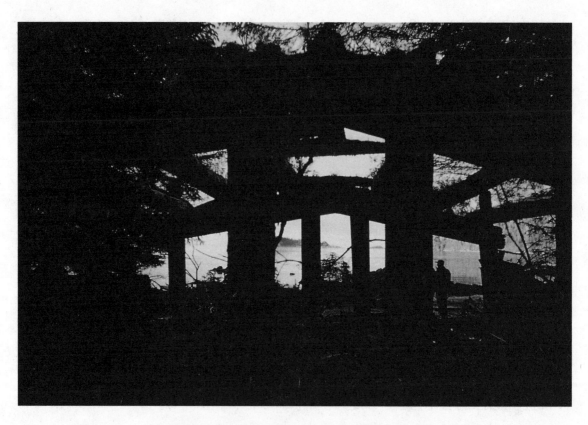

Reid silhouetted in the last of the old Haida houseframes standing at Ninstints, June 1957. Photograph by Harry Hawthorn (UBC Museum of Anthropology archives).

Introduction

<center>I</center>

Bill Reid lived and worked at the intersection of two powerful traditions in the arts – one nurtured over centuries in the rich, seahunting villages of the northern Northwest Coast of North America, the other in the city-states of Europe. Unlike many people caught in similar positions, Reid rose to the demands that these traditions made on one another, so that both came to flourish in his work without either losing its identity – much the way two songlines coexist, enriching one another without losing their identity, in polyphonic music.

He is not the only artist whose work embodies two profoundly different cultural traditions. Donatello, Yeats and Bartók are other examples. But he was the first such artist on the Northwest Coast, and there have not as yet been many in North America – where the fruitful coexistence of antagonistic histories is a theme of some importance.

Like every major artist, Reid was also an unusually thoughtful, observant and articulate human being – one who kept on deepening and growing all his life. For these reasons among others, what he chose to say about his art, and about the world in which he made it, is of more than passing interest.

Reid coauthored three books during his lifetime.[1] In addition, he wrote essays, poems, radio and film scripts, and lectured on the subjects dearest to his heart. This book includes examples of all these literary genres. Some of the works collected here have never before appeared in print. Others were published here and there, in newspapers, magazines or exhibition catalogues. Those that were published at all were sometimes poorly edited and proofread, and many were difficult

The notes to the introduction are on page 34.

even for serious readers to find. It seemed to me important to make these works available. It also seemed to me important to date them correctly and put them in sequence.

Well before his death in 1998, Bill and I had talked about compiling a selection of his writings. We had gathered a few texts, made a rough list of other things to include, and discussed a few revisions, but his disintegrating health made many simple tasks complex. I was not at all sure that pestering my friend about details was a right use of his time, and we had not gone far with the editorial chores when he died. I have completed them with the indispensable help of his widow Martine.

Joy, he liked to say, *is a well-made object.* And objects (as he also liked to say) have a way of becoming more than objects, through the skill, intensity and love that render them well made. Art as Reid conceived it is inseparable from craftsmanship – and equally inseparable from thought about the nature of the world and from the intricate and speechless force of deep emotion. Because he understood that all these things are fused in a work of art, he could be absolutely sure that having art around is good for everybody, not just artists and their patrons. So with very few exceptions, what he chose to say about the arts is addressed to all his fellow human beings, not to any private club of artists or collectors, anthropologists or critics, nor to any ethnic group.

There are however some harsh words. Many readers – Haida readers most of all – may be surprised to see Reid say that *Indian art is a dead art* [p 45], that *the Indians of our coast have passed from the scene as vital contributors to the world of art* [p 52] or that *Haida culture has just about reached the end of its string* [p 196]. It is more fashionable now to speak in glowing tones about cultural revivals on the Northwest Coast – and Reid as much as anyone set those revivals on their course. But he knew well how hard it is to make a work of art that measures up to the classical Haida standard, and how much easier to make a souvenir or curio or a "personal statement" instead. That is why he scoffed at the revival

he was helping to provoke. He far preferred to think of Haida art as honorably dead than to see it go on living as a parody.

Many readers may be equally surprised to see Reid, early in this book, speak of Indians as "them," Europeans as "us." Those however are the idioms he had learned – and the person he learned them from was Sophie Gladstone Reid of the Qqaadasghu Qiighawaay, his Haida mother. For her it was the language of denial, but she taught it to her daughter and two sons as the language of acceptance. Two of them absorbed it without apparent question and went on to live unusually successful but otherwise quite normal urban lives. Bill himself unlearned this language very slowly, suspicious to the last of eager joiners and wary of being one himself. Through art, and not through rhetoric or genetics, he became a Haida artist. But in 1985 – as soon as the newly amended laws of Canada allowed – he applied for legal status as an Indian. The petition was not granted until 1988, when he was 68 years old, but he had made his own decision. In February 1986, while addressing a provincial government commission, he asked the committee members a question: *Why should the Haidas – we Haidas – want this particular morsel of wilderness left untouched?* [p 215].

This book is many things, but one of the most important things it is, in my opinion, is the story of a long and conscious journey from one pronoun to another.

II

In a few museum collections there are works of Haida art some three centuries old, and there are photographs from 1878, showing major Haida villages densely packed with masterworks of monumental sculpture. But missionaries came together with the cameras, and under missionary pressure, the sculpture and the houses started to come down. By 1900 – when the linguist John Swanton arrived in the village

of Skidegate and a body of classical Haida oral literature was finally transcribed – the face of the culture was already hidden.

Half a century later, in 1943, Bill began his own series of journeys back to Haida Gwaii: a pilgrimage that ended only when his ashes were scattered and interred, in 1998, in the village of Tanu.

Things in Skidegate had changed much less between 1900 and 1943 than they had between 1885 and 1900. The missionary impact was still heavy; the face of the old world was turned away. Bill's grandfather, Charles Gladstone, who was then 66, took him around to meet some friends. One of these was Henry Moody, who had worked intensively with Swanton in 1900 and 1901. Another was Henry Young, who had listened in on some of the same sessions and known the same Haida poets, singers and historians from whom Swanton took thousands of pages of dictation. Moody and Young, both in their early seventies, were living spokesmen for a world no longer present to the eye. Moody drowned in 1945, before Bill had learned what he could teach. Young lived into his late nineties, dying in 1968. In him Bill saw and felt the force of Haida narrative tradition. The stories were what kept both Henry Young and Charles Gladstone carving, though they had no good models from the old days left at hand, and in the lingering missionary atmosphere, substantial works of pagan art were effectively forbidden.

In Skidegate in 1953, after spending several days with Henry Young, the anthropologist Wilson Duff made the following brief entry in his notebook:

He has tried to tell [the stories] through interpreters, but the interpreters (e.g. [Reid's uncle] Percy Gladstone) do not understand the old language well enough. The only people who understand when he tells a story are Charlie Gladstone, [Arthur] Moody, [Jimmy] Jones, Solomon [Wilson]. He is caught with stories that he wants to tell but can't.[2]

Reid was caught as well – by the power of the forms that had emerged, in sculpted wood and metal, bone and stone and goat-horn, from stories such as Henry Young still knew. Reid could, of course, have learned the spoken language, but he did not see where that exercise might lead. So he went, like many European artists, back to the museums, to study the visual language instead.

At his grandfather's funeral in Skidegate in 1954, Bill was introduced to the work of the Haida artist Daxhiigang (Charlie Edenshaw), a predecessor he would revere for the rest of his life. On the same occasion, he was given the Haida name *Iihljiwaas*, "Manly One" or "Princely One." It is a suitable honorific for a tall, reserved, and still essentially unrevealed male quantity, as Reid must have seemed to the elders of Skidegate in the early 1950s. It is also a name with a long history in Skidegate[3] (though one of its former owners distinguished himself by raiding Reid's ancestral village, Tanu.)

His second Haida name, *Kihlguulins*, "The One Who Speaks Well" or "The One with the Lovely Voice," came in 1973, when his artistic and verbal skills alike were known in Haida Gwaii. The name not only fit his character; it linked him with a very distinguished predecessor. The name Kihlguulins once belonged to Daxhiigang's cousin Henry Edenshaw, the first Haida certified as a schoolteacher under the colonial regime. This earlier Kihlguulins, who lived from 1868 to 1935, was widely regarded in his time as the most fully bicultural Haida of all – and it was this Kihlguulins's niece and Daxhiigang's youngest daughter, Florence Davidson of Masset, who presented Reid with the name. He was startled when, two years later, she gave the same name to another skillful orator, then Prime Minister of Canada, Pierre Trudeau.[4]

In 1978, at the raising of the pole he had carved for the village of Skidegate, Bill learned once again that in the magic realm of Haida ritual, things could and did go wrong. The name bestowed upon him then was Iihljiwaas – a name he already possessed.

The last Haida name Reid was given before his death was *Yaahl Sghwaansing*, "Solitary Raven."[5] This again was a gift from Florence Davidson. On the strength of the metaphor alone, it pleased Bill more than any other. He was therefore genuinely hurt when Mrs Davidson revoked the name soon after she'd conferred it. It was rumored, of course, that Reid had failed to pay what Mrs Davidson believed the name was worth, but this was only one of several indications that some Haida leaders regarded their most famous (and least obedient) living son with considerable ambivalence. The question of the name was unresolved when Mrs Davidson died, in 1993, at the age of 96. Five years later, Reid himself was dead. At his mammoth, night-long memorial, held at the University of British Columbia's Museum of Anthropology on 24 March 1998, Robert Davidson – Florence Davidson's grandson and Bill Reid's obvious successor as the senior living Haida carver – reconferred the name. Reid has been, without dispute, the Solitary Raven ever since.

III

The histories to which Bill Reid belonged had, of course, done something more than merely intersect; they had collided, with most of the damage sustained on the native side. Reid in a sense was thrown clear of the wreckage, and in sorting out the story, he searched around the world to see what clues and treasures had survived. He was not the first or last artist faced with such a task. The sculptors, painters and poets of Renaissance Europe were heirs to both pagan and Christian traditions – and, like it or not, to the fever of self-righteousness that seethed between the two. Classical Greek and Roman sculpture was still being destroyed out of fear of idolatry in fourteenth-century Tuscany, at the same time that Ghiberti, Donatello and Brunelleschi were measuring and salvaging all the classical work they could find.[6]

Reid's expeditions to Haida Gwaii in the 1950s, to salvage works of classical Haida sculpture, are in the Renaissance tradition, and to a student of the Renaissance, his praise for his predecessor Daxhiigang is more than a little reminiscent of Ghiberti's praise for Giotto.

The problematic coexistence of high art with a thriving trade in curios and trinkets is a Renaissance syndrome too. Fifteenth-century Florentines, eager to see the masterworks commissioned for the Baptistry and the Duomo, had to wade through souvenirs to find the art, no less than the tourists, students and professors of today who come to see Ghiberti's *Gates of Paradise* or Reid's *Chief of the Undersea World*.

Bill frequently made light of himself as an uptown Indian, sometimes even describing himself as "to all intents and purposes a good WASP Canadian." For those who didn't know him, this self-deprecating humor may be easy to misread. In fact, he had an honest monk's indifference to material possessions and an intimate acquaintance not only with the arts of North America and Europe but also with the forests and the beaches and the inshore waters of the Northwest Coast. And he knew better than to think that what he knew about such matters was in any way inborn.

Late in his life, when he was interviewed by Kwakiutl artist and photographer David Neel, Reid complained that "Nobody comes around to ask me about canoes. Some have the attitude, *I'm an Indian. I don't have to learn how....*" And indeed, another Haida canoe-maker, Morris White, told Neel exactly that: "I studied pictures and a few old canoes, but basically we knew about canoe design just like we had a microchip in us."[7]

Something else Reid learned from his Haida mother is that all racist theories of culture are wrong. But he knew it was equally wrong to think of culture as a craft fair, where styles and identities and histories are nothing more than costumes we can all pull freely off the rack.

According to Reid, the essence of the maker has to be smelted into

the work. Then a work of art becomes a binding force in two domains. It gives its strength to its maker's own community, where its meanings (in the best of cases) are most fully understood, and it reaches out to other human beings, wherever and whenever they may live.

Looking at damaged but honest works from the distant past, he is struck by "the great mystery":

how little men, painfully pecking away day after day, sometimes week after week, at pieces of stone, could hold such powerful visions that their final realizations transcend them and their time, become independent of their creators, come to possess existences separate from those who made them, and separate from us who come after. [pp 95–96]

Looking then at shiny, new but imitative work from the present day, he comes to this conclusion:

I don't think you can take the design and the art without taking the people as well. And I think when that is done … you have completely empty images conforming only to the formal aspects of the art, without any feeling or any emotion behind them. [p 198]

What gives an artist a place in society, then, is the same thing that gives his work a place: not his ethnic identity but talent coupled with a sense of responsibility. Cultural and social responsibility, no less than responsibility to insight and emotion, materials and craft.

In that committee room in 1986, where Reid announced himself as Haida, he said at the outset, *I found that a large overburden came with this artform…* [p 213]. Just how large, I think this book, in its softspoken way, explains.

His closing words to the commissioners were these:

As for what constitutes a Haida – well, Haida only means human being, and as far as I'm concerned, a human being is anyone who respects the needs of his fellow man, and the earth which nurtures and shelters us all. I think we could find room in South Moresby for quite a few Haida no matter what their ethnic background. [p 217]

IV

For nearly twenty years – 1939 to 1958 – Bill made his living by speaking on the radio. That phase of his life came to a close when, at the age of 38, he received his first major sculptural commission, but the experience underlies this book. Most of these texts are really not *writings* at all; they are *speakings* – some of them improvised, others rehearsed and painstakingly crafted.

Martine Reid, in her eloquent afterword, describes how he dictated "The Spirit of Haida Gwaii" in 1991, and the manuscripts can tell us quite a lot about the growth of the poem "Out of the Silence," finished twenty years before. In the first extant draft – written with a red felt pen on yellow paper – Bill was groping, sketching, warming up his voice. First he wrote a clause:

To look at a work of the art of the N. W. Coast

and on a separate line, another clause:

is to see only the shape of what it once was.

Next he doctored the first clause, adding an adverb, changing a preposition. Then he wrote the sentence out again from scratch and, with several more trials and retractions, pushed it forward into running prose:

today See
To look at a work A the art of the N.W. coast
~~it is all only the after~~ ~~but it is some~~

To look today at a work of the art from ~~total art~~ past cultures of N.W. Coast art,
is to see only its after-life, the ~~residual vitality~~ residual vitality, ~~which~~
~~almost~~ all that is left of the (magical?) human forces that ~~first~~ aheed it, which
spent force now. ~~but the~~ but still powerful enough to ~~reach reach~~
reach on through the basin of space time cultures, if we in turn reach out to
them.

 It is so easy to become entranced by the soft curtain of age, seeing this
 instead of what it observes.

Even an ugly trinkling can make a beautiful scene
+ a beautiful mask; though to death of many years, (a finely crafted bowl, an elegant
 headdress.
softened by age,
can become a ~~merely~~ symbols which tell us

that the cycle of life,
death, decay + re-birth
is a natural ~~+ constant~~ constant
This is not what their makers intended.
These were objects of bright paint,
to be admired in the newness
of their crisp line,
the smoothest flow +
of sure elegant curves + recesses.
~~~~, and in the brightness
of pad pigment
They told the people
of the completeness of their culture,
the continuing lineages of the great families.
of their closeness to the surrounding world
of myth + legend

*To look today at a work of art from past centuries of NW Coast art, is to see only its afterlife, its residual vitality, all that is left of the (mystical?) human forces which first shaped it, almost spent forces now, but still powerful enough to reach us through the barrier of space time & culture, if we in turn reach out to them.*

*It's as easy to become entranced by the soft curtain of age, seeing this instead of what it obscures....*

FACING PAGE:
"Out of the Silence"
manuscript
(1970–1971)

Finding his rhythm, he shifted back to writing like an orator, laying down the phrases and the clauses line by line – though this too was revision more than composition. He was improvising now on a passage he'd composed some four years earlier, and which first appeared in print in the exhibition catalogue *Arts of the Raven* (1967). But there the words were prose; here they became an incantation:

> *Even an ugly building can make a beautiful ruin*
> *& a beautiful mask, (a finely crafted bowl, an elegant*
> *headdress,) through the dark of many years,*
> *softened by wear,*
> *(can) become (merely) symbols which tell us*
> *that the cycle of life,*
> *death, decay & re-birth*
> *is natural & correct.*
> *This is not what their makers intended.*
> *These were objects of bright pride,*
> *to be admired in the newness*
> *of their crisp lines,*
> *the powerful flow*
> *of sure elegant curves & recesses.*
> *– yes, and in the brightness*
> *of fresh pigment....*

Perhaps they tell more - to us as well as them.
A story of little people.

~~[struck out]~~
in an tiny world
of smaller parts
of absurdly huge tree
of storing woods
a wild water beyond.
who tried and ...
gave way
to long island winter,
+ twister wind this to
no matter how long ~~[struck out]~~ or called this rock.
marked and aware
of this greatness.

In todays crowded world,
we can only wonder that they were so few.
eightteen handfuls of men huts
clinging to tiny but huts
on the jungle backed beach.
But it was a rich land,
above all, a rich sea.
+ between, the always beautiful beach

millions of salmon returned each year
to the creeks + rivers
to spawn + die.
A miracle
that ensured the survival of this race.
+ at the same time

After fifty lines, he stopped. Later, with a different pen and paper, he shifted back to the outward dress of prose. What appears to be the earliest extant typescript is arranged in short prose paragraphs, but in another early version, the first three pages of the text are typed again by clause and phrase – in lines defined by syntax, not by meter – though the lines are not so short, in this typed version, as they are in the first handwritten draft:

> *These were objects of bright pride,*
> *to be admired in the newness of their crisply curved lines,*
> *the powerful flow of sure elegant curves and recesses*
> *– yes, and in the brightness of fresh paint....*

Reid wrote the poem in his own hand, yet it is less a piece of writing than a piece of oral literature, a piece of spoken music, which the speaker has transcribed. Both forms of the text – one superficially prosaic, the other superficially poetic, both equally poetic in the deeper sense – originate with Reid. But the real form, which we have to learn to hear instead of see, merely glances off the paper. In that respect, Reid is close to his teacher, Haida mythteller Henry Young.

"Don't talk, painter, paint," Paul Klee reproached himself in the midst of a lecture he gave in Jena in 1925. But Klee was a man of many talents: skilled writer and violinist as well as painter. Reid, like Klee and Matisse and Kandinsky, believed in a deep unity of all the arts, with music at their core – and what he most loved in music was the old composers' mastery of structured, sculpted form. Bach and Mozart were tangible presences in his studio, and the instant he came through the door, the rock music favored by some of his assistants ceased abruptly and a classical recording supervened. The interwoven figures on the pole he raised at Skidegate in 1978 [pp 126, 129], or those in the *Bear Mother* drawing he coaxed from a sheet of paper in 1982 [p 186],

At most there were probably no more
than 100,000 of them, the population of a
small town, scattered along c 1000 miles of
coastline, 1500 miles more likely if bays +
inlets & islands are reckoned, isolated in
clusters of a few hundred each, only for the
nearest neighbors, cut off ~~ately time they greatly~~
separated from each other by dense jungles,
~~to each of the open of sea ~~ ~~had the coast that was~~ But
+ much of the greenery, at any rate, + by
suspicion ~~animosities~~ that often
separated them as much as the elents

owe as much to Bach's fugues and toccatas as they do to the work of the old master carvers of Qquuna and Tanu. One of the things that impressed him most about his Kwakiutl teacher Mungo Martin was that he sang all the while he was carving.

And like that other master goldsmith, Lorenzo Ghiberti, Reid believed that the figures he created deserved to have something to do. Even when making a single image – *The Cumshewa Raven*, for instance [p 185] – he wanted to feel the force of a story, the shape of a character. The link between sculpture and literature, like the link between sculpture and music, was that strong. In this respect again – though Henry Young lived in another history, apart from Bach and Ghiberti – Reid and Young had something important in common.

Bill knew many Haida words, but English was his only spoken language. He was superbly polylingual with his hands. What is called the art "style" of the Northwest Coast is not in fact a style; it is a language, with a grammar and a lexicon of idioms and elemental forms. "Style" is what distinguishes one artist from another when both are fluent in the language. Reid began to learn this visual language late, and at a time when no one spoke it well. He came late also to the languages of European art. This did not prevent him from having things to say or finding ways to say them, in whichever of these languages he chose. In time, he was fluent and eloquent in the extreme.

Could one translate a sentence from spoken Haida or English into the language of Haida carving or formline painting? That is a lot to ask of translation. Could one compare statements or styles in two such dissimilar languages? That may be more feasible. I think that at its best – as in "Out of the Silence" – Bill's literary work is highly reminiscent of his carving. Both have a quality handsomely defined by Doris Shadbolt as "interlocking density – [a] combination of technical virtuosity, formal complexity and compounded iconographic meanings."[8]

I see another strong connection between Reid's writing and his

The wonder is that they were so few— at most no more than 100,000, the population of a small town, scattered along 1000 miles of coast line, more likely 10,000 miles if bays + inlets + promintories + islands are measured, isolated in clusters of a few hundred each, miles from their nearest neighbors, cut off from each other by dense jungles, + much of the year by stormy seas, + by suspicions + animosities that often separated them as much as the elements. Five distinct language groups + hundreds of dialects helped little in communication. Oh, they survived, + survived well. They could hardly help it. For it was a fabulously rich land, above all, a rich sea, + these were a ~~that~~ sea people. Millions of salmon etc.

drawing. Neither seems willing to remain in two dimensions. Speaking is three-dimensional; it is spatial, in a way that writing is not. All of Bill's best writing has the quality of speaking – and all of his best drawing has the character of sculpture. The paper cuts and drawings that he made in 1965 for Christie Harris's *Raven's Cry,* though unsophisticated technically, are reaching at least for the taste of three-dimensionality inherent in a woodcut. The much more accomplished drawings that he made two decades later for George MacDonald's *Haida Monumental Art* and for his own book, *The Raven Steals the Light,* are more sculptural still. The forms are whittled into the paper. They also have, to quote Doris Shadbolt again, "a certain spectral quality, like branches that have smouldered to ash while retaining their form."9 Bill himself referred to them as ghostly. Their three-dimensionality is delicate, intangible perhaps, yet it is thoroughly convincing.

*Solitary Raven: The Selected Writings of Bill Reid*

Between the *Raven's Cry* illustrations and the highly sculpted drawings of the early 1980s, Reid worked in many media – gold, silver, oak, redcedar, boxwood, alder, yew, diamonds, fossil ivory, argillite and words. During those same years he made his most intensive explorations of the pure graphic language of the northern Northwest Coast: the language of the formline.

*Examples of Reid's drawings are reproduced on pp 30–33 & 185–186.*

Formline art can be flat. (One of its synonyms is "flat design.") Yet in the hands of some practitioners – Daxhiigang was one; Reid became another – the articulated line acquires real dimensional power. It becomes a speaking line, whose inflections form a system of gestural perspective. It becomes *the calligraphy of vision.* For many craftsmen it is merely a technique. For Reid it was a magical discovery – as inexhaustibly exciting as optical perspective for Uccello and Ghiberti.

Late in life, he started quite literally to draw in three dimensions. Throughout the 1980s, working on a series of large bronzes, he often turned for a change of pace to making smaller wire sculptures. These in essence are three-dimensional drawings, created by bending and

twisting a prefabricated, monotonic line that comes in the form of steel wire. There is nothing specifically Haida about them, but they are among the finest and most complex drawings he ever made.

The formline, the whittled line, the twisted steel line all became, in Reid's hands, forms of the speaking line. They became graphic counterparts to what Haida sculptors call *deep carving*. When the story goes out of the line, the line becomes flaccid and flat. Drawing, like writing, only speaks when it really has something to say.

For Reid, the formline, the preeminent form of the speaking line, was intimately linked to the Northwest Coast canoe, an ocean-going redcedar dugout carved, then steamed so that the tree opens its mouth, its hands, its womb and becomes nothing less than the cradle of civilization. Bill was delighted by Buckminster Fuller's notion that technology and art begin in earnest when human ingenuity is tested by the sea. During a lecture in New York in 1984 (not otherwise included in this book because the manuscript we have is only a fragment), Bill put the thesis this way:

*It is possible to build some kind of structure merely by piling pieces of debris on top of one another until you get something you can use, no matter how clumsy it may be, provided you build it on land. But when you decide to go to sea, you discover very soon that you have to contend with factors such as weight-to-volume relationships, width-to-length ratios, relations of strength to thickness, depth and shape to stability. And that's only the beginning. You have to consider the nature of materials, and to invent the tools to effect their transformation. You have to consider means of propulsion and navigation: how to get from here to there and back again without getting lost.*

*And in the end you find yourself transformed. You find yourself with an ability previously possessed only by God or whatever blind force shaped the universe: the ability to design. Along the way, you've probably had to invent language, the most important of tools, and instead of a naked, sometimes erect*

*ape who made his living largely by turning over rocks to find what was under them, you've become a human being.*[10]

His last major work, *The Spirit of Haida Gwaii*, is a canoe filled with the creatures of Haida myth: beings who lived in the voices and the minds of the Haida poets Skaay and Ghandl, and in those of Henry Moody and Henry Young. It is the speaking line moving into three and even four dimensions, giving a visible form to the birth of language – which gives birth to the visible forms the boat contains.

### Editorial Postscript

Reid was an artist and a master craftsman, conscious of his skill, and therefore orderly in his work. Other things being equal, the papers he left behind would, I think, have been the customary mixture of chaos and care which is the sign of active life. Other things were not, however, equal. Parkinson's disease – an affliction Bill shared with Thomas Hobbes, Eugene O'Neill and Salvador Dalí – multiplies increasingly the labor and the pain of daily life. For an artist in such a predicament, there is one overriding concern: to outwit an uncooperative body and continue making art. Such simple luxuries as a clean, well-ordered workbench, desk and archive drift bizarrely out of reach. Bill did not lack for admirers, and these did what they could – but admiration in itself does not create much order. Some of the manuscripts I hoped to find (notably that of the eulogy for his grandfather, written in 1954) had disappeared. Some that survived were incomplete. But among the records he had kept, those held by his wife Martine and several friends, and those in archives at the CBC and at the UBC Museum of Anthropology, lay the makings of this book.

The editorial principles I followed are easily explained. I chose the things that interested me most and used the best texts I could find. I

worked from Bill's own holographs and typescripts insofar as I could find them, and compared the varying manuscripts with each other and with printed texts wherever these exist. In the case of spoken texts, I also used whatever I could find – films, tapes, transcripts, Bill's surviving notes. When the sources diverged, I chose the readings that I thought embodied Bill's best judgement, and when obvious corrections were required, I made them without qualm.

Apart from this introduction and Martine Reid's afterword, the main text of the book is entirely Bill's, and all the sidenotes and endnotes are mine. The notes are uniformly in italic, in a smaller size of type, so my own voice and his can be distinguished at a glance.

Several of the texts were composed to the accompaniment of slides or moving pictures, and I have mimicked these in print as best I could. The early piece called "Totem," for example, was written as the voice-track for a documentary film. Another, "The Classical Artist on the Northwest Coast," was an illustrated talk, delivered from rough notes and captured only on audiotape. I was able to obtain, from a variety of sources, still photos nearly identical to the key frames in the film, but the slides that went with several texts, including the "classical artist" lecture, have vanished. With help in several cases from Bill Holm, I was able to remember or divine what the originals had looked like, and then to seek out duplicates or substitutes. Many of these substitutes were taken by Reid's friends Wilson Duff, Harry Hawthorn, Ulli Steltzer and Bill McLennan. Putting them together with his texts seemed not at all like a repair job, but more like a reunion. And with Ulli Steltzer's photographs especially, I am certain that the substitutes are better than what they replace.

So far as the text itself is concerned, it may be useful to remember that the thirty pieces in this book were composed in the course of half a century of rapid social change. I have altered a few archaic spellings but have not updated any terminology. Like almost everybody writing

at the time, Reid used the term Kwakiutl (rather than Kwakwalan or Kwakwaka'wakw) for members or descendants of all the Kwakwala-speaking tribes. (That usage is as technically inaccurate, but as innocent, and almost as widespread, as the habit of calling the Netherlands Holland.) In the earlier pieces, he says Bella Bella and Bella Coola where later he would have said Heiltsuk and Nuxalk. And in 1982, he debated with a critic he referred to as Miss Fleming. For anglophone men of Reid's generation, this was still respectful language in 1982 (though for Ms Fleming it was not).

Other terminological inconsistencies are the residue of simple historical facts. The British Columbia Provincial Museum and the Royal British Columbia Museum are two successive names for one institution. So are the National Museum of Canada and the Canadian Museum of Civilization. The Queen Charlotte Islands, the Charlottes and Haida Gwaii are likewise all one place. Each of these names has its own political overtones, but the overtones are frequently irrelevant to what is being said. Reid almost always chose whichever name, at the time of writing, was most likely to be understood.

Incidentally, I have kept most of Bill's typographic preferences too. For instance, *native* and *non-native* were for him important terms but not the names of political factions or nationalities. He wrote them always lowercase, and that rule is followed here. This is his book.

Reid has been the beneficiary of some very perceptive (as well as some very dubious) critical writing. But I was struck, in reexamining books and articles about him, by the inconsistencies in dates and other details. Such questions will be answered in due course by Martine Reid's catalogue raisonné, which is now in preparation. In the meantime, it appeared that an outline chronology would be useful. The one included here [pp 237–241] has been checked against Martine Reid's working notes, and I believe it to be correct as far as it goes.

[ 29 ]

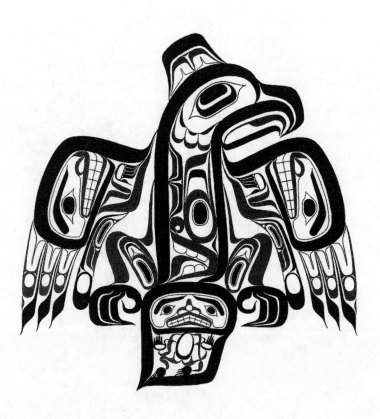

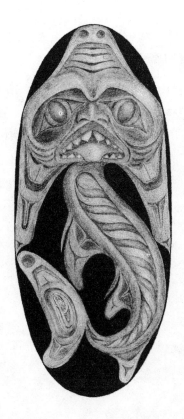

FACING PAGE: Untitled drawing from the *Raven's Cry* series.
Ink on paper with photomechanical collage, 1965.

ABOVE: *Haida Eagle.* Serigraph. Image 41 cm high, 1974. Original in black and red.

ABOVE RIGHT: *The Tanu Dogfish*
(from the *Haida Villages* series, commissioned for George MacDonald's *Haida Monumental Art*).
Graphite on paper. Image 28 cm high, 1982. Private collection.

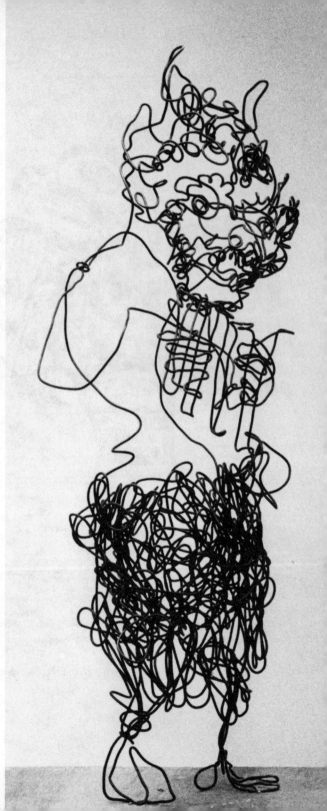

*Pan and Bacchante.*
Twisted wire. 32 & 33 cm tall, 1984.
Private collection.
Photograph by Ulli Steltzer.

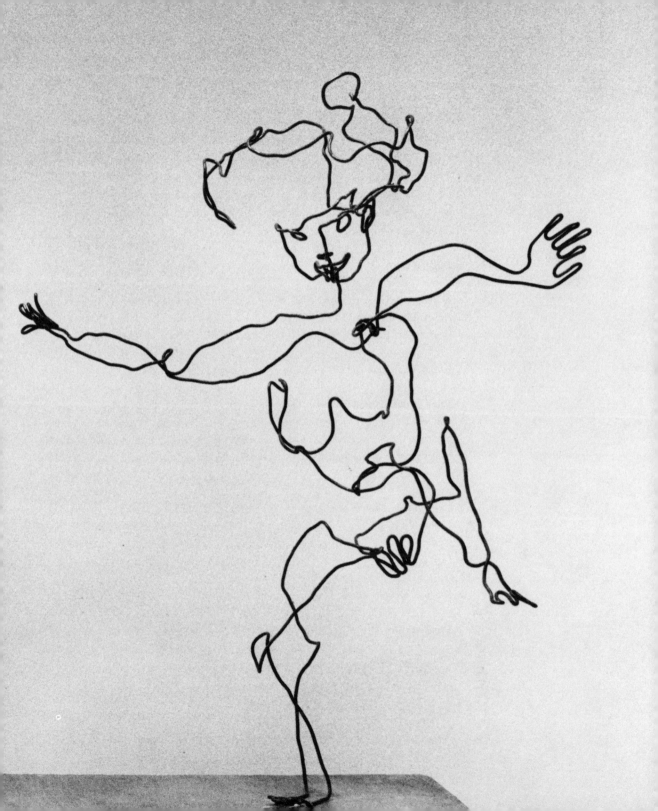

1 *The first was* Out of the Silence *(1971), a poem by Reid commissioned by Edmund Carpenter to accompany a large suite of photographs by Adélaïde de Ménil. The second was* Form and Freedom *(1975), based on a prolonged recorded conversation (convened, once again, by Edmund Carpenter) between Bill Reid and Bill Holm. The third was* The Raven Steals the Light *(1984), ten stories based on ten detailed drawings.* Out of the Silence *was a subterranean success, quickly issued under five different imprints in two countries. Its text, however, is brief — some 1500 words in total — and is reprinted here in full.*

2 *Duff n.d.2: 6-3.*

3 *A Skidegate man by the name of Iihljiwaas is mentioned in Kilxhawgins's history of Tanu, one of the major works of Haida oral literature, dictated to John Swanton in the winter of 1900–1901. Cf Swanton 1905b: 422, 424 n 24, 447; Bringhurst 1999: 311, 315–331.*

4 *Cf Blackman 1982/1992: 124–126.*

5 Yaahl *means raven in northern Haida, the dialect spoken by Florence Davidson. In southern Haida (spoken, for instance, by Henry Young) the word for raven is* xhuuya, *but in names, the northern term is often used even in the south. (The meanings of Reid's Haida names given in the revision of Doris Shadbolt's excellent book [1998: 205] are unfortunately scrambled.)*

6 *Ghiberti tells the story of one such incident (at Siena in 1357) in §3.3 of his* Commentaries.

7 *Neel 1995: 23, 85.*

8 *Shadbolt 1986/1998: 109.*

9 *Shadbolt 1986/1998: 103.*

10 *Unpublished mss in the possession of Martine Reid. Cf Fuller 1981: 23–24.*

**Solitary Raven**:
The Selected
Writings of
**Bill Reid**

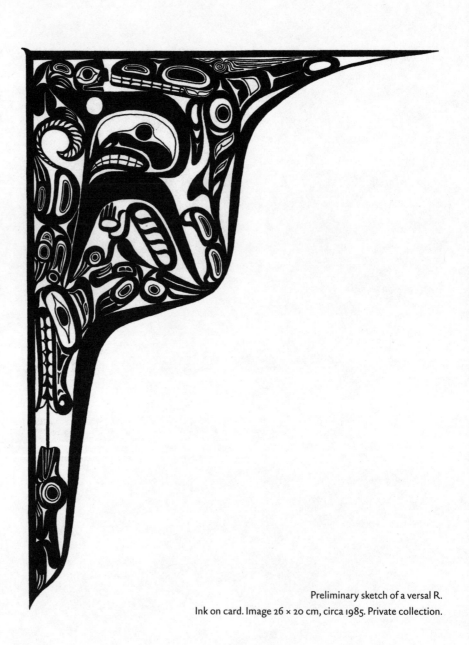

Preliminary sketch of a versal R.
Ink on card. Image 26 × 20 cm, circa 1985. Private collection.

# Journey to Tanu

The whole story is hundreds of years old, and even the parts we know remain to be set down, but the last chapter in the history of the Haida totem poles pretty well belongs to Wilson Duff. He's the anthropologist at the Provincial Museum in Victoria: a young fellow, imaginative and skeptical, who didn't believe that all the poles were either unsalvageable or unobtainable. So about a year ago this spring he went to see for himself.

The totem pole country of British Columbia extends from the northern part of Vancouver Island up the coast to the Alaskan border and inland a short way up the Nass and Skeena rivers, around Prince Rupert. And he covered it pretty well, bringing back a fine film record of his trip and a conviction that at least six poles from two of the abandoned Haida villages on the Queen Charlotte Islands could be, and should be, preserved.

Well, in spite of the fact that this is supposed to be totem land, and the artistic works of our native people are our most outstanding achievement along artistic lines to date, and the good poles are among the most magnificent pieces of monumental sculpture in the world, you can't just go and ask for the few dollars necessary to preserve some of the last and finest examples. So Wilson spent a lot of time last winter showing his films to any group which showed interest, writing newspaper and magazine articles, and doing everything he could to point up the urgency of the situation. For cedar, from which the poles are made, weathers fast in our damp, stormy, coastal climate, and most of the poles were already nearly a hundred years old.

Then one of the huge pulp and paper companies out here got interested and agreed to underwrite the expedition. Then followed

*In July 1954, Reid accompanied anthropologist Wilson Duff to Haida Gwaii to salvage several classical Haida housepoles from the uninhabited villages of Tanu (Ttanuu) and Skedans (Qquuna). Later that year, Reid wrote and recorded this informal talk for CBC radio. The work was first broadcast in September 1954.*

another trip to the Charlottes, and the delicate diplomatic problem of unscrambling the ownership claims and negotiating the purchase of the poles. For the descendants of the proud men who raised them, to honor themselves and their families, still guarded their rights to them – and had pretty well decided to leave them to rot, rather than have another of the last links with the past pass from their hands.

But they became convinced that, permanently preserved, the poles would form a better memorial to the past greatness of the Haidas than crumbling to dust in the deserted villages.

And about here is where I get some right to be telling this story. I'd met Wilson, heard his plans, and when the plans became reality, I invited myself along. My grandmother had been born at one of those abandoned villages, and I wanted to see something of the old way of life, at least its ruins, before even these were gone. So about the last week of June, we went by air to the Charlottes, and to the Skidegate Mission, where my mother comes from, and where many of my folks still live. And there we picked up the boat and crew who were to do the actual work.

The boat was the *Seiner Two*, owned by Jimmy Jones, skippered by his son Roy. They and three others, all from the village, with Wilson and myself, made up the party. We started off at four o'clock on a Saturday morning, picked up a load of lumber from one of the logging camps for crating the poles, and about the middle of the afternoon we arrived at the first village, Tanu. My grandmother was born there, and so was Jimmy Jones.

Now, from the boat all you could see were a few poles leaning at crazy angles, and one houseframe, all of them almost lost in the young spruce forest that had grown up around them. We went ashore in the skiff, and Jimmy Jones pointed out a rock where he'd played as a boy. "Poor boy," he said. "No shoes, no pants, just a little shirt, swimming and diving all day long every day, poor boy."

And then we went ashore and approached the first pole, the fa-mous Weeping Pole of Tanu.[1] It stood between two spruces, taller than it was, that had grown there since the people left. The central figure is human, with a strong old face and great tears streaming from the closed eyes. It seemed to be in terrible mourning, as it had been for the sixty-five years it had stood alone, mourning for the people who had died in the great plagues of the last century, and for those who had been forced to leave this, their home, and for the ruin into which their culture had fallen. We walked along toward the next standing pole, Jimmy Jones pointing out on the way a flat rock on which he said the old people used to sit night after night, looking out at the sea.

The next pole was the best, as far as condition went: completely in-tact, with a few traces of the original paint showing. Some of the old ladies at Skidegate had attended the potlatch when it was raised, about seventy years before. The frame of the house it had once decorated still stood, and the whole thing had weathered to an incredibly beautiful shade of blue-grey, enhanced by the dark green background of spruce.

A little farther on was the last pole we were to lower at Tanu, the largest of the three and a magnificent piece of early Haida sculpture, although quite badly weathered. Jimmy Jones said he remembers it being old when he was a boy.

And then we got to work. And believe me, if you ever hear anyone talking about lazy Indians, tell him to try to keep up with a highball crew from Skidegate sometime. They rigged lines to the surrounding trees, dug out the bases of the poles and cut them into manageable lengths – between eight and twenty feet, making the cuts at points where the design would be least affected. And before we attempted to move them at all, we crated them with heavy two-by-six lumber, so no further damage could come to them.

At about this point, I'm afraid, totem poles stop being beautiful, tragic reminders of a romantic past and become the most unwieldy,

Endnotes follow each individual work. The notes for this piece are on page 44.

stubborn pieces of waterlogged tree that six men ever tried to wrestle out of the bush, over boulders and drift logs and into the water so we could float them to the boat. But – with very little assistance from me at this stage of developments – they made it. We towed the sections to the seiner at high tide, loaded them aboard – probably the biggest deckload a west coast fishboat ever carried – and three days after we arrived, we left Tanu.

We unloaded our Tanu poles at the logging company dock and went on to the second village site, Skedans.

I had no personal relationship with this place, but I think it had perhaps even more appeal. Most probably because it is one of the loveliest places I have ever seen. As Wilson says, a classic village site: a narrow spit of land running out to a high, rocky point and enclosing a small bay, covered with lush grass and dotted with perfectly symmetrical small spruce trees and the leaning forms of memorial and grave poles. Back of the village site, the land sloped sharply upward through virgin forest, the trees widely spaced and the underbrush cleared by the deer. Nobody could plan a finer park.[2]

The poles here were in poorer condition than those at Tanu: only one standing, another on the ground with a large section missing. Someone had cut it out with a saw, with no regard for the design, apparently for firewood or something. The third pole was actually only half a pole, but in a way it was the best of the six. It had fallen on its side into a tree which had grown around it. The side uppermost had almost entirely rotted away, but the underneath side was in such good condition that the original color of the wood and the individual adze marks could be clearly seen. It was very old – and on the northern coast, the older the work, the better. We split the rotten half off and took the rest.

The process was much the same here but much faster. We were now experienced totem pole salvagers. What took three days at Tanu

took only a day and a half at Skedans, and because the weather promised to turn nasty, we hurried back to get rid of our load and return to Skidegate.

Three of the poles are now in Victoria, three at the University of British Columbia in Vancouver. They will never be raised again. Any further exposure would only start the process of decay again. Instead, they will be preserved inside, and if Wilson's program of having contemporary carvers copy fine old poles continues, exact replicas will someday stand in our parks and campuses.[3]

I remember that, after we finished crating the last pole at Skedans, Wilson looked at the dismembered pieces of rotting wood and wondered aloud if in the future the trip would be known as Duff's folly. I think he's got little to worry about. Badly weathered as most of them are, the Haida poles still show such a high standard of artistic achievement that their loss would have been tragic. Until now, we in Vancouver had no good examples of Haida house frontal poles, our predecessors having been content to let them be shipped to other countries or rot in the forests. The whole thing was necessary and a great success. But I will never forget the wonderful, desolate beauty of those poles, which we were the last to see as they stood or lay among the ruins of the abandoned villages of the Haidas.[4]

*Solitary Raven:*
*The Selected*
*Writings of*
*Bill Reid*

Reid and colleagues at Tanu, Haida Gwaii, with crated poles, July 1954.
Photographs by Wilson Duff (Royal British Columbia Museum, PN 5787, PN 7509).

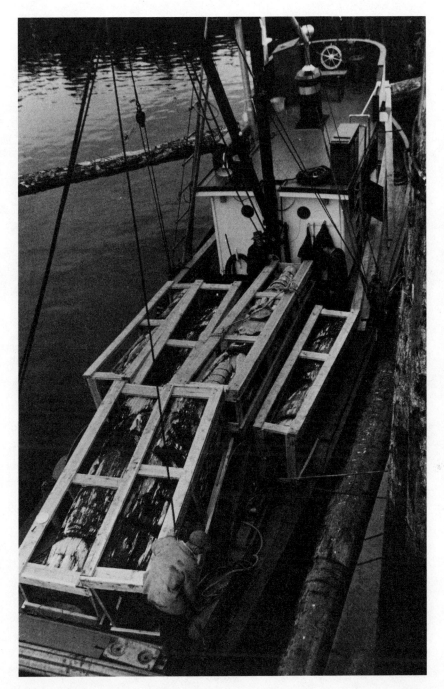

The sectioned and crated pole on the facing page is the housepole of *Naagha Hliman Xhunanadas* (Tanu house 24). It was raised about 1870 by a headman of Reid's own lineage, the Qqaadasghu Qiighawaay. The dismembered pole is now in the Museum of Anthropology, University of British Columbia, Vancouver.

On this page, all three sections of the same pole are riding on the aft deck of *Seiner Two*. The other three crates contain the housepole from *Ghut Kyaal Naas* (Tanu house 20). Remains of the latter pole are now in the Royal British Columbia Museum, Victoria. Roy Jones is at the stern. Behind the wheelhouse are Reid and Jimmy Jones, the owner of the vessel.

*Journey to Tanu*

1 *Years later, Reid learned more about this pole and began to describe it quite differently. Based on Charles Newcombe's conversations with knowledgeable Haida speakers a century ago, we can be confident that the so-called weeping figure is one of the incarnations of Tangghwan Llaana, "Sea Dweller." In Haida myth and art alike, this mythcreature, headman of a village on the seafloor, is distinguished by protruding or exaggerated eyes. In the late 19th century, he was prominently carved on three of the housepoles at Tanu. (See Swanton 1905b: 157–159, MacDonald 1983: 96, Bringhurst 1999: 103–110.)*

2 *Not long after this was written, the Skidegate Band Council was persuaded to allow the hill behind Skedans to be logged. The work was done by an unskilled crew, who maximized destruction of the site and also minimized the monetary return.*

3 *The rescued poles – identified according to the system established in George MacDonald's* Haida Monumental Art *(1983) – are Tanu 11, 20 & 24, and Skedans 1, 24 & 25. Tanu 24 and Skedans 24 & 25 are now in the* UBC *Museum of Anthropology, Vancouver; the other three in the Royal British Columbia Museum, Victoria. Duff referred to these poles as "our stock of 'old masters,' to be copied in new, sound cedar by Mungo Martin [Naqap'ankam] and his fellow Indian carvers" (Duff 1957: 22), but his plan to commission native carvers to replicate the poles has never yet been fully realized. Martin, assisted by Reid, carved a replica of Skedans 1 in 1957, but it is displayed as a tourist attraction, not a work of art, standing beside the highway at the Canada/USA border crossing, Douglas, BC. In 1967 Henry and Tony Hunt carved a replica of Tanu 11, which stands now in Thunderbird Park, near the* RBCM *. Beside it is a replica of a mortuary pole, Tanu 15x. The original of this pole was bought for the museum by Charles Newcombe in 1911. Martin made the replica in the 1950s. A third pole from Tanu – one of several taken from the village in 1935 and erected as tourist bait on the mainland – was copied in 1974. The remains of the original are now in the* RBCM *; the replica, carved by Frieda Diesing and Josiah Tait, stands in a public park in Prince Rupert. Replicas or variants of seven other poles – from Skidegate, Masset, Cumshewa and Ninstints – have been carved for Vancouver and Victoria, and a replica of one (from Yan) for Haida Gwaii. Four of these eight were carved by Reid, with the assistance of Doug Cranmer.*

4 *Duff 1954a, 1954b and 1955 are three brief accounts of the same voyage, good to read beside Reid's "Journey to Tanu."*

# People of the Potlatch

First, this should be remembered about Indian art: it is a dead art. As dead as that of classical Greece, of ancient Egypt, as dead as the rotting cedar of the grey, dismembered ghosts of the totem poles you'll see in the main room of the art gallery during the Indian show there.

It's true that Mungo Martin[1] in Victoria – a genuine link with the great carvers of the past – and perhaps myself, and maybe a handful more, are still producing a few things in the traditional form, but we're atavists groping behind us toward the great days of the past, out of touch with the impulse and social pattern that produced the art.

Second, this was a great art: sophisticated, polished and refined, primitive in the technical sense only, the finer works the results or the labors of highly trained, specialized and talented artists.

It can be viewed in many ways. The general public, acquainted only with a few gaudily and falsely painted totem poles, views it as curious grotesqueries, strange, even ugly. Or with a little deeper interest, it can be considered as a mass of fascinating and complicated puzzles, to be solved when the key symbols are known, and classified according to the various creatures depicted. Or you can admire its ingenuity. You can marvel at a people who, with the crudest of tools, could fall and carve great tree trunks into huge totem poles or create ocean-going boats – up to sixty feet in length out of a single log – or mold a mountain sheep horn into a beautiful spoon, or from a single board, by notching and steaming, bend the four sides of a box, sometimes straight but sometimes beautifully curved. And remember, you had only one chance to get those joints right – and more often than not, they are right. And then there's the anthropological approach, when a

In April 1956, the Vancouver Art Gallery mounted an exhibition of native Northwest Coast art under the title People of the Potlatch. To celebrate the opening of the exhibition, Reid wrote and recorded this monologue for CBC Radio. The text was then adapted as the voicetrack for a CBC documentary film based on the same exhibition. Audrey Hawthorn's People of the Potlatch (1956) is the published catalogue of the exhibition.

profound study of the culture of these people relates the art to the times and circumstances that produced it.

But perhaps the only valid approach today, and the one which I hope those of you who see the show at the gallery, or other exhibits of Indian art, will take, is to view it for its own sake, as one should approach any great art, to see in it the beauty of form, the strength and subtlety of line and shape, to experience the emotional impact one gets in the presence of greatness.

For it is really only this that justifies such exhibitions: the fact that this art has elements of the universal – quite apart from the people and the society that produced it – which make it as important to the sensitive mid-twentieth-century man or woman as it was to the people it was originally made by or for, though perhaps in an entirely different way.

So what reason is there for assuming that this is a great artform, worthy of an expensively prepared exhibition in an art gallery, preceded, say, by a show of leading contemporary painters and followed by the sculpture of Henry Moore?

Well, of course, the proof of the greatness of this artform, as of any, is in the visual evidence itself, judged objectively by an experienced and sensitive observer. But perhaps some of the other levels of appreciation I referred to before are useful in the initial approach, so let's look a little into the history and background of the people who produced it.

I'd like to establish one point about this particular talk before going on, however. The entire field of west coast primitive art is too vast to be dealt with in one short essay, and in any case, I have special knowledge of only a few of the subgroups of the culture, all quite closely related. So I will speak only of them. I have great respect for the expressive, simple and natural carvings of the Coast Salish – the people from the Fraser Valley and estuary and parts of Vancouver Island – but I don't pretend to know much about them. And the fantastic work of

the Bella Coola people, an offshoot of the Interior Salish, isolated from their own kind in a little pocket on the coast, remains to me a mystery.

The little I know of the art of these people centres around the north, where apparently most of it began, perhaps with the Tsimshian, the people who live on and around the Nass and Skeena rivers.[2] They too may have originated as the cut-off offshoot of an earlier migration, and may have developed, or even brought with them, the beginnings of the art. Some legends say they did. Or it could have started in Alaska, with the Tlingit, who in turn may have acquired the early forms from the people of Asia. But in any case, as far as I'm concerned – and perhaps this is merely prejudice, as they are my mother's people – the final distillation of the artform seems to have been accomplished by the Haidas, the native residents of the Queen Charlotte Islands and (following a recent migration) of parts of southern Alaska.

And then there are the Kwakiutl, the best known of the totem-pole people, who live around the northern half of Vancouver Island. Their art is superficially like that of the northern natives yet actually so distinctive, the approach so different, that it forms a school unto itself.

The arts of the Tlingit, the Tsimshian and the Haida are very closely related. They shared the same general culture, lived in the same types of houses, dressed very much the same, followed the same ceremonials, and through trade and warfare, absorbed each other's artforms. The great families had the same crests, the totemic figures which formed the basis of all Northwest Coast art – the Raven, Eagle, Bear, Wolf, Beaver, Dogfish, Killer Whale and many more. Some were based on actual animals, such as the frog, mosquito and mountain goat; others were pure mythology, such as the Sea Wolf and Sea Bear, and the Thunderbird, who may or may not have been originally the fish hawk. All were related in some way with the legendary history of the families who claimed them as crests. These – and nobody has ever compiled a complete list – were the only subjects permitted the artist.

And each had to conform to certain rigid conventions, had to contain the proper identifying characteristics executed in the approved conventional style. And all art had to follow the form of the object to be decorated, whether it be a totem pole, where the shape of the tree itself dictated the form, or a storage box for instance, where the practical considerations established the size and shape, and the design followed. For the art of these people was above all practical. They made nothing (except latterly for trade purposes) which did not essentially fulfill some function, either practical or ceremonial. Even the totem pole, at least the house frontal pole, was originally a practical supporting part of the house.

It could never be, as our art is, the expression of an individual. All the important art was commissioned by wealthy nobles, and the artist, whether he be carving a totem pole, making a mask, a feast dish, a spoon handle, a bracelet, or any special object, had to confine himself to the crests of his patron, arranged in the way laid down by that patron. And he had to conform to the general concept of what such an object should be. This was a very conservative, long-established society, and free expression was probably as far removed from the thoughts of the artist as it was from being accepted by the society as a whole.

And there were the technical limitations.

One thing they had in abundance: time. This is, and was in the past even more, an extremely wealthy part of the world. The sea gave generously of its riches, and food was never a problem. And the forests gave them what they needed for building and manufacture: the great, straight-grained cedars for houseposts and planking, for the great variety of dugout canoes, for the food boxes and for an infinite number of useful objects. Cedarbark produced baskets, fabric, hats, even woven water buckets and cooking utensils. All this required hard work to gather, but this was summertime activity, and the long, wet winters

were used for ceremony – the prolonged potlatches so often referred to and so little understood these days – and for the creation of manufactured goods, useful or ornamental, but usually both. And the economy was rich enough to support the exceptional artists and craftsmen (there seems to have been no distinction) and to permit them to follow their careers without economic worries.

But aside from time and basic materials, they had little to work with – a few crude tools, some stone, in the early days probably a few iron knives and later adzes and chisels made mostly from old files obtained from white traders. Painting was limited by the very few pigments, laboriously created. The women had no spinning mechanisms beyond a simple disc with a hole in it, and no looms, only a stick from which the yarn was hung.

So there you have the conditions under which the artist worked. A rigid convention beyond which he dare not stray, a rigid form dictating the very shape of the finished work, a demanding patron dictating to the last detail the subject matter, a long-established tradition with which there was no breaking, and very limited technical resources. Anything but the right atmosphere to produce a vital and lasting artform.

And yet there's no denying it did just that. And the reason, I think, lies largely within the very factors which apparently would restrict artistic development.

First, the restricted subject matter – the heraldic crests – represented highly respected legendary figures with whom all the people including the carvers felt a definite affinity. When the Northwest Coast artist created one of the imposing abstractions of, say, the Beaver, he certainly had no idea of expressing the essence of a rather large semi-aquatic rodent. Rather, he was expressing all the wealth and power and greatness attributed to themselves by the members of the family

claiming a more-than-life-sized, mystically endowed beaver who figured prominently in their history, a concept the artist could understand and appreciate.

And though it was essential that the Beaver conform to a conventional pattern, that pattern was so flexible that there was an almost infinite number of variations which his interpretation could assume, and in a culture very sensitive to minute subtleties of line and form, any successful variation must have been of great satisfaction to both artist and audience.

If painting and carving had to conform to the shape of a useful object, then it was incumbent on the ingenuity of the people as a whole to evolve an artform adaptable to such a function, and of the individual artist to interpret that form in order to perfectly complement the object to be decorated.

The restrictions imposed by the artist's patron called again for the use of great imagination and ingenuity in creating a uniform work of art containing in perfect harmony all the various ingredients called for.

And though the technical limitations were many, the intensive training and practice in all the crafts – necessary from an early age for ordinary survival under the difficult circumstances of life – produced craftsmen of the highest quality: a whole race of people who could and did make for themselves all the physical necessities of life and who, when sufficiently talented, could apply the same skills to major works of art.

So in spite of the restrictions, the Indian artist of our coast, as any good artist anywhere, managed to express something of his own individuality and contrived, even within this rigid framework, to produce distinctive creations.

And his society respected him for it. Once the conventions were fulfilled, apparently the artist was encouraged to show the great freedom of developing his variations on the old themes. For this was the

essence of the northern art: the refining and exploration of every possible variation of one basic design concept. And that, I believe, explains why every piece, of no matter what size – a totem pole sixty feet tall or a shaman's charm three inches long – has a monumental quality, and why at this distance in time, we still can feel the power of these figures.

For – and this is the purest theory on my part – the result of this long, subconsciously carried-on research into their own art, was to produce one basic line and one basic form. The line is the one which contains the familiar eyeshape which constantly occurs in all art of the northern coast, and the form is the three-dimensional expression of this. Almost every line or form in any carving or painting, in the very shape of the dishes and curved boxes themselves, contains some elements of these basic shapes. And the shapes themselves – well, they are of a general pattern, a lateral oval, flattened on the bottom. And they seem as though they should conform to some geometric principle, but if they do it is contained in no conventional geometry. It is as though each infinitely small segment of the line were a very subtle variation of every other part. And the end effect given by this passive-looking form is the realization of incredible tension, as though immense forces had been tamed and contained in it.

And all the art is an extension of this. No suggestion of movement is given, but each figure suggests enormous, momentarily restrained strength. In the faces there is no expression, but there is no blankness either. Rather, a suggestion of contemplation of things beyond good or evil. Beyond man, perhaps beyond this world, certainly beyond imagining.

Well, it's all over now. Perhaps it was over before disease and the ways of the white man, and the end of potlatching, and Christianity brought the whole movement to an end. It could be that the last refining had been accomplished, and only repetition and gradual degeneration were in store. There seems to be some evidence to that

effect. Certainly some of the art objects seem to approach as close to perfection as can be imagined in that medium. We will never know. We can only look at what they did produce ... and perhaps feel a deep regret and maybe a little shame that such a culture should have been allowed to disappear so completely, practically during our own life-times, and also feel a certain pride in belonging to the same race as a people who could create such ingenious, expertly made and beautiful objects: the human race.

And so the Indians of our coast have passed from the scene as vital contributors to the world of art. And they left us a great clutter of objects for museums around the world, a line, a shape and a form, an example and a hope. An example of a people, very few in numbers, who developed a high artform, understood by and participated in by all, so that every aspect of everybody's life was enriched by it. An example that contains within itself the hope that we may someday, on a much broader scale, do the same.

NOTES

1 *Just a year after this piece was written, Reid worked briefly under the guidance of the Kwakiutl carver Naqap'ankam (Mungo Martin). See p 146.*

2 *Anthropologists nowadays are usually careful to distinguish the Nishga or Nisga'a (the people of the Nass River) from the Tsimshian (the people of the Skeena River). The Nishga and Tsimshian languages, though closely related, are separate – and in recent years, separate land claims have given the historical distinction a renewed political importance. In 1956, when Reid wrote this piece, few anthropologists, and few native people apart from the Tsimshian and Nishga themselves, were attentive to the differences. The Haida poets and oral historians who dictated works to John Swanton in 1900–1901 also grouped the Nishga and Tsimshian together. (In classical Haida, both are known as Kilghat.)*

# Art of the British Columbia Indian

A hundred years ago, when this province was born, the arts of the coastal Indians had reached their zenith. In great timbered houses in hundreds of villages, lavish potlatches passed the winter months, celebrating in song, dance and feasting the achievements of a proud people.

In front of the houses of the north coast, huge totem poles told of the mythical origins of the families of their aristocratic owners. The light of the winter fires illuminated the wonderfully intricate masks of the actors in involved dance dramas, and the beautiful robes and head-dresses of the highborn guests and hosts.

Hundreds of immense canoes, among the most beautiful and sea-worthy open boats ever constructed, carried large parties to pot-latches, to war, or to visit the young white settlements in the south. The white man had brought disease, alcohol, corruption and exploitation to the natives, but he had also brought new wealth for more lavish giving and new tools to permit the old designs to be worked into larger and more complex forms.

Five years later, the smallpox plague, which had been working its way across the continent, struck the coast of British Columbia, and in a few short months much of this colorful civilization was swept away, two-thirds of the people dead, villages deserted, canoes rotting on empty beaches.

In the north – the centre of the finest material artforms – pot-latching was practically over, and with it, the carving of totem poles, masks, rattles and ceremonial equipment. European utensils soon replaced the carved food boxes, watertight baskets, and all the ingenious and beautiful artifacts of daily life.

*Reid was commissioned to write this introduction to the section "Art of the B.C. Indian" in the Vancouver Art Gallery's exhibition catalogue* One Hundred Years of British Columbia Art, *compiled in 1958 by Robert Hume.*

[ 53 ]

FIRST NATIONS
HOUSE OF LEARNING

X̱WI7X̱WA

Not that it was all over. Most of the beautiful slate carvings of the Haidas were still to come. The Kwakiutl, until the legal banning of the potlatch in the early years of this century,[1] would still create their fantastic bird masks.

But it couldn't last, and today, only a handful of native craftsmen work in the tradition of their ancestors, and only a few of their works compare in any way with the masterpieces of the past. It is only in collections of the cracked and broken, time-blackened, dry and faded, or occasionally well-preserved relics of these people that we can feel for a moment a little of their recent greatness.

In assembling this collection, the Art Gallery did not try to give a comprehensive picture of the Indian's life. The objects displayed were chosen for their artistic qualities, the beauty of design and excellence of workmanship. If some of them are utilitarian devices, it is because the art of these peoples was largely an applied art, decorating many practical articles, particularly those used at potlatches. They are not arranged according to their place of origin, or the different groups who produced them, but in an attempt to show them to the best advantage possible as the beautiful sculptural objects they are.

Actually, to know the technical facts about these people and their art adds little to an appreciation of it. You can, if you wish, learn to identify the different styles, to know if the artist who created a certain object was Tsimshian, Kwakiutl, Nootka, Salish or Haida. You can much more easily learn to identify the various human, animal and mythical figures in the carvings, characters in the old legends, each of which was the individual genesis of a great family. In the more recent carvings, you can even determine the names of the men who carved them.

And in comparing them all, you can find in Salish work the qualities we think of as primitive in art: direct, unsophisticated, almost childlike creations. The Kwakiutl can best be described as the dram-

atic, theatrical artists of the coast, their carvings bold and terrifyingly imaginative, their colors violent and garish. The Haida are the classicists, working always within a strict convention, exploring and refining it with infinite subtle variations, preserving always a conservative austerity, sacrificing movement and expression for unity and form. The Tsimshian were the most expressive, you might say: their human faces almost delicate, carved with a tender sensitivity, their animal forms with an understanding born of complete familiarity.

These were not formal tribal or political units. There was among the Indians of the Northwest Coast no recognized association larger than the family. There were large linguistic groups, each containing many related dialects, and each having many distinctive cultural traits, reflected in the style of their art. But more apparent than the differences is the similarity of mood, a restrained, sombre quality, the only expression possible of a people who for centuries were part of our dark, rich coast. And through these centuries, this expression became – at least in the north – a high art, no simple subconscious projection of savage superstition but a sophisticated creation of a cultured civilization, the best works performed by trained professional artists.

The best of their work ranks with that of any fine artist past or present, anywhere in the world.

And so, the technical knowledge is not really important, for these things must be judged and appreciated as all other works of art, for the beauty of their forms, their concept and design, and for the excellence of their workmanship.

NOTE

1 *In fact the potlatch was outlawed by act of Parliament on 19 April 1884, with effect from 1 January 1885, but enforcement of the law was highly unsystematic in the early years.*

# Totem

*Reid wrote and recorded these words in 1963 as the voicetrack for a* CBC *documentary film about a visit he and others had made six years earlier, in 1957, to the southern tip of Haida Gwaii. It was the second of two Provincial Museum expeditions to salvage carvings from abandoned Haida villages. The destination was the village site shown on recent maps as Ninstints, on Anthony Island. The salvaged carvings were taken to the British Columbia Provincial Museum in Victoria and the University of British Columbia in Vancouver, where most of them remain. Several were transferred in 1976 to the Queen Charlotte Islands Museum in Skidegate, where they were destroyed by fire.*

Anthony Island is very small: a mile and a half long, a few hundred yards wide, approachable only by a small boat or a canoe: a large rock, covered with scrub timber and salal, lying off the southern tip of the Queen Charlotte Islands. And on the eastern side, protected by a promontory, stretching along the beach of a little bay, was the last large group of standing Haida totem poles: the remains of a deserted village remembered as Ninstints, the name of the last chief. It was known for centuries to the Haidas as *Sghan Gwaay Llanagaay,* "Red Cod Island Village."[1]

In those days, many boats came and went through this passage: the long beautiful dugouts of the Haidas, taking people to the fishing grounds, war parties on raids, bringing guests to the great feasts honoring the men who raised the poles, towing the logs to carve them from. We came as guests too, to honor the carvers in our own way, by taking what remained of their work, to preserve it and show the outside world something of the wonder of the old days.

We were very late. It had been seventy years since the handful of survivors of the disastrous battles with the white man's guns and devastating plagues had left. A fire had destroyed a large part of the village during that time, and the rains and winds of all those winters had crushed all the houses and toppled many poles.

These first hours on the island were the best of all: a thrilling and a sad time for us, when we could forget for a moment why we were here and enjoy to the full the sombre power and beauty of these massive sculptures. And to think also of what had been lost. Not only the poles and other material things that had been destroyed or allowed to decay through neglect, but all the rich pattern of legend and ceremo-

nial which lay behind these massive expressions of a rich and colorful way of life.

For each of these carvings represented three things: a leading figure in one of the ancient epics in which each great family traced its mythological beginning, and the achievement of the family head, who had it erected to tell of his wealth and his proud ancestry, and most important to us, the skill and virtuosity of the carver, an artistry born of an old tradition, nurtured in a society where painting and sculpture, song, dance and legend were the major part of the pattern of life.

We weren't *too* late. Everywhere, there was a wealth of wonderful detail: powerful wings and feathers, huge impassive eyes, little crouching figures. The jungle growth of the North Pacific had almost reclaimed some of the poles, crawling over them and splitting them with its roots, but it had protected some too. The trees that had grown around this house frontal pole had broken the violent winds of three-quarters of a century. It still stood tall and straight, and even the finest details of its carving remained. It was a very pleasant thing, on that first day, to look up and try to unscramble the fantastic abstractions and relate them to the few legends we knew.

We decided that this pole told the story of the Bear Mother, kidnapped by a young bear chief (who of course assumed human form when he reached his home and removed his shaggy coat), of their marriage and the twin, half-human cubs she bore, and of the sacrificial death of the Bear Father so the twins could be returned to their human kindred and become the first ancestors of the bear clan.

Perhaps a legend something like that is pictured here.[2]

And these were the graves of the highborn *xhaaydla xhaaydaghaay*.[3] Those square cavities in the tops received their coffins, and a great carved and painted slab was placed over the front. The slabs have long ago fallen to the ground, and little trees have wound their roots among the crumbled bones of the proud chiefs.

Photographs by Bernard Atkins, 1957 (Royal British Columbia Museum, PN 7660, PN 7644).

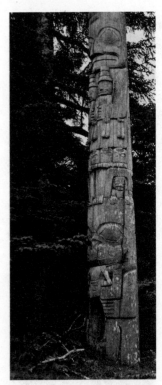

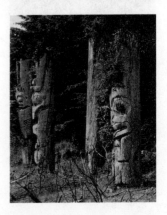

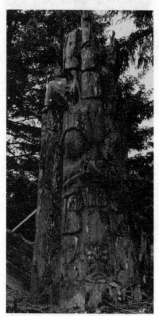

Only one houseframe still stood – and perhaps it stands no longer. One man could shake it with a gentle push when we were there. Its frontal pole once stood between the two centre columns. It was a small house by west coast standards, but these beams and timbers show its massive construction and the perfect proportions of its austere architecture.

We could have kept on with this aimless, exciting and melancholy exploration for days. But there was no anchorage for the boat, and so we had to set up camp before the threatening rain began. There were eleven of us altogether: four anthropologists, three Haida fishermen – the skipper of the boat, his brother and the cook – two cameramen, an enthusiastic amateur authority on Haida houses and villages, and me, a descendant of the Haidas and representative of the CBC.[4] The cameramen took pictures, the cook cooked, and the rest of us ferried supplies from the boat and set up a pretty comfortable and, we thought, adequate camp.

We all depended upon (and I think envied a little) the effortless competence of the Haida crew in this and the harder tasks to come, but we all made a creditable job of adapting to the not very arduous circumstances of camp life. Most of the city dwellers began to grow beards. The Indians shaved with their battery-operated electric razors.

And that ended our first day on Anthony Island.

The next day we approached the village with a different purpose. The wonder of the poles still was there, but now we turned to the job we had come to do: to cut them down and take them from this place where they had stood so long. This huge Beaver was left intact and standing after the fire had burned the house behind it and eaten through the pole, just above its head. Its back had been burned thin, and the wood was old and pulpy. A paper totem pole, Wilson called it. It was in a difficult position, so it had to be lowered onto its face, and

a lot of careful planning and rigging went on before the few cuts needed to sever it from its base were made. It's hard to get used to the idea of handling a ton or two of wet, rotten wood as you would a piece of fine china, but it must be done that way, until the sections are crated. And certainly works of art of this quality deserve no less. There was a lot of relief and satisfaction after we turned it over and found scarcely a splinter dislodged from the old giant's wrinkled face.

And that's how it went, day after day, as the best of the poles fell to the axes and saws of the falling crew. The skills learned in logging camps and on fishboats were much more important than doctorates or degrees in this most vital part of the whole job. Roy Jones of Skidegate is one of the best bush engineers you could find.

And the time came for our Bear Mother and her family. The spruces that had sheltered them now helped ease them to the ground. The old cedar was wonderfully sound, and the saws had to cut deep before the tall column began to yield. And even then, it seemed to struggle to remain upright. But finally, slowly and carefully, and I think with the same dignity it had always had, it began its final descent.

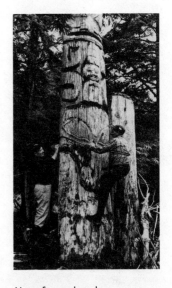

Houseframe photo by Harry Hawthorn, June 1957 (UBC Museum of Anthropology archives); others by Bernard Atkins, June 1957 (RBCM PN 7497, PN 7641).

The rain had threatened ever since we arrived on the island, and when it came, it did so with a vengeance. It wasn't a violent storm, as storms are judged on the Northwest Coast, but the calm gave way to choppy seas which drove the boat to a safer anchorage off the main island. The poles became black and streaky, and seemed to recede further into the trees that surrounded them. It was impossible to work, and inactivity brought a feeling of complete isolation as the sea boiled around us and the rain and wind rattled the canvas of our tents.

The reason for the massive, solid houses of the Haidas became much clearer to me. It must have been a fine feeling to leave the violence of the elements outside timbered walls and tell again the old stories in the warmth of the central fires and the company of close

[ 59 ]

friends and family, with the canoes safely beached and the totem poles keeping watch outside.

The poles still kept watch for us, but our flimsy shelter offered little attraction, and the grey damp seemed to stifle conversation. And

so we slept, or wrote up reports, or stumbled around on the soggy, littered beach when mere sitting became too tedious.

I forget how long it rained during that first storm. I know it was pleasant the first night, as it always is when sleeping out, to go to bed and listen to the drumming of rain on canvas. It wasn't so pleasant waking up the next morning with water lapping around our feet, soaking through the sleeping bags, and spending the next day trying to keep a fire going in the rain so we could dry them before the next night. We still had a lot to learn about Northwest Coast rain and the rate of runoff on small, rocky islands.

I suppose it did stop raining once in a while during the remaining week or so we were there. In any case, it eased up enough to let us get on with the job. And when it got too bad, we found other things to do. We'd gone on an exploring and hunting walk around the island when we arrived. There were a few scrawny deer to be seen, but we didn't get any. I got lost a couple of times. But we did find the site of another village, so long abandoned that nothing remained except the shell heaps left by the people and the vague outlines of house foundations. It was an easy walk through park-like forest, only a short distance from Ninstints. Whether it was an earlier home of the same people or another contemporary centre of population we couldn't even guess. But the shell heaps were very deep, and many people had lived there for a long time.[5]

The highlight of our exploring lay a little further along the coast: a large cave, exciting in itself, as caves always are, but more so for the signs of long occupancy it showed: the first knowledge we had of cave-

dwelling among the Haidas.

The walls were worn smooth by the waves that hollowed it out, long before the island rose entirely from the sea, which had also left the smooth layer of sand that formed the floor at the rear. But most of the floor was solid shell, feet deep, accumulated over many years of human habitation. Later on, Wayne Suttles and Mike Kew did considerable digging in this shell, but most of the things we found were lying on the surface. Not much: the halves of a wooden whistle, a small bow – perhaps a child's toy – a blanket pin. But these little fragile things, more even than the deserted villages, made us wonder what they were really like during their centuries of long isolation.

*Solitary Raven:*
*The Selected*
*Writings of*
*Bill Reid*

For we don't really know very much. It's less than two hundred years since the first white men came this way, but they didn't bother to come ashore, or if they did, they left few reports, and from then on, life changed so rapidly, and new legends invented by prejudiced missionaries, ignorant traders and half-informed scholars created a pattern of confusion only now being slightly unscrambled. But of course, we can never know the real truth. We do know that the people lived by the sea, knowing every aspect of its changeable nature, every year gathering a rich harvest from its teeming depths and shoreline. We know they were a fine-looking people, with pride in their race and lineage, never permitting them to live simply on the bounties of their rich seas and forests. They were an ingenious people, using such unlikely materials as shredded cedarbark and spruce roots for basketry and clothing, and, with the most primitive of tools and an infinite knowledge of the material, falling huge trees and creating almost entirely of wood a great material culture.

It was the sea that shaped the first and, to the end, the most beautiful of these creations, the matchless grace of the Northwest Coast canoe. The cedars grew tall and straight in the rainforests of the north, but it took the experience of generations of skillful men to change their trunks into seagoing boats, sometimes seventy feet long. The log

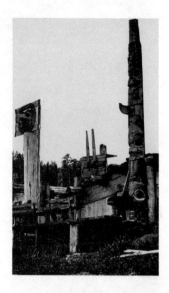

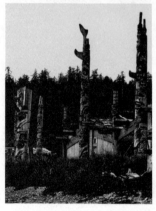

Skidegate, 1881. Photographs
by Edward Dossetter
(American Museum of
Natural History Library
Services neg 42267).

was shaped and hollowed, and then, in the supreme example of primitive genius, the whole thing was steamed by partly filling it with water and adding hot rocks until the water boiled, so it could be spread to the proper beam. This gave the beautiful flaring curve to the sides, and the rough seas dictated the high bow and stern. And so as always, perfect function produced perfect beauty.

But it was when these practical skills and sure sense of design, born of necessity, were applied to the lavish heraldry of ceremonial life that the full splendor of Haida art was born. And though the white man brought disruption and eventual destruction to these people, he also brought a flood of new wealth and new tools to augment the stone hammers and adzes and the few iron knives they had had before. And so for a little while, during the first two-thirds of the last century, creativity on the west coast flourished as it never had before and perhaps never will again. In every village on the Charlottes, totem poles grew in a rich profusion: forests of strange birds, beasts and heroic figures almost obscuring even the massive lodges they decorated.

It wasn't to last long. Even in these old photographs, most of the houses are deserted and many of the poles already in ruins. But it was a spectacular hothouse growth while it lasted, and life must have been a continuous round of feverish activity, of obtaining wealth from the sea and the fur trade, building houses, carving poles, and participating in the great feasts when the houses and poles were erected.

For each housebuilding and pole-raising was a family affair, with the head of each branch being given a specific job for his group to do. One to carve the pole – or hire an artist to carve it – one to hew the house timbers, another the planking, another the roof. And when it was all done, the owner of the new dwelling rewarded each according to his rank, and there was a lavish feast where the story of the house was told and it was given its name, and the right to use the crests on

the pole was established. The villages must have been fine sights in those days, when the houses were new and the poles bright, when there were hundreds of people to clear away the litter of living.

And if the lavish scale of wealth was new, age-old ritual and convention still dictated the way of life: the right design for a new hat, the proper jewellery. And the old ways and beliefs were still considered far superior to the barbarian customs of alien invaders.

The new money was useful, because the silver and gold coins could be beaten into bracelets and carved with family crests, but abalone shell from California was valued more than the finest of the white man's jewels.

And there is one thing more we do know but cannot fully understand (and I hope never will be able to understand): how it all ended, and what finally happened to the people. The story of Ninstints is typical of nearly all the villages on the coast. A forgotten history, hundreds, perhaps thousands of years long, while the culture slowly developed, then the stimulation of early contact with the Europeans, with peaceful trading giving new impetus to old arts, and then distrust, suspicion, disease and liquor, violence both in clashes with the whites and in tribal warfare, the traditional small raids deadly affairs now, as firearms replaced primitive spears and clubs.

And then, 1862 – when a traveller to Victoria unwittingly brought the seeds of sudden disaster. Many Indians from all the coast were camped there, and the smallpox moved through them like a swift fire. The settlers panicked and drove them out. On the long trip home, they left most of their numbers dead or dying, till the beaches from Victoria to Alaska were littered with blackened corpses. It would have been better if all had perished on the way, but some reached home. The canoes that had brought an end to all their greatness lay on deserted beaches to crack in the sun and decay in the winter rains.

Even more, I think, than the deserted villages, the fallen houses and decaying poles, the deserted waterways of the Charlottes bring home the tragic history of these dark islands. It seems always that around the next point you should come upon a flotilla of long canoes, gracefully carrying singing people on their way from village to village to take part in one more of the many ceremonies that formed the main thread of their lives.

The weather cleared, and the work went on: a routine now, broken by some more wonderful moments.

This little man provided one of the finest. Once he'd sat on top of the Beaver pole, but when the fire toppled it forward, he'd fallen not into the damp ground which would have eaten away his strong features, but over the edge of the bank above the beach. Some high tide had washed up an oil slick which perhaps had helped preserve him. When we turned him over, the features that looked to the sky were as sharply defined as the carver had made them.

The impassive old giants had been cut down to manageable size and caged, yet they remained as remote, austere and unapproachable as ever.

Impassive and unconcerned they might be, but they resisted with their sodden weight their passage back to the sea. Soon a navy freighter was to pick them up, to take them away to the Victoria museum and the university.

The high tide came late at night, and in the pitch darkness we collected the sections from along the beach, where they lay in haphazard disorder, and boomed them up, ready for their journey from the island. The next day, we checked the lashings and waited for the next tide to lift them free. The time had come to leave the island and its dead past. Its epitaph has been written, in the final paragraph of his report, by Wilson Duff:

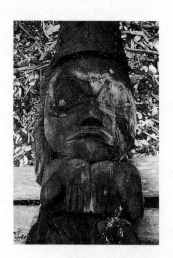

Photograph by Harry Hawthorn, Ninstints beach, June 1957 (UBC Museum of Anthropology archives).

*Little remains of the thriving community known to the early traders, and the territories of the Kunghit people are more deserted now than they have been for many centuries past.... What was destroyed here was not just a few hundred individual human lives. Human beings must die anyway. It was something even more complex and even more human.... What was destroyed was one more bright tile in the complicated and wonderful mosaic of man's achievement on earth. Mankind is the loser. We are the losers.*[6]

NOTES

1 *The name has been reinterpreted lately as Sghaang Gwaay, "Wailing Island," but the oldest Haida testimony on record (obtained in 1900) is at one with Reid's interpretation. Sghan in Haida is Sebastes ruberrimus in Latin: a fish with many English names, including red rockfish, yelloweye rockfish, red rock-cod and Pacific red snapper.*

2 *George MacDonald catalogues this pole as Ninstints 17 (MacDonald 1983: 113). The Bear Mother story was a great favorite of Reid's, but this interpretation of the pole is one he might, on reflection, have chosen to augment or revise.*

3 *Xhaaydla xhaaydaghaay is one way of saying "the Haida" in Haida. It means "the people of the xhaaydla," which is to say, the people of the surface of the sea.*

4 *The Haida skipper (Roy Jones) and three of the anthropologists (Wilson Duff, Michael Kew and Wayne Suttles) are mentioned by name in the text. The fourth was Reid's friend Harry Hawthorn. (Reid also neglects to mention photographer Bernard Atkins.) Duff and Kew published their detailed account of the expedition in 1958, and the "enthusiastic amateur," John Smyly, published his own "Ninstints Notebook" in Abbott 1981: 107–114.*

5 *This was the village of Qaadajans, "Backbiter Town," evidently an earlier site than Sghan Gwaay Llanagaay and only some 500 m away.*

6 *This passage is taken from Duff & Kew 1958: c63. Reid abridged it slightly; I have abridged it a little more, because it is quoted again in full on pp 111–112 as the conclusion to Reid's eulogy for its author, Wilson Duff.*

# The Art: An Appreciation

*Reid composed this meditation in 1967 as an outgrowth of his work on the Vancouver Art Gallery's* Arts of the Raven *exhibition. It was published – along with essays by Wilson Duff and Bill Holm – in the exhibition catalogue.*

To consider the art of the Northwest Coast in any but a most subjective way would be for me an almost impossible exercise.

For two decades now, I have lived intimately with the strange and beautiful beasts and heroes of Haida mythology and learned to know them as part of myself – and through their powerful realizations in the high art of the Indian past, perhaps to know something of the people who at one time shared this intimacy.

Whether my impressions are true or not, these vanished men and women have emerged through their art out of a formless mass of ancestral and historical stereotypes – warriors, hunters, fishermen, every man his own Leonardo – to become individuals in a highly individual society, differing in every detail of life and custom from us, but in their conflicts and affirmations, triumphs and frustrations, an understandable part of universal mankind. So the art, because it embodied the deepest expression of this essential humanity, can be as meaningful and moving to us as it was to them. Of course, we have lost much which they had. We see the masks, the costumes, the boxes, the rattles and the whole profusion not as part of the fabric of life, to be displayed at feasts, to be handed around, admired and criticized by a population of informed critics, but as isolated remnants, time weathered, museum dusted, too often cracked and broken.

Even these remnants must be removed from us by space as well as time, so much of their dimension destroyed by glass, the contact broken by barriers. But if we can bring to these our contemporary sensibility, enriched by a knowledge of the world's art, we may perhaps find in them deeper meaning even than their creators intended.

To do this it may be necessary to flesh them out in imagination as

they once were....[1] Even in the light of the fires, in the protection of the massive houses, perhaps only the lesser demons were kept outside. The rigid conservatism of an old tribal system enduring through centuries, giving pattern but no explanation, must have nagged constantly at the restless humanity of such a dynamic people. In their art, they seem to have been seeking always a solution to this oldest problem, finding not the answer but the reassurance that enabled them to fill their centuries with vital and creative lives.

But we deal in this exhibition with two groups of people, two styles of expression, related only superficially: the austere formality of the north – the Tlingit, the Haida, the Tsimshian – and the wild extravagance of the Kwakiutl. The validity of this division can be questioned. Often there was wild extravagance in northern design, less often restrained elegance in the Kwakiutl. But the prevailing modes are on the one hand classical control, on the other prodigal theatricality.

My knowledge of Kwakiutl art begins and ends with an enthusiastic appreciation, enhanced by my having been privileged to see on two occasions superb examples of masks and costumes displayed as they should be, as part of the winter dances. These were not original, but sensitively conceived reenactments by Bill Holm and his dancers in the appropriate firelit setting of a Kwakiutl house and Kwakiutl "audience" for whom these dances are still a living part of existence. One has to see the supernatural dignity of the cannibal birds, as they gyrate with snapping beaks, or witness the humor of the Bukwis,[2] or experience the magic of the transformation masks where an eagle becomes the sun, instantaneously, before one's eyes. And then to feel them all come together in the impact of the Hamatsa drama, the wordless telling of the emergence of man from his primordial past. Otherwise the faded trappings of Kwakiutl dramatic art can be only a flicker of the whole, seen briefly in a dark mirror. But even this is a powerful image, as this exhibition proves. It seems that the only limitations to Kwakiutl ex-

pressiveness were those of material and technique, and the eventual bounds of wildly untrammeled imaginations.

In the north, the art was no such explosion but a controlled and mannered process, determined by rules and conventions so strict that it would seem individual expression must be stifled. But it is the conflict between this rigid discipline and the genius of the great artists which gives such dynamic power to the images. If every line must flow in a preordained course and, no matter how it swells and contracts, must eventually turn again upon itself, and if every part of that line, wide or narrow, straight or curved, has equal strength, the tension produced is enormous. If every structure, be it box or totem pole, spoon handle or rattle, must have for every thrust a counterthrust, then each object becomes a frozen universe, filled with latent energy. The basic lines of a box design start with a major image, rush to the limits of the field, turn back on themselves, are pushed and squeezed toward the centre, and rippling over and around the internal patterns, start the motion again. Where form touches form, the line is compressed, and the tension almost reaches the breaking point before it is released in another broad, flowing curve. In totem pole or spoon handle, the upward or outward thrust inherent in the shape of tree or horn is exactly balanced by the downward flow of the design.

All is containment and control, and yet always there seems to be an effort to escape. The rules were there, and they were a part of a pattern that went far beyond the conventions of art, were more than a part of the life of the people, were the very essence of their lives. So it had to be within the strictures that individuality developed, and as each artist grew, he discovered new ways of making a personal statement and developed a distinctive style that set him apart from all others.

Sometimes the means were simple and almost playful. Symmetry, if not a rigid rule, was certainly implicit in much of the design. Yet in the finest works you find not exact symmetry but subtle variations

from panel to panel, element to element. In many cases this is carried through to the extent that two sides of a box differ in every detail while retaining apparent sameness. Every possible change was rung on every theme, and the result was a monumental calligraphy which could wander back and forth from two-dimensional design to sculptural form, exploring all combinations between.

One thing has become apparent through my years of familiarity with the art of the Northwest Coast, particularly from the investigations leading to this exhibition. If these people were an artistic race, they were not a race of artists. The recurrently similar styles can lead only to the conviction that the high art of the region was the product of a few men of genius, many of whom apparently had long, slowly maturing, productive careers. Much comparative work must be done to confirm or disprove this and other speculations, but at a wild guess it is possible that during the nineteenth century, the time of the greatest flowering of the art, and the period from which most of the material for this exhibition derives, the great works came from the hands of twenty or thirty men, and the number could be much lower. The support of an appreciative community, which gave their talents an honored place, assured time and resources for their impressive output. Their great triumph was their continued affirmation of the exploring spirit of mankind, unquenched by the limitations of the physical world and the restrictions of their own society.

The great tragedy was that, when release came, the force that brought it blindly swept away in its destructive fury of corruption, disease and death, the conventions, the society, and the people themselves.

If the impact had been kinder, who can tell in what new channels the old, powerful stream of the arts of the Northwest Coast may have flowered? We can at least be grateful for the record of human achievement they bequeathed us.

1 *Here occurs a lovely passage of some 200 words which Reid reused almost verbatim three years later in his best-known piece of writing, "Out of the Silence." To avoid repetition, I've excised the passage here, though this was its first home. As originally published, the 1967 essay reads as follows:*

… To do this it may be necessary to flesh them out in imagination as they once were. It is easy to become entranced by the soft curtain of age, seeing this instead of what it obscures. An ugly building can make a beautiful ruin, and a beautiful mask in the dark of many years, softened by wear, becomes a symbol which tells us that the cycle of life, death, decay and rebirth is a natural and beautiful one.

This is not what their creators intended. These were objects of bright pride, to be admired in the newness of their crisply carved lines, the powerful flow of sure, elegant curves and recesses – yes, and in the brightness of fresh paint. They told the people of the completeness of their culture, the continuing lineages of the great families, their closeness to the magic world of universal myth and legend.

Perhaps they told more – a story of a little people, few in scattered numbers, in a huge dark world of enormous forests of absurdly large trees, or stormy coasts and wild waters beyond, where brief cool summers gave way forever to long, wet, black winters, and families around their fires, no matter how long their lineages, needed much reassurance of their greatness.

Even in the light of the fires, in the protection of the massive houses….

*Compare the opening pages of the next piece, "Out of the Silence."*

2 *Bukwis (in Kwakwala, B*a͟q*'w*a͟s *or B*a͟k*'w*a͟s*) is a figure of significance in Kwakwalan mythology and ritual theatre. He plays a central role in a story written in Kwakwala by Q'i͟xitasu' (George Hunt) between 1895 and 1900, based on information from an unnamed member of the Kwiksootainuk band (Boas & Hunt 1902–5: 249–270). Bill Holm (1983: 143–145) has written insightfully about the revival of Bukwis masks and dances by Mungo Martin and others, and Reid was deeply impressed by the Bukwis masks and dances he had seen. One day in Skidegate, in 1984, when we were talking of such things, he said to me that Bukwis seemed to him the nearest thing in Kwakwalan mythology to the Snag (Ttsam'aws) in the Haida mythworld. The Raven, the Snag and the Dogfish Woman were, for Reid, the three most potent beings in Haida mythology.*

# Out of the Silence

When we look at a particular work
of Northwest Coast art
and see the shape of it,
we are only looking at its afterlife.
Its real life is the movement
by which it got to be that shape.

It's easy to become entranced
by the soft curtain of age,
seeing this
instead of what it obscures.
An ugly building
can make a beautiful ruin,
and a beautiful mask
in the dark of many years,
softened by wear,
becomes the symbol which tells us
that the cycle of life,
death, decay and rebirth
is a natural and beautiful one.

This is not what their creators intended.

These were objects of bright pride,
to be admired in the newness
of their crisply carved lines,
the powerful flow

The genesis of this piece –
written in New York and
Montreal in 1970 and
1971 – is discussed in
some detail in the editor's
introduction. It was first
published in 1971,
together with a suite
of 64 photographs by
Adélaïde de Ménil.

of sure, elegant curves and recesses –
yes, and in the brightness
of fresh paint.

They told the people
of the completeness of their culture,
the continuing lineages of the great families,
their closeness to the magic world
of myth and legend.

Perhaps they told more –
a story of little people,
few in scattered numbers,
in a huge dark world
of enormous forests
of absurdly large trees,
and stormy coasts
and wild waters beyond,
where brief cool summers
gave way forever
to long, black winters,
and families round their fires,
no matter how long their lineages,
needed much assurance of their greatness.[1]

The wonder of it all
is that there were so few –
a tiny handful of seahunters
clinging to tiny footholds
on the jungle-backed beaches.

But it was a rich land,
above all, a rich sea.
Millions of salmon returned each year
to the rivers
to spawn and die,
a sacrifice that assured
the survival of their kind,
and at the same time
gave easy life
to the bear, the otter, the eagle
and a host of others,
a few of whom were humans.

In a few weeks,
men could gather enough salmon
to last a year.
Shellfish grew thick on the rocks
and sandy bottoms;
halibut carpeted the shelf floor;
berries were plentiful
on the bare hillsides;
and if there weren't enough
bare hillsides,
a fire on a hot day
would provide one for the next year.

Sea lion and sea otter,
seal and whale and porpoise
were everywhere,
and all flesh was meat.

*Solitary Raven:*
*The Selected*
*Writings of*
*Bill Reid*

In early spring
the rivers swarmed with oolichan,
the magic fish of the north coast,
ninety per cent oil,
and to those who knew it well,
fragrant, delicious oil
to enhance the flavor
of dried salmon and halibut,
to mix with dried berries,
to flavor stews,
and, though they did not know this,
to provide most of the stored nutrients
necessary for life
in the too-often sunless seasons.

There were nettle roots
and waterlily roots and seaweeds,
gull eggs,
black bear, grizzly bear, deer,
and much more,
right there for the taking.

If the sea hunt were unsuccessful
or smoked fish ran out
before the new season arrived,
mussels were a dark blue mantle
on almost any rock,
cockles lay exposed at low tide,
abalone and rock oysters[2]
could be found with little effort,
tide pools yielded delicate sea urchins,

the octopus could be flushed from his cave,
and clams lay under most beaches.

Even today,
only a stupid man could starve on this coast,
and today it is not as it was.

Then there was the forest.
Nowhere else
was there anything like the Douglas-fir,
the strongest, toughest, in many ways
most remarkable wood in the world.

Trees six, eight, twelve feet through the butt,
forty or fifty feet to the first limbs,
two or three hundred feet tall.

They are nearly all gone now,
but for a while they provided
the beams and uprights and siding
for half the houses of America,
and supports for many big buildings.

But to be used,
they had to wait for the white man
and his steel axes and saws.
They were just too tough and hard and heavy
for the stone axe and wooden wedge.

The spruce and hemlock
were splintery and hard to work

*Solitary Raven:*
*The Selected*
*Writings of*
*Bill Reid*

and weathered badly.
So a richness in timber
lay untouched and useless
till the white man came.

If this had been all,
these people might have degenerated
to simple dependence on food resources.

But there was the cedar,
the west coast cypress,
growing huge and plentiful
in swampy areas
around creeks and rivers.

Oh, the cedar tree!

If mankind in his infancy
had prayed for the perfect substance
for all material and aesthetic needs,
an indulgent god
could have provided nothing better.
Beautiful in itself,
with a magnificent flared base
tapering suddenly to a tall, straight trunk
wrapped in reddish brown bark,
like a great coat of gentle fur,
gracefully sweeping boughs,
soft feathery fronds of grey-green needles.

Huge, some of these cedars,
five hundred years of slow growth,
towering from their massive bases.
The wood is soft,
but of a wonderful firmness
and, in a good tree,
so straight-grained
it will split true and clean
into forty-foot planks,
four inches thick and three feet wide,
with scarcely a knot.

Across the grain
it cuts clean and precise.
It is light in weight
and beautiful in color,
reddish brown when new,
silvery grey when old.

It is permeated with natural oils
that make it one of the longest lasting
of all woods,
even in the damp
of the Northwest Coast climate.

When steamed,
it will bend without breaking.
It will make houses and boats
and boxes and cooking pots.
Its bark will make mats,

even clothing.
With a few bits of sharpened stone and antler,
some beaver teeth and a lot of time,
with later on a bit of iron,
you can build from the cedar tree
the exterior trappings
of one of the world's great cultures.

Above all, you can build totem poles,
and the people of the Northwest Coast
built them in profusion:
forests of sculptured columns
between their houses and the sea,
proudly announcing to all
the heraldic past of those who dwelt there.

At most there were probably no more
than a hundred thousand people,
scattered along a thousand miles of coastline
– ten thousand miles more likely,
if bays and inlets and promontories
and islands were measured.
Isolated in clusters of a few hundred each,
miles from their nearest neighbors,
cut off by dense jungles,
by stormy seas for most of the year,
by five separate language groups
and hundreds of distinct dialects,
and by suspicions and animosities
that often separated them
more than the elements.

What can a few people do,
except cling to a marginal existence?

And yet –
one of these clusters was Tanu.
It wasn't even a single political entity,
but two villages
separated by only a few yards.

*Solitary Raven:*
*The Selected*
*Writings of*
*Bill Reid*

It knew no law beyond custom,
no history beyond legend,
no political unit
larger than the family,
no government
beyond an informal meeting of family heads,
plus the tacit acceptance
of the superiority of the ranking chief.

At the height of its influence,
it had less than a thousand people
living in about twenty-five houses.

But if the wooden structures of Tanu
had survived the hundred years
of north coast weather
since the last of its survivors left,
its ruins would rival man's greatest achievements.

Tanu may have been the crowning gem
of west coast material culture.
Some old memories still recall

its artists and builders as the best,
and old photographs
show something of its glory.
But it was only one
of dozens of proud citadels –
Kaisun, Kiusta, Sghan Gwaay, Skidegate, Masset,
Kitwancool, Kispiox, Kitseguecla, Kitwanga,
Kincolith, Kasaan, Klukwan,
Bella Bella, Bella Coola,
Koskimo, Quatsino, Nootka,
and many more.

In each village were great houses
some seventy feet by fifty feet
of clear roof span,
with gracefully fluted posts and beams.
In the houses there was wealth –
not gold or precious stones,
but treasures that only great traditions,
talent, and sometimes genius,
with unlimited time and devotion,
can create.

There were treasures in profusion –
thousands of masks,
painted and carved chests,
rattles, dishes, utensils of all kinds,
ceremonial regalia –
all carefully stored or proudly displayed
during the great feasts and winter ceremonies.

The people of the Northwest Coast
were rich,
their sea even richer;
they were enormously energetic;
and they centred their society
around what was to them
the essence of life:
what we now call "art."

*Solitary Raven:*
*The Selected*
*Writings of*
*Bill Reid*

Old people can still tell how it was
when, by boat, they rounded a point of land
and entered a sheltered bay
to find a village of large houses
and totem poles facing the sea.

Like heraldic crests, these poles
told of the mythological beginnings
of the great families,
at a time before time,
when animals and mythic beasts and men
lived as equals,
and all that was to be
was established by the play
of raven and eagle,
bear and wolf,
frog and beaver,
thunderbird and whale.

The poles were many things.
The housepole told
of the lineage of the chief

who presided within.
The memorial pole commemorated some great event.
The grave pole contained the body
and displayed the crest
of a leading noble.
In many of the great houses,
massive figures, illuminated by firelight,
supported the roofbeams.

Each pole contained the essential spirit
of the individual or family
it commemorated,
as well as the spirit
of the artist who made it,
and, by extension, the living essence of the whole people.

While the people lived,
the poles lived,
and long after their culture died,
the poles continued to radiate
a terrible vitality
that only decay and destruction could end.

Even trapped
in the stairwells of museums,
truncated and dismembered
in storage sheds,
or lying in shattered fragments
in now vanished villages
they once glorified,
the contained power –

born of magic origins
and the genius of their creators –
still survives.

All things must die,
and great art must be a living thing,
or it is not art at all.

*Solitary Raven:*
*The Selected*
*Writings of*
*Bill Reid*

These monuments were the work
of master carvers and apprentices
who brought to final perfection
an art style whose origins
lay deep in the past and partly in Asia.
It was an austere, sophisticated art.
Its prevailing mood was classical control,
yet it characterized
even the simplest objects of daily life.
These seagoing hunters
took the entire environment as artform.

That effort is now wholly past.
Even memory of it fades.
Already the forest has reclaimed
the tiny clearings
men once maintained
along the twisting walls
of this stormy coast.
Only a handful of poles now stand,
or more frequently lie,
in the damp, lush forests.
Like the fallen trees they lie beside,

they have become
the lifeblood of younger trees
growing from their trunks.
In a scene subdued
by a magnificent moss covering
and by silence,
they return to the forest
that gave them birth.

*Out of the*
*Silence*

NOTES

1 *This passage is repeated from Reid's 1967 essay "The Art:*
  *An Appreciation." (See the note on p 70.)*

2 *The rock oyster is* Hinnetes giganteus, *the big Pacific rock*
  *scallop, called by its familiar local name. Though the poem was*
  *written thousands of miles from home, it evokes the forests, bays*
  *and beaches of the Northwest Coast with meticulous precision.*

# Curriculum Vitae 1

Father: William Ronald Reid, naturalized Canadian citizen, born American citizen in Detroit area of Michigan, of Scottish and German parentage. Left home at age sixteen, spent most of his life as itinerant entrepreneur in a variety of roles in most parts of the U.S. and Canada. He was operating a hotel in Smithers, British Columbia, following the 1914–18 war when he met and married my mother, Sophie Reid, born 1895 in Port Essington, B.C. Her parents were Charles and Josephine Gladstone, natives of the Haida village of Skidegate Mission, Queen Charlotte Islands, where she spent her early childhood. Later she became a permanent (i.e., twelve months a year) student at the Anglican residential school at Coqualeetza, near Chilliwack, B.C. There she learned English, dressmaking, regular school subjects, and sometime in her late teens obtained an elementary school teaching certificate. She was teaching at the Indian school at Old Hazelton, near Smithers, when she met and married my father. Shortly thereafter he moved his operations to Hyder, Alaska, and she went to stay in Victoria, where I was born. She rejoined my father and lived in Alaska till after the birth, in 1921, of my sister, now Dr Margaret Kennedy, formerly chief psychologist at Hackney Hospital in London, England, now practising in British Columbia.

Because of American prohibition laws, my father moved his business across the line to Stewart, B.C., and my mother and the children returned to Victoria, where we lived until I was six years old, and where incidentally I attended the kindergarten conducted by Miss Alice Carr, sister of Emily.

In 1926 we rejoined my father in Stewart. Although there was a Canadian school in Stewart, it was more than two miles away over a

*Reid wrote this brief autobiography in 1974, for the catalogue of the Vancouver Art Gallery's Bill Reid retrospective exhibition. He was 54 at the time, yet his career as a Haida artist had, in reality, barely begun.*

road almost impossible during the winter, so it was thought better that I, and later my sister, attend the American school in neighboring Hyder, Alaska. This I did for the next five years, until I completed grade six. As a result of these early associations – my American teachers and peers, my American father and my Indian mother, whose cultural values came somewhat from her native ancestry, but much more from her colonial English, Anglican Church education – I have always felt much more a native of all of English-speaking North America than of any particular political division of it.

I transferred to the Canadian school in Stewart following grade six, and the next year, when my father's business had gone bankrupt because of the depression, my mother took her now three children (my brother Robert having been born in 1928) back to Victoria. I never saw my father again, though we kept up a desultory correspondence until his death in 1942. I finished grade school and attended Victoria High School in Victoria, where I got good marks but was a most unenthusiastic student. Later I attended Victoria College for a year. In those days, I believe, that counted as the first year of university, but now it would be considered grade thirteen.

That was the end of my formal education, as I had neither the motivation nor the finances to continue. However, I did have quite a good speaking voice and a good command of English, and I drifted into an unpaid job with the local radio station as an announcer-operator. In a year there, I obtained enough experience to get a paying position at a station in Kelowna, B.C.

The war had started in the meantime, but I was rejected for service for most of its duration because of my defective vision. Until late in 1944, I worked in a number of commercial radio stations in eastern Canada and later in Vancouver, where I was finally inducted into the army. My military career consisted entirely in starting training programs which were discontinued as various sectors of the war front

became inactive, and I was discharged at the end of 1945, never having been further from home than Calgary.

During the war, in 1944, I married Mabel van Boyen. We had a daughter, Amanda, in 1950, adopted a son, Raymond, in 1955, separated in 1957, and were divorced in 1959. To complete the record, in 1960 I was married to Ella Gunn, but that relationship was completely unsuccessful. We actually lived together for only a few months, separated finally in 1962, and were later divorced.

After the war I went to Toronto to work for Jack Kent Cooke,[1] and in 1948 joined the Canadian Broadcasting Corporation as an announcer, working mainly with the radio news department. In 1951 I returned to Vancouver, and worked with the CBC there until I finally left the broadcasting industry in 1958. During my tenure with the CBC in Vancouver, I again worked with the news department, did a series of music programs, and did a certain amount of writing, mainly about subjects connected with the west coast native populations.

The most important work I did in this field was to write and narrate the television film documentary *Totem,* which was an account of the salvaging of the last of the totem poles from the Queen Charlotte Islands, and a brief account of the people who carved them. The film was produced by Gene Lawrence. I also wrote and narrated a film record of the Vancouver Art Gallery exhibition *People of the Potlatch.* My interest in my maternal ancestors began quite late in life and was reflected only occasionally – and then from the non-Indian viewpoint – during my broadcasting career.

I was actually in my early teens before I even became conscious of the fact that I was anything other than an average Caucasian North American. My mother had learned the major lesson taught the native peoples of our hemisphere during the first half of this century, that it was somehow sinful and debased to be, in white terms, an "Indian," and she certainly saw no reason to pass any pride in that part of her

heritage on to her children. I never visited her native village, or saw my grandmother when she was alive, or my grandfather until I was an adult.[2] But gradually – probably through contact with my mother's brothers and sisters, some of whom still lived in the village, and all of whom had maintained close contact, I began to become more conscious of the Haidas, and as I never knew any of my father's people, the Haidas became my only relatives. I also became vaguely aware that they had some artistic abilities, although my knowledge of this was pretty well limited to the gold and silver bracelets owned by my mother and my aunts.

In my early twenties, I at last got to know my grandfather and began what has become a lifelong series of visits to the Queen Charlottes. He spoke little English, and of course I spoke no Haida, so communication was difficult, but I did learn that he was in fact the last in the direct line of Haida silversmiths, having learned from Charles Edenshaw,[3] the greatest of them all, with whom he'd lived as a youth. He was also a commendable slate (argillite) carver. Through him I also gained the friendship of many of the old men and women alive at that time who still remembered something of the great days of the Haida past and, more important, who still had a pride in that past. And I began more and more to identify with them. My return to Toronto might have brought a break with this newfound tradition, but in a way it actually strengthened it. For one thing, I discovered the collection of Northwest Coast art in the Royal Ontario Museum, and particularly the great Haida totem pole from Tanu, birthplace of my grandmother.

In 1948, I decided I would like to try to emulate my grandfather and the other Haida silver- and goldsmiths, and eventually leave broadcasting in favor of the jewellery-making trade. I was lucky to find an excellent training program at the newly formed Ryerson Institute of Technology, which I could attend while still holding my job with CBC. While at Ryerson, I learned the elements of traditional

European jewellery-making methods, and also developed an interest in modern jewellery design, which I still retain. At the end of my two-year course, I was offered an apprenticeship in a good platinum and diamond workshop, where I remained for about a year and a half, still retaining my broadcasting position.

In 1951, my family and I returned to Vancouver, where I continued to work for the CBC, and established a basement workshop to make jewellery. And with my return to the coast, my interest in Haida art gained more stimulus, and I began to devote all my creative activities to applying the European techniques I had learned to an expanded application of the old Haida designs to jewellery. Lacking the techniques and equipment I had, the older carvers had been pretty well limited to the making of the classic Northwest Coast engraved bracelets. I was able to extend this into such forms as earrings, brooches, rings, decorated boxes, etc., and to bring to all forms a three-dimensional quality the older works had lacked.

It was during this period that I built up an unrepayable debt to the late Charles Edenshaw, whose creations I studied, and in many cases shamelessly copied, and through whose works I began to learn something of the underlying dynamics of Haida art. This later permitted me to design more original pieces while still staying within the tradition.

I also tried my hand at a small amount of slate and wood carving. In 1957 I was invited by Wilson Duff, then curator of ethnology at the British Columbia Provincial Museum, to spend two weeks carving a copy of a Haida pole under the direction of the late Mungo Martin. In 1958, the University of British Columbia received a grant from the Canada Council to restore some of the old totem poles in its collection, the grant to be administered by the Department of Anthropology under Dr Harry Hawthorn. But the old poles were too far deteriorated for restoration, and any attempts to restore them would only have destroyed their aged grandeur. It was decided instead to attempt

to recreate a section of a Haida village on the campus of the university. Purely as an act of faith, as I see it now – because previous to this I had only carved one small simple figure during my two weeks with Mungo Martin – Dr Hawthorn employed me to design and direct, and for the most part to create, the poles and houses for the project. For the three ensuing years, with the invaluable help of the talented Kwakiutl artist Douglas Cranmer, who subdued his own creative impulses in the interests of the project – and with a further grant from the Canada Council, a small additional grant from the university itself, and the priceless cooperation of the lumber industry in British Columbia, which provided all the materials – we built the two houses and seven carvings which now stand on the university grounds.[4]

The university project was finished in the spring of 1962, and I started a small jewellery business of my own, producing mainly items of gold and silver in Haida design. I also did a few smaller woodcarvings, the most important being a pole for the Shell Oil Centre in London, England.[5]

In 1966 Bill Holm, Wilson Duff and I were asked to help in the preparation of the centennial exhibition at the Vancouver Art Gallery – a large display of the arts of the Northwest Coast natives, gathered from all the leading museums and private collections in North America. I was given the task of selecting material from all the Canadian and midwest and eastern American collections, and later of working with the other consultants, the gallery staff and the designer, the late Robert Boal, in the preparation and installation of the show, known as *Arts of the Raven*. Holm, Duff and I also helped in the preparation of the catalogue and wrote the text. At the same time, I made a large gold casket, surmounted by a three-dimensional eagle, for display in the Canadian Pavilion at Expo '67 in Montreal. This is now on display in the McMichael Collection in Kleinburg, Ontario. Also as part of the centennial projects, I was commissioned by the British

Columbia Provincial Museum to execute a large cedar screen, seven feet square, as part of the decor for their new building.

At the conclusion of these projects, I was awarded a senior fellowship by the Canada Council to spend a year in Europe to further my studies in the metal trades, particularly in silversmithing, and to study, and as far as possible photograph, the Northwest Coast items in the many European collections. This proved to be a far more ambitious undertaking than I was capable of carrying out, and I was able to get to only a portion of the major collections. I also found that to attempt to become a competent silversmith in such a short time, at my time of life, was a self-defeating process, so I actually spent most of my time improving my jewellery-making (i.e., goldsmithing) techniques and doing what I had long desired: making jewellery in contemporary, universal design rather than in the Haida tradition. I was given invaluable assistance in these projects by the Central School of Design in London, which most generously made its facilities available to me during my stay in the city.

I should say here that I found my experience in London rewarding personally, of course, but also that the influence on my work was enormous. Not only did I complete two of my best works while I was there, but at least in the field of metalwork, I believe the London experience brought about a marked improvement in all my subsequent work.

On my return to Canada in 1969, I settled in Montreal, doing a few small slate carvings until I set up a jewellery workshop, and in the next three years I produced – with the possible exception of the massive woodcarvings of the fifties and sixties – the best works of my career, both in Haida and in contemporary design. These included a miniature carving in boxwood illustrating the Haida myth in which the Raven discovers mankind in a giant clamshell, a slate panel pipe, a carved and chased silver casket, a gold vessel surmounted by a full-dimensional whale, made for the *Legacy* exhibition at the British Col-

umbia Provincial Museum, a gold bowl illustrating the Bear Mother legend, a gold and silver necklace purchased by the Canadian Guild of Crafts for inclusion in the International Craft Exhibition to be held in 1974 in Toronto, as well as many items of jewellery in both contemporary and Haida design.

In the spring of 1973, I was offered a commission to do a massive version of the *Raven and Clamshell* carving as part of the decor for the new Museum of Anthropology to be built at the University of British Columbia – a private commission from Mr Walter Koerner, a long-time patron and friend – and I returned to the west coast to carry this out. Unfortunately my present state of health (I have suffered for most of my life from spinal problems) does not permit me to proceed with this project.[6]

Aside from my carving and jewellery-making activities, I have, during the past decade, been involved in a few small publishing ventures. In 1965 I illustrated a children's book by Christie Harris, *Raven's Cry,* and in 1970 I wrote the text for a book of photographs by Adélaïde de Ménil, *Out of the Silence.* During the past couple of years I have also published a series of silkscreen prints of Haida designs.

1 *Jack Kent Cooke was an associate of Toronto entrepreneur Roy Thomson (Baron Thomson of Fleet). He managed a chain of radio stations, including one in Kirkland Lake, Ontario.*

2 *There are photographs to prove that Reid was in Skidegate at least once during early childhood, and that he and his grandfather met at that time, but the early contact does not seem to have stayed in his memory.*

3 *The Haida artist Daxhiigang (1839–1920) did not speak English but is widely known all the same by his English name, Charles (or Charlie – after Bonnie Prince Charlie) Edenshaw. The book that he and his work richly deserve has yet to be written, though Wilson Duff had made a solid start before he died. Bill Holm's brief but very helpful study of Daxhiigang's work is published in Abbott 1981: 175–200. Alan Hoover has published two brief studies as well. Duff's notes and drafts – brilliant in their hunches, often capricious in their details – are posthumously published in Duff 1996: 216–250. See especially pp 233–239.*

4 *These houses and poles were originally located in the Totem Park region of the UBC campus. They were moved in 1979 to their present location, on the grounds of the Museum of Anthropology. The Nimpkish carver Douglas Cranmer (1927– ) who worked as Reid's assistant throughout the project had, like Reid himself, trained briefly with Naqap'ankam (Mungo Martin).*

5 *This is a freestanding interior pole, 248 cm tall, now in the Haida Gwaii Museum in Skidegate. There are two main figures – the Grizzly with frog (below) and the Raven with salmon (above) – and a single watchman at the top.*

6 *Reid did, however, proceed, relying heavily on assistants. The result – the large yellowcedar sculpture called* The Raven and the First Men *– was completed in 1980 and has remained on exhibit at the UBC Museum of Anthropology.*

# The Myth of the Land Bridge

*This short piece, written in 1975 or earlier, was published as the prologue to the book that Reid coauthored with Bill Holm:* Form and Freedom: A Dialogue on Northwest Coast Indian Art *(1975). It expresses, in Reid's distinctive way, one of his most deeply held beliefs: in the plurality of the truth.*

In the world today there is a commonly held belief that, thousands of years ago as the world today counts time, Mongolian nomads crossed a land bridge to enter the western hemisphere and became the people now known as the American Indians.

The truth, of course, is that the Raven found our forefathers in a clamshell on the beach at Naikun. At his bidding, they entered a world peopled by birds, beasts and creatures of great power and stature, and, with them, gave rise to the powerful families and their way of life.

At least, that's a little bit of the truth.

Another small part of it is that, after the flood, the Great Halibut was stranded near the mouth of the Nimpkish River where he shed his tail and fins and skin, and became the first man. The Thunderbird then took off his wings and beak and feathers to become the second man, and helped the Halibut build the first house in which mankind spent his infancy.

And the Sxwaixwe rose out of the Fraser. Needing a wife, he created a woman from the hemlock on the bank, and she, in time, gave birth to the children who became the parents of all men.[1]

There is, it can be said, some scanty evidence to support the myth of the land bridge. But there is an enormous wealth of proof to confirm that the other truths are all valid.

NOTE

1  *Suttles 1983 is a useful meditation on the identity of the Coast Salish mythcreature known as the Sxwaixwe or Sxwayxwey.*

# Pieces of Stone

In the presence of greatness, the most appropriate response is a respectful silence, and in the presence of the eloquent silence of these stone images, I find myself more at a loss for words than usual.

But it is part of the fate of our age that we must attempt to put into words responses that should be understood on some deeper level. So I will try to express something of what these pieces of stone mean to me.

Last night I read Wilson's catalogue and found it exciting, adventurous, with great controlled leaps of imagination. It is a great creative work of the intellect, whose tools are words.

The tools I work with are different, so perhaps it's natural that I look at things from a different viewpoint: the viewpoint of the men who made them, no matter how far removed in time they may be, or how different in culture.

I may be very wrong, but I like to think that they weren't really that different from us, some of them more talented, some of them men of genius, some not so proficient. And they had backs that ached from sitting in one position too long, and jobs that went wrong, and family problems, and probably even deadlines that had to be met. I think of them as being just little people, who lived a short time, and performed their peculiar roles, and vanished into the impenetrable anonymity which holds all the carvers who made this exhibition possible.

And that I think is the great mystery – or as Wilson might say, the great paradox: how little men, painfully pecking away day after day, sometimes week after week, at pieces of stone, could hold such powerful visions that their final realizations transcend them and their time, become independent of their creators, come to possess exis-

*In March 1975 an exhibition of stone artworks from the Northwest Coast opened at the Victoria Art Gallery, Victoria, BC. The exhibition was organized by Reid's friend and colleague Wilson Duff, whose catalogue, entitled Images Stone B.C., remains a fundamental work on the Northwest Coast tradition. Reid wrote this brief address for the opening.*

tences separate from those who made them, and separate from us
who come after.

I think it is presumptive foolishness to think that we, as humans,
ever owned these things, or own them now, or to think that in some
way their only purpose is to serve as means of communication, or to
be mirrors of our own monstrous cleverness as a race. They exist sep-
arate and apart; we are privileged to coexist with them.

These, of course – true or not – are remarks that can be made
about any great works of art. I have a more personal interest in these
particular pieces. It is a strange and exciting feeling to know that my
own little efforts are only among the most recent in what may very
well be the oldest uninterrupted artistic progression in human
experience.

For it now seems that many millennia were spent in developing
what we know as the Northwest Coast style, with gradual shifts in
population, slow changes in culture. But no great cataclysmic wars of
conquest, or disastrous plagues or natural disasters until, of course,
the coming of the Europeans. And that's a story we all know too well.

In keeping with what I've said, I must believe that my own things,
in some humble way, have an existence quite separate from me. But I
think I may be permitted to rejoice with them in their distinguished
genealogy.

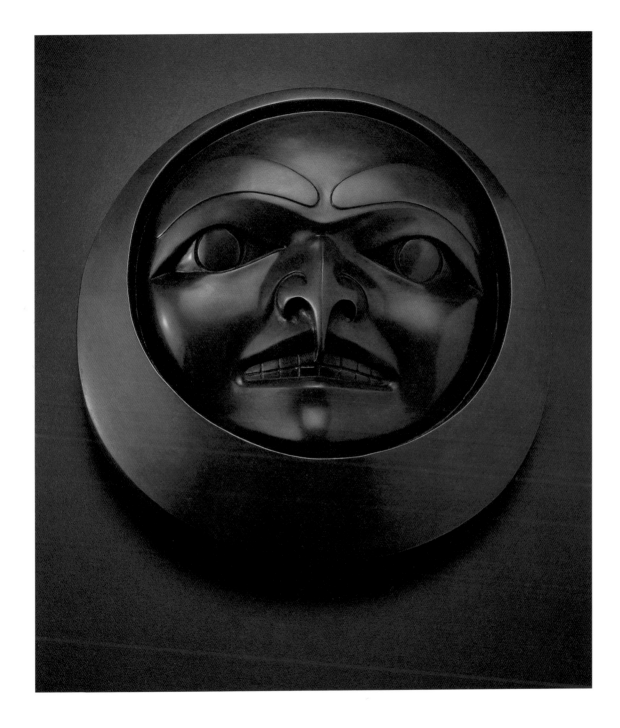

Two versions of *The Raven and the Big Halibut Fisherman* [*Xhuuya at Xhaw Sghaana*] Relief print from engraved silver block. Image 9.5 × 12 cm. Engraved by Bill Reid; printed bichrome and monochrome by Robert R. Reid, circa 1958. Private collection.

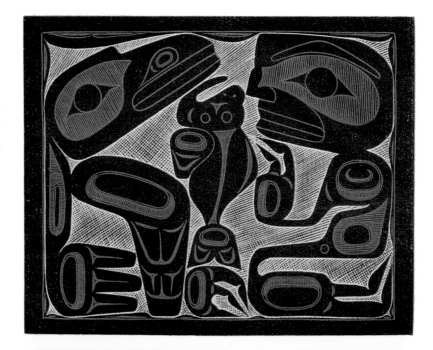

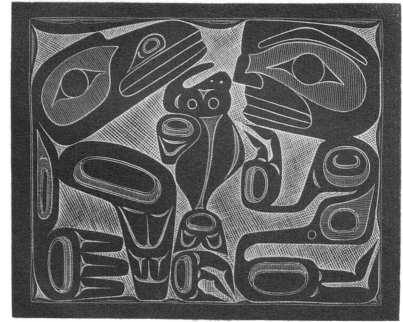

◄ OVERLEAF:
*Killer Whale Spirit* [*Sghaana sghaanaghwaay*]. Cast bronze. 36 cm diameter, 1984. Private collection. Photograph by Kenji Nagai.

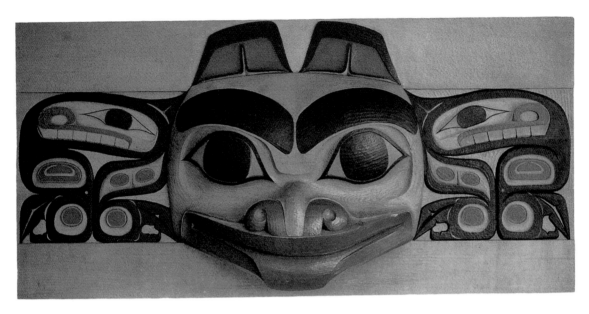

*Grizzly Bear Mortuary Panel.*
Carved, painted and stained redcedar. 96 × 200 × 32 cm, circa 1961. Private collection.

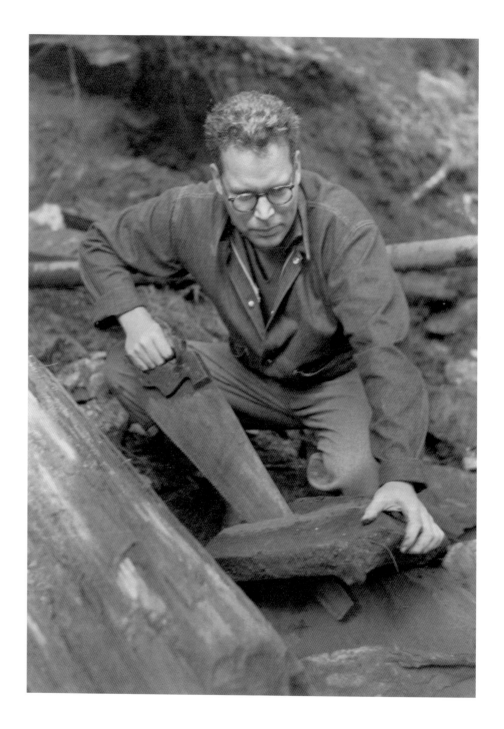

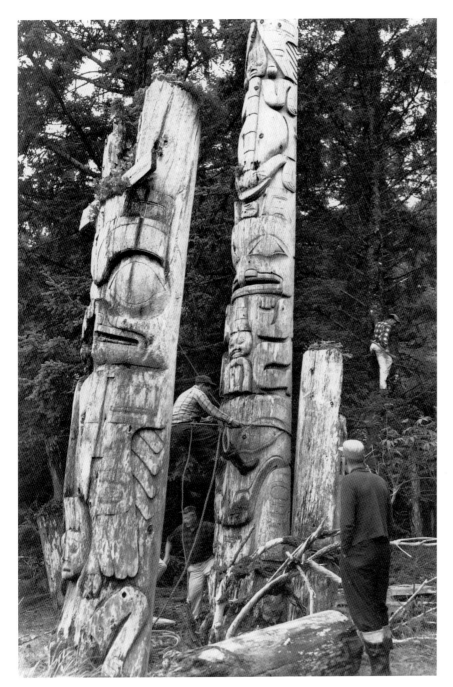

THIS PAGE:
Sghan Gwaay Llanagaay
[Ninstints], June 1957. Reid
is in the right foreground
with his back to the camera.
Roy Jones is climbing the
rotting frontal pole of
House 14. At left is the
associated mortuary pole
known as 14x2. Photograph
by Bernard Atkins (RBCM
PN 9049).

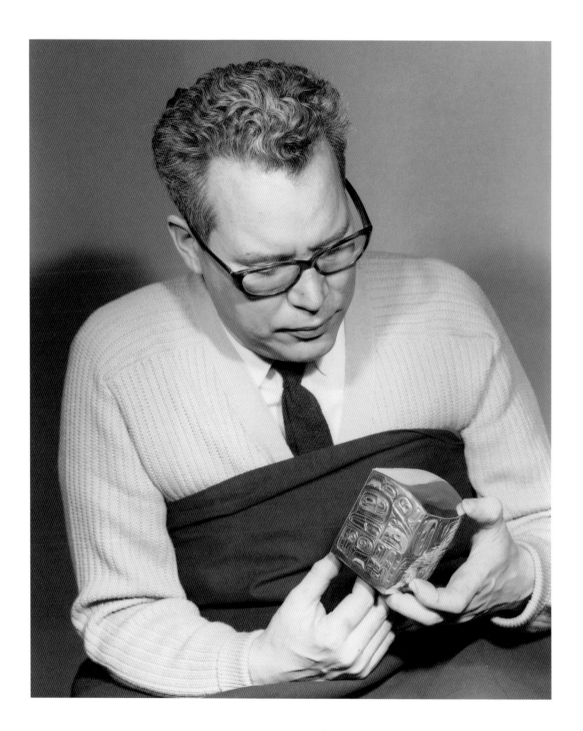

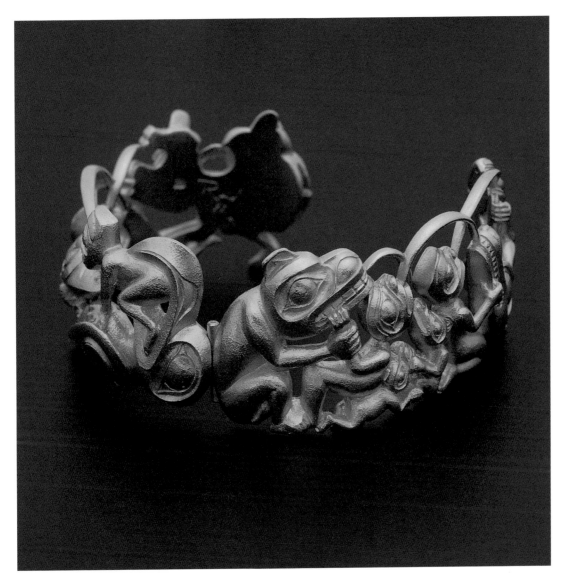

FACING PAGE: *Iihljiwaas*: Reid with his silver chest, based on a painted bentwood box by the Master of the Black Field (see pp 155–158). Cast and engraved silver. 10 × 9 × 9 cm, 1964. Private collection. Photograph: UBC Museum of Anthropology.

ABOVE: *Mythic Messengers* bracelet. Cast gold. Circa 18 cm diameter when closed, 1986. Private collection. Photograph by Kenji Nagai.

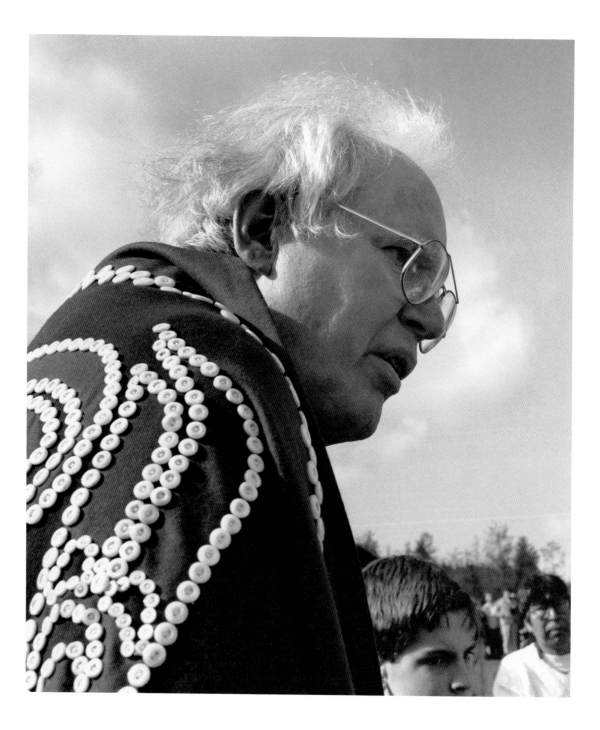

*Kihlguulins*: Reid in Skidegate, for the launching of *Loo Taas*, 12 April 1986,
and *Loo Taas* in Vancouver harbor, 2 May 1986.
Photographs by Ulli Steltzer.

*The Spirit of Haida Gwaii* descending into position in the chancery courtyard,
Canadian embassy, Washington, DC, 19 November 1991.
The work is cast bronze, 6 × 4 × 3.5 m (20 × 13 × 11½ ft), weighing 4,900 kg (10,800 lb).
Photograph by George Febiger.

FACING PAGE: *Yaahl Sghwaansing*: Reid in Washington, DC, watching installation of the sculpture.
Photograph by Ulli Steltzer.

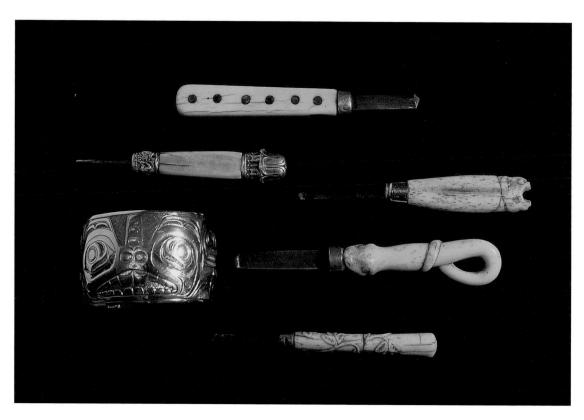

Engraving tools made and used by Daxhiigang (Charles Edenshaw), later used by Charles Gladstone; together with a silver bracelet by Daxhiigang, restored by Bill Reid.
*Tools*: recycled steel, bone and wood, circa 1870. *Bracelet*: coin silver, circa 1880/circa 1978.
The longest of the engraving tools is 14.5 cm in length. Private collection.
Photograph by Michel Setboun.

# Wilson Duff

*First trailer, Second Beach, Skidegate Inlet, Q.C.I. · August 1976*

When Madeline[1] phoned and told me Wilson had died, here on the Charlottes it seemed at first just another dismal small muffled electronic sound such as we hear through the background noise of our faulty radio and TV reception, echoes of an outside world where people seem to spend most of their time killing each other or themselves. It didn't seem surprising that it had happened to someone who was an old friend and colleague. Perhaps I'll have to return to Vancouver and the university to really feel the impact of his loss.

He was supposed to come here this year, to spend a couple of weeks with me after he finished conducting a tour around the Islands to show a boatload of people the deserted village sites. Too bad he didn't make it. If you can forget their tragic history and overlook its results, there's a paradoxical tranquility about these beautiful stormy islands that might have kept him with us for a while.

He hadn't been to the Charlottes for about twenty years, and that's sort of strange, considering that his main interest centred on the art that originated here and the people who made it. But there may have been a good reason. I think he wanted his Charlottes to be the home of the old Haidas, when the totem poles were new and the great carvers were just finishing their latest boxes, masks, rattles and all the other gear, and the painting was new and bright – not a largely deserted land with a few crumbling relics of rotten wood and a handful of fishermen and loggers and their families occasionally remembering memories as they become more and more like the world that surrounds them.

*Wilson Duff, an uncommonly insightful scholar of Northwest Coast art, took his own life on the evening of 8 August 1976, at the age of 51. He and Reid had known one another for 25 years and had travelled together to Haida Gwaii in 1953, 1954 and 1957. It was also Duff who arranged Reid's brief apprenticeship in pole carving under Naqap'ankam (Mungo Martin). Reid's eulogy, written in Haida Gwaii, was published in the Vancouver Art Gallery's magazine* Vanguard *in October 1976 and again in Donald Abbott's* The World is as Sharp as a Knife: An Anthology in Honour of Wilson Duff *(1981).*

I said he was my friend, and in a way this was true. We used to get together and drink a little and very often exchange long periods of rather uncomfortable silence. That was when we tried to discuss something other than Northwest Coast art. He helped me out from

time to time, when I was suffering from the malady that eventually caused his death and needed sympathetic company. I tried to do the same for him, with little success.

So I guess I was his friend. But I think that certainly more than me, perhaps more than anybody, his true friends were Albert Edward and Charles Edenshaw, of Kiusta, Skidegate, Naikun and Masset, and all the great artists and, as he thought, philosophers of the great age of Northwest Coast art. I think he really loved them, at first as creators of beautiful things, but later, as he tried to see through the curtain of age and cultural difference, as real people, who had lived vital, interesting lives, and through their works had something vital and interesting to say to him and to us. I wish I were romantic enough to believe he was now able to really talk to Albert Edward and his distinguished nephew, and find out definitely who made what and what it was all about. And perhaps exchange a few words with the Raven.

Well, what about Wilson Duff, Professor of Anthropology? The most repeated remark is that he left a great deal undone. It's true he didn't write very much. He wanted to be a good writer, and he was, but it was terribly difficult for him, every word a hard birth after long labor.

But he was a good teacher and in his very low-keyed way a powerful propagandist for the art of the Northwest Coast people. Many wealthy dealers in primitive art in New York and London should pay tribute to the part he played in bringing this great treasure to the attention of the public. And much more important, a couple of generations of students owe their discovery of this rich heritage to his enthusiasm and knowledge.

And equally important, if there is truly a renaissance of native Northwest Coast art, it is as much the accomplishment of a small group of dedicated academics – Hunter Lewis, Harry and Audrey Hawthorn, Bill Holm and others – as it is of the carvers themselves. And Wilson was certainly one of the foremost of these. For years he was the friend and advisor of Mungo Martin and later the Hunts in Victoria.[2] He gave me my first opportunity to carve on a large scale, and became a friend and advocate of most of the younger artists. On behalf of all of us, I'd like to thank him for that.

A couple of years ago, for his fiftieth birthday, partly as a joke, but with some serious intent, I made Wilson a silver medallion with a Haida design on the front and an inscription on the back giving his name and the date and describing him as a "survivor, first class." I'm glad that he wore his survivor's medal quite proudly from then on. I suppose it's ironic if he were wearing it when he died, but in a larger sense, as long as people study, enjoy, enthuse about and come to love the Northwest Coast art, at least some part of him *will* survive.

Wilson wrote as the final paragraph of the report of the salvage of the poles at Ninstints:

*Little remains of the thriving community known to Colnett and Duncan and Gray. The territories of the Kunghit people are more deserted now than they have been for many centuries past. A few fragments of memory, a few bright glimpses in the writings of the past, some old and weathered totem-poles in a storage shed, and the mouldering remnants of once-magnificent carved posts and houses on the site of the old village – these are all that survive of the tribe and village of Chiefs Koyah and Ninstints. What was destroyed here was not just a few hundred individual human lives. Human beings must die anyway. It was something even more complex and even more human – a vigorous and functioning society, the product of just as long an evolution as our own, well suited to its environment and vital enough to participate in human cultural*

*achievements not duplicated anywhere else. What was destroyed was one more bright tile in the complicated and wonderful mosaic of man's achievement on earth. Mankind is the loser. We are the losers.*[3]

*Wilson Duff*          Well, one somewhat flawed, quixotic, sometimes naïve, difficult, but very likeable, intelligent and somehow necessary tile is gone from our mosaic. We'll miss him. *Kilstlaay!*[4]

NOTES

**1** *Duff had resigned his curatorship at the Provincial Museum in 1965 to join the faculty of the University of British Columbia. It was Madeline Bronsdon of the university's Museum of Anthropology who telephoned Reid with the news of his friend's death.*

**2** *For Mungo Martin and Henry and Tony Hunt, see note 5 on p 146.*

**3** *Duff & Kew 1958: c63. The "Kunghit" people were the* Ghangxhiit Xhaaydaghaay, *the Haida of the southernmost part of Haida Gwaii. Throughout the early contact period and for some time before, their principal village was Sghan Gwaay Llanagaay, "Red Rockfish Island Town." In the late 18th century, the hereditary leader of this village was the headman of a lineage called the* Qayju Qiighawaay *(Raven side). Holders of this office bore the title* Xhuuya, *which means Raven. Early European traders altered this to "Koyah" and knew Sghan Gwaay Llanagaay as "Koyah's village." The British mariners George Dixon and James Colnett bought furs from Xhuuya (Koyah) in 1787. So did the American mariner Robert Gray in 1789. After his humiliation by another trader, Robert Kendrick, in 1791, Xhuuya lost his position as headman of the village. Revenge attacks ensued, and over the next few years, many members of Xhuuya's lineage were killed in altercations with other Haida and with visiting Europeans. By about 1800 another lineage, the Saki Qiighawaay (Eagle side), was preeminent in the region. The headman of this lineage then became the headman of the town. This line of headmen bore the title* Nang Stins, *"One Who is Two." Anglicized to "Ninstints," this became the town's new English name. Sghan Gwaay, "Red Rockfish Island," where the town once stood, is charted now as Anthony Island.*

**4** *The literal meaning of this word is "the [one who] touches (stl) by speaking (kil). The functional meaning is "sir" or "your honor."*

# Eighteen Sixty-Two

And so, after perhaps eight thousand years which saw the people slowly spread along the coastline and the river valleys, building their many languages and different ways of life, dreaming a world full of legend and myth, after all this time, in one terrible year, between the spring and autumn, it all came to an end.

Disease, firearms, liquor had already decimated some peoples and affected the rest. But the European tools and trade had at the same time brought to a fierce flowering all the ritual arts. When the horror came to the coast early in 1862, it found the villages flourishing as never before. When it died from a lack of victims, the totem poles looked down on the unburied dead and the pitifully small groups of stunned survivors.

The Tsimshian lost half their people, the Kwakiutl two-thirds, the Haida three-quarters.[1]

It is one of the world's greatest tributes to the strength of the human spirit that most of those who lived, and their children after them, remained sane and adapted, in part at least, to the strange new world in which they found themselves.

A world that was no safe haven for a shattered people, ruled by those intent on destroying all that remained of their essential lives: their languages, their customs and beliefs.

The lights in the villages burned very low for a hundred years.

Perhaps that dreadful end, more than a century ago, left the seed of a new beginning.

Certainly the power of the old ways lived on through the long, troubled years, and the strange forms of the old arts were much too powerful to die.

Smallpox is but one of many diseases brought to the Americas, Asia and Africa by invading Europeans, but it proved the most lethal of them all – and of all the epidemics to wash across the northern Northwest Coast, the worst on record was the smallpox of 1862. Reid speaks about this fateful year in early works such as "Totem" and in later ones such as "Haida Means Human Being." Here in this short, undated prose poem, he addresses the theme directly. I estimate the date of composition to be 1978. A recording of the piece, read by Reid, forms part of the standing exhibit at the Royal British Columbia Museum.

The people are still here, changed in appearance, in language and custom, but still alive – a part of the present with strong roots in the magic past.

And their images become every day more and more a part of all our lives.

*Eighteen Sixty-Two*

NOTE

1 *Scholarly studies over the years have not reduced these grievous estimates, though they have rearranged them slightly. The most recent and thorough work on the subject is Robert Boyd's* The Coming of the Spirit of Pestilence *(1999). By his estimates, in the 1862 epidemic alone, the Haida lost three-quarters of their population, the Kwakwalan peoples (Kwakw̲aka'wakw) a little over half, the Tlingit one-half, and the Southern Tsimshian two-thirds (but the whole Tsimshianic group, including Gitksan, Nishga, Coast Tsimshian and Southern Tsimshian, closer to one-third). Over the full century of death, 1774–1874, Boyd's figures show that the Tlingit and the Tsimshianic peoples both lost two-thirds of their population, the Kwakwalan peoples five-sixths, and the Haida nine-tenths.*

# The Classical Artist
# on the Northwest Coast

This is to be – the first part of it anyhow – a kind of introduction to the very basics. Not the basics of Northwest Coast art but of one little segment of it: the high classical art of the northern groups on the coast, which are the Haida, the Tlingit and the Tsimshian. The Bella Bella and the Kwakiutl were somewhat separate and either absorbed a lot of influence from their northern neighbors or were seminal in the art of the northern people, depending on which version you want to listen to. Somewhere in between is probably the truth.

The northern groups developed over the centuries a very formal kind of expression which we have been able to analyze to a certain extent – to the point where we can now go back and recreate it, based pretty well on an intellectual analysis of the forms that make it up. This, I think, is why the so-called renaissance of Northwest Coast art is so successful, as opposed to the efforts to revive other artforms elsewhere in the world. The rules, once you understand them – for this one particular form of Northwest Coast art – are pretty easily discernible and can be followed. What happens after that depends on the personality of the artist – the talent and genius, if you want, that he brings to it: the devotion and, most of all, the emotional energy which he manages to infuse into it.

This is a series of ovoids – and understanding the ovoid is essential, I think, to the appreciation of the art of the Northwest Coast people. Somehow or other it developed over centuries, becoming more and more refined and achieving an identity that is unmistakeable. It can take many forms, but it is always clearly identifiable in any Northwest

*Reid delivered this lecture at the UBC Museum of Anthropology on 6 February 1979, using a number of illustrations. Some were conventional slides of his own works and of older pieces from several museum collections. Others were sketches made especially for the lecture. Only six of the original slides have survived, and they are reproduced here on p 119. I have replaced most of the other illustrations with new photos and drawings.*

Coast art. It really forms the essential building block of the whole – both the forming and the tightening.

It's a very interesting form in itself. This seemingly simple form, which looks something like the cross-section of a bean, is one of the most remarkable products of the human imagination. It represents sort of the yin and yang combined in a single form which can be adapted to many different situations and can express many different emotional contents. It can be elongated, stretched out, and in that shape it seems to have very great elastic tension.

It's a very tactile thing to me. It's as though it were not just a flat design on a box or a piece of cedar, painted or carved in low relief, but as though it were somehow a three-dimensional object which responds to the pressures that are put upon it. If you take an ovoid and stretch it, as in the top example, the tension goes up, the line becomes narrower and somehow you can almost see the top rim of that ovoid pulling against the bottom part and pulling it up into the concave shape which it assumes there. Then as you relax the tension somewhat and allow the ovoid to compress, that lower rim falls away a little bit. When the tension is relaxed, the lower form manages to resist the attraction of the upper. As you get closer to a symmetrical object, the bottom flattens out further until it becomes, as in the third example, almost completely horizontal. Moving down again, the lower part of the ovoid then becomes convex as it makes its way toward a complete circle.

Now this isn't the way it always happens. You can have ovoids with convex lugs that are even more elongated. Some of them, even the long ones, can be almost symmetrical top and bottom. But whatever they are, they have this enormous tension built into them – a tension that I think reflects in some way the personalities of the people who made them, the individuals as well as the society that produced those individuals.

You never see ovoids like this in solid color as essential elements. They can be parts of larger elements, but I imagine they were probably first used – this is pure speculation – as eye forms, outlines of eyes of the creatures being depicted. Perhaps that accounts for the thicker line at the top, tapering off toward the bottom. This may be the origin of all the forms that you find in Northwest Coast art. In any case, this thickening of the line at one part and then the compressing of it elsewhere adds to the tension within the forms and also gives the whole design a circular – imperfectly circular – motion that goes along continuously. If you look at a flat design or at a totem pole or anything else in this art, your eye is constantly moving from one form to another. It is being directed there by the form established by the artist who created it.

When an eye is represented, the ovoid defines the eye socket, another, finer line delineates the edge of the eyelid, and in the centre you have the iris of the eye itself. This is the form that most Haida, Tlingit and Tsimshian eyes take in flat design. It was probably afterward – after the form had been used to represent the eye – that it was extended to other parts of the anatomy of the animal being depicted. The eyes turned into joint marks, which are very common things in many forms of art throughout the world.

The result is said to represent the ball and socket joint, with the solid area in the centre representing the ball and the larger area representing the socket. But these forms are used in all paintings and in low-relief carvings to show the points of articulation between the different parts of the animal. They are used where ball and socket joints are found, as in the shoulder joint of a man or a bear or a beaver, but they also can be used where there is no ball and socket joint, as between the flukes and body of the whale. Wherever there is some clearly defined junction between the different parts of the anatomy of an animal, it is generally represented or indicated by one of these joint marks.

As far as I can see, the only reason for the small, fine line around the central area in a joint mark is that it was borrowed from the eye form, just because it looked nice. In a joint mark, it hasn't any anatomical reference. When depicting an eye, as distinct from a joint mark, we can separate the iris from the pupil by making a small oval or round form in the middle of it. And because eyes on the Northwest Coast – the eyes of humans at least – were all dark, the iris and the pupil are the same color, differentiated only by a line. In a joint mark you don't find quite the same canoe shape enclosing what would be the iris if it were an eye. The joint mark is more purely decoration.

When the decoration is expanded, the simple form becomes a face, something known in all the literature as a Salmon Trout Head. I'm not exactly sure what a salmon trout is, other than a steelhead. But I think most people who have worked with this design are pretty well agreed – and I am certainly convinced – that this is actually a very abstract version of a human face in profile. But whatever it is, it is used as decoration, as far as we who do this artwork are concerned. Perhaps in the early days, when there was real understanding of the symbolism of the art, it was understood as representing some deeper or more spiritual aspect of the animal depicted. Or perhaps – as some people have speculated[1] – it was understood as a genealogical reference.

The ovoid, to return to its abstract form, can take on many different appearances. It can be very thin and attenuated, with soft, flowing lines, a great deal of white space and very little actual substance in itself. Or it can be very heavy, almost rectangular or verging on the square, and can give a very powerful, massive feeling to the work. But no matter how different they may be, those illustrated here are all undeniably ovoid forms. They belong exclusively to the art of the Northwest Coast and constitute a basic and essential part of Northwest Coast design.

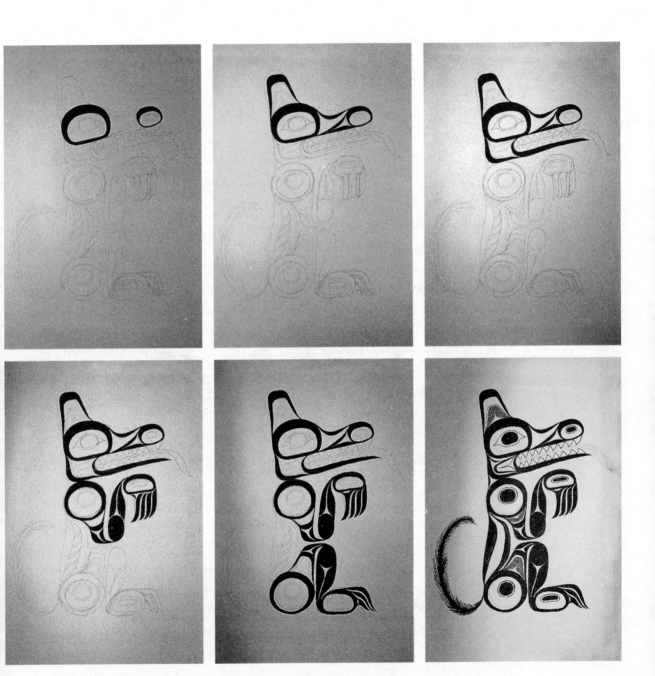

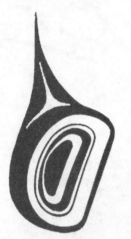

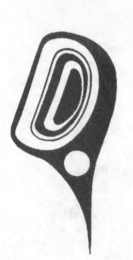

If you add some bits and pieces to the ovoid, you wind up with an animal of some kind, as in this case, where I tried to depict a wolf.

So here you have the world-famous formline, which can be further decorated with interior designs to create the very complex and beautiful forms which we know as Northwest Coast art. These are some of the ways in which these forms can grow. It doesn't mean anything very much, and this is a very bad drawing. But I want to be able to tell you one more thing. It is a very simple thing in its way, but it is what I consider to be a very important aspect, a very important clue, to the whole appreciation of the art of the Northwest Coast people.

The ovoids have to lead off to other parts of the anatomy of the animal – but they still have to remain there, clearly defined. So they have these little triangular forms or half-moon forms which follow around the surface of the ovoids and keep them separate from the other elements of the design. I had a long discussion about this on the phone with Hilary Stewart, who is doing a book on appreciation of Northwest Coast art.[2] As an observer, she saw these forms as coming *into* the ovoid and spreading out to encompass it. I said no; that didn't seem to me quite right. It feels to me as if the form comes *out* of the ovoid, though both explanations are probably quite valid, depending on your point of view.

In any case, protecting the identity and tension of the ovoid, you have these small triangular or half-moon forms. The Northwest Coast artist, I think, felt closely wedded to the forms that he was dealing with – this after all is the only kind of art he knew, the only kind he was brought up with and recognized as art – and the tensions that build up within these drawings are pretty intense. I think it would be an impulse on his part to find a way to release this tension every now and then.

One way of doing so – one of the most ingenious, and one that gives an insight into the extremely sophisticated attitudes these people

had toward their art – is this little circle here on the lower right-hand side which marks that boundary of the ovoid. This, I believe, had once been the half moon or one of those little triangular forms. And some genius along the way conceived the idea of releasing the tensions within these forms and allowing them to assume a natural – *physically natural* – form.

You know how if you could suspend a drop of water in a vacuum, or if it falls through the air, whatever shape it starts off with, it will become globular. I think this is what has happened here. The artists have realized that if the tension is released from that little form, it will relax and become circular. So that is not really a circle; it is a half moon or a triangle that has been allowed to escape somehow or other. And not only would it be conceived this way in the mind of the artist; it also would be seen that way by anyone who viewed it.

It's a kind of joke in a way. There were a lot of little humorous things that went on in these artforms. There were in-jokes that only the artists and insiders – those who were terribly familiar with the artwork – knew. But it's more than a joke. It's also a means of stopping the constant motion of your eye. You come to the circle and your mind says, "This is a place to stop and rest for a moment." Then it says, "No, this isn't really a circle. This is really a half moon or a triangle." It adjusts to it and goes on.

Now let's look at the application of some of these ideas.

This is a container for gambling sticks.[3] Gambling, obviously, was a very important activity on the coast, and the people devoted a great deal of care to the creation of the sticks, their decoration, and also to the bags that held them. You can see here, without my telling you much about it, that you have a remarkable example of the use of the ovoid, showing the variety of ways it can be used and the variety of shapes it can assume. It's quite square in places, and in others it's very

Captions for the numbered illustrations on pp 121–124 are with the endnotes on pp 129–130.

1

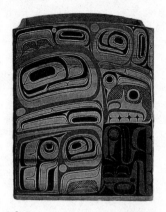

2

round and flowing. Whatever else it is, it certainly dominates the pattern of the design.

The classic place to observe this aspect of Northwest Coast art is of course on the painted and carved boxes. This is a painted design from the end of a box. It shows how attenuated the line can become and still remain within the convention, and it shows how in some instances the ovoid forms can become almost completely circular and lose their tension.

This [*not shown*] is a classic Northwest Coast chest.[4] I don't really know what to say about this. There are hands or claws; there is a face. Beneath the face there is another little face that represents the creature's body. The face within the body has no hands, but it has things that might be fins, might be wings, might be ears, might be any number of things. I think it's meaningless to say this represents a particular animal or other sort of creature. To me it's just something to be appreciated visually.

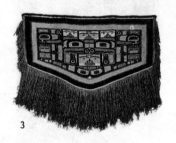

3

This is another very dramatic use of flat design in the Northwest Coast tradition: the Chilkat blanket. The pattern boards from which these were made resemble very much the paintings on the boxes and screens. When they are translated by the weavers they assume an entirely new character. But while the ovoids and the inner forms become less smooth and precise than they were in the original painting, they retain the essential quality of Northwest Coast art, which I think is contained tension and power.

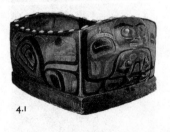

4.1

This is a feast dish from the National Museum in Ottawa. This to me represents just about the highest achievement in Northwest Coast art. It illustrates more aspects than anything else I know. On the sides we have flat design which would usually be painted. In this case it's also carved in very low relief. It embodies all the essential elements that are necessary to this design. As you move around to the ends, you

get into higher relief, though still very much flattened, and the integ-

ration between the flat areas and the relief areas is very easy; it makes a very easy transition. At the other end, you have much higher relief on the large face at the bottom – and in the little face that looks out from between the eyebrows and ears, you have almost full-dimensional carving. This is a feature of the genius of the Northwest Coast artist that you don't find repeated too often, this very easy transition between flat design, very low-relief, high-relief and full-relief carving. They could embody all of that in a single work.

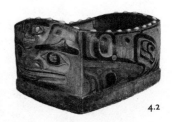

4.2

To my way of thinking, the large, full-relief carvings such as totem poles and masks grew out of this complete understanding of the flat design, and that is why the same feeling, the same emotional input, is found in all genres of the art.

By the way, you can see a very good example of the little circular divider in this particular case.

Here's another example of the transition between the flat design and the full-relief carving. This is a beautiful little rattle. It's decorated with elements of abstract design and at the same time it has a little person clearly defined. In this rattle you have again the flat decoration, but it is used in a three-dimensional way. I don't know if you can see it, but at the top there is a little man, and the fin of the creature becomes totally dimensional.

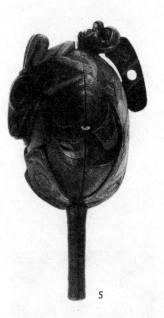

5

Now, if you don't mind, I'll show you a few of the ways I've used flat design, integrated it with three-dimensional work and tried to keep the whole hanging together.

This is the top of a silver box. The lid is made of argillite. There are completely abstract forms decorating the wings of the bird. There is a less abstract, more dimensional body. The head and feet are quite representational. This kind of thing was done quite frequently among argillite carvers. The harmony they managed to achieve in these disparate forms is quite remarkable.

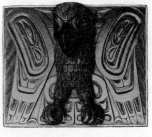

6

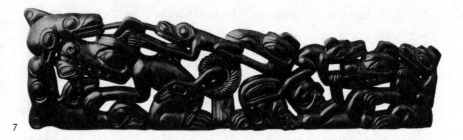

7

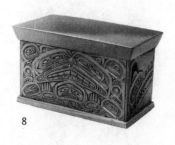

8

This is an argillite pipe. Although it's full-dimensional carving, it's quite flat, and it has the same movement of the forms. At least I strove to get that same fluidity, the same contained tension, that you find in more abstract designs on the boxes.

And this is not exactly a reproduction of a conventional Northwest Coast chest, but my version of it, done in a new material. That is the only thing that makes it different: the material is one that wasn't used by the original people. It's made of gold, and it's quite small – about two inches long – but even at this scale, the monumentality of the design, I think, is quite apparent. And here again you have this more or less representational creature which is actually made up of formal elements, the central one of which is the ovoid.

Now, you might be interested to know what the carving will look like that eventually will be in the rotunda of this building,[5] so I brought along some slides of the small Raven which I made. It will give you a slight preview of what's going to take place out there. It also shows, I think, how you can combine these very formal elements with quite representational elements and make an integrated work. The face on the tail of the Raven is an elaboration of the joint mark in which the ovoid has pretty well disappeared altogether. The concentric ovoids that you generally find in such a thing have been taken over by the face, which originally would have decorated only the central ovoid. It has expanded to take over the whole thing. So although it is a face, it doesn't represent anything in itself. It is just an elaborated joint mark.

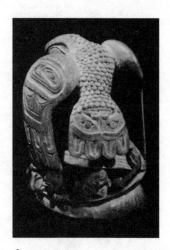

9

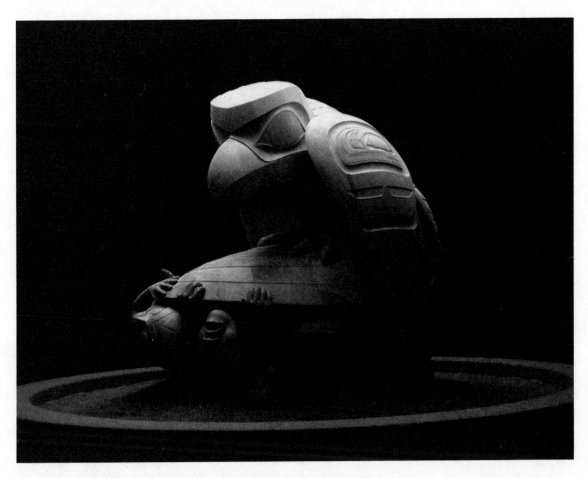

*The Raven and the First Men.*
Carved laminated yellowcedar. Approx. 2 m high, 1980, based on the boxwood carving of 1970.
UBC Museum of Anthropology. Photograph by Bill McLennan.

The elaboration goes even further in some cases. For instance, one of the eagle tails on one of the poles out there behind the museum has as its joint mark the face of a little man with feathers on his head, and he has sprouted not only hands and feet but a whole body. So he is a complete little man, sitting there representing nothing but the tail of the eagle.[6]

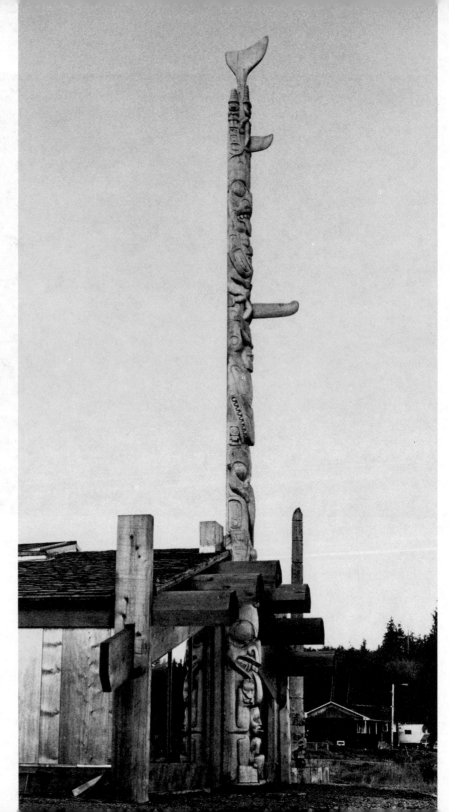

The Skidegate pole, raised in June 1978. The ovoid in the Raven's right wing was carved by Robert Davidson. Photograph by Ulli Steltzer.

FACING PAGE:
Chaatl pole 25, standing in the trees, summer 1953. Photograph by Wilson Duff (RBCM PN 5802B).

This, finally, is something few of you are likely to get a chance to see, so I brought it along to show you this evening. This is one of the two or three tall totem poles still standing on the Queen Charlotte Islands. It's at the west coast village of Chaatl, on Buck Channel, near the western end of Skidegate Narrows. For years I knew it only as a rumor, and I had been to Chaatl three or four times and looked high and low for this pole. You would think a forty-foot totem pole would be reasonably easy to find even in the woods if you knew the site of the village, but I missed it every time until finally I was taken there by a friend. It was one of the really exciting things that has happened to me, and it's a glorious work even in its present state of decay.

What I've been trying to say is that somehow or other, through the forms which they developed over hundreds of years and applied in their art, these people managed to lock such tremendous power into their work that even after 150 years or so of assault from the elements, and with most of the carving worn away, the tremendous force of this old pole still comes through. Its power in a sense is undiminished.

That's probably the oldest pole still standing on the Charlottes – and this is the newest. It's a pole we just put up in June, and I'll show you a few shots of it lying down so you can see it. It's very difficult to photograph standing poles in such a way that you can see them. Here are some of the details. This ovoid was donated to the pole by Bob Davidson, who came around and carved it.[7] I think that looking at small elements like this you can see the building blocks a little more clearly than by looking at the overall thing.

The guy lines are down now and it's standing as it will, I hope, for the next hundred years. Maybe somebody will find it in the midst of the woods one of these days.

That's about all I have to say. If you have any questions, please ask Mr Holm.[8]

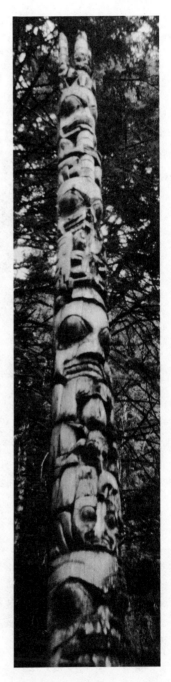

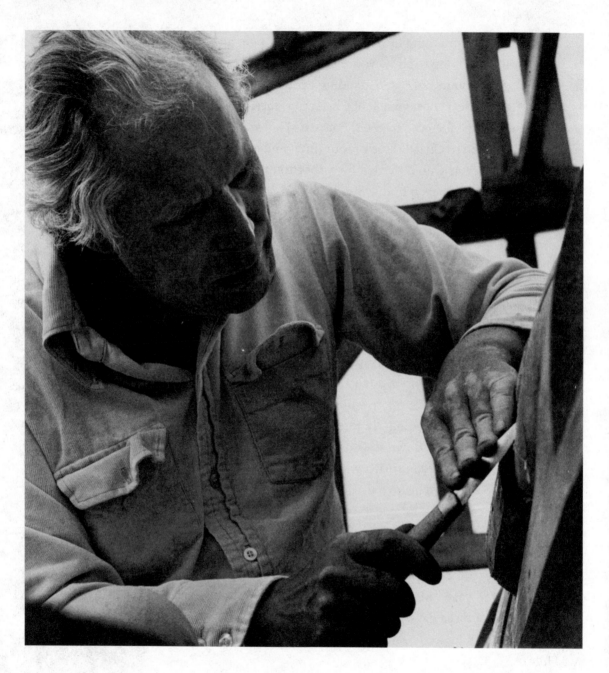

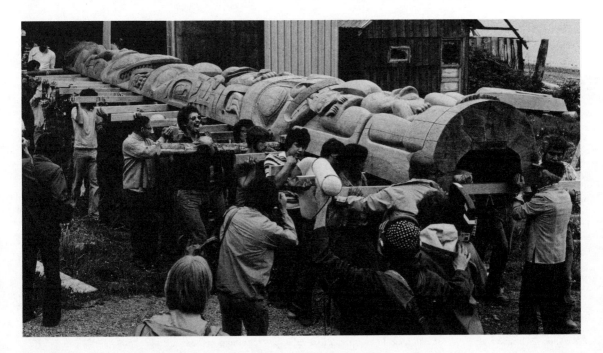

Reid at work on the pole, Skidegate, September 1977, and the morning of the pole-raising, Skidegate, 1 June 1978. Photographs by Ulli Steltzer.

## NOTES

1 *Such notions were explored at length by the American anthropologist Carl Schuster, whose work Reid knew through their mutual friend Edmund Carpenter. Wilson Duff also entertained the notion that the salmon trout head was specifically an emblem of the qaa/naat (maternal uncle/maternal nephew) relationship, crucial to the functioning of Haida matrilineal society. Reid was more enthusiastic about one of Duff's more down-to-earth remarks: that "the 'salmon trout head' motif ... does not represent a salmon trout head any more than a 'herringbone' pattern represents a herring." (See Schuster & Carpenter 1986–88; Duff 1996: 179.)*

2 *Stewart's* Looking at Indian Art of the Northwest Coast *was published later in the year in which Reid gave this lecture (1979).*

*Captions for pages 121–124:*

1 Anonymous. Dancing blanket. Painted caribou hide with quillwork. Before 1890. American Museum of Natural History (E 1580).

2 Replica, by Richard Sumner, of the AMNH blackfield box (*cf* p 157). Painted redcedar. Private collection.

3 Anonymous. Chilkat blanket. Dyed mountain goat wool and shredded yellowcedar bark. 91 × 167 cm, circa 1880? AMNH (16/351).

4 Anonymous. Feast dish. Redcedar, paint, opercula & abalone shell. 28 × 36 × 16 cm, circa 1878. Canadian Museum of Civilization, Ottawa (VII-C-78). Photographs by Wilson Duff (UBC MOA archives).

5 Anonymous. *Rattle: Killer Whale and Human.* Alder, paint and cord. 32.5 cm long, before 1875. Smithsonian Institution, Washington, DC (Dept of Anthropology 20584).

6 Detail of silver and argillite chest. 10.5 × 8 × 6.5 cm, 1971. Private collection.

7 Panel pipe. Argillite. 27 × 7.5 × 1.5 cm, 1969. UBC Museum of Anthropology.

8 Gold chest. 5.5 × 3.5 × 3 cm, 1973. Private collection.

9 *The Raven Discovering Mankind in the Clamshell,* rear view. Boxwood. 7 cm tall, 1970. UBC Museum of Anthropology.

3 *Even with Bill Holm's generous help, I have not found a gambling stick container that meets this description. Most such containers are painted leather bags. The object shown is another piece of painted leather, a dancing apron bought by George Emmons in the Haida village of Ghawkkyan in Southeastern Alaska. It is an artifact I know Reid admired, it has all the characteristics he mentions, and though it is certainly not a gambling stick container, it may just be the work he had in mind.*

4 *There are on the order of a hundred older Haida chests in public and private collections. It would be nice to know which one Reid chose on this occasion. Bill Holm has suggested that it was probably one from the Field Museum of Natural History in Chicago, FMNH 14851. The Field Museum chests were of special importance to Duff as well (Duff 1996: 224).*

5 *In 1973 Walter Koerner commissioned Reid to carve, for the UBC Museum of Anthropology, a large version of his small boxwood sculpture* The Raven Discovering Mankind in the Clamshell *(1970). The larger work, known as* The Raven and the First Men, *was finished and installed some eighteen months after this lecture was given. Immediately following the lecture, a member of the audience asked how the large work would differ from the small one. Reid replied, "Instead of being three inches tall, it's going to be seven feet tall. It will look down on you instead of you looking down on it."*

6 *The pole Reid is referring to is Tanu 24 – one of those that Duff, Reid and their colleagues removed from Tanu in 1954. The three main figures – eagle, raven and bear – are now in the great hall of the UBC Museum of Anthropology. In fact, all three main figures on this pole have "complete little men" in place of the usual nether faces (and all are clearly shown – cleaned, stabilized and displayed in their current position – in Shadbolt 1986/1998: 62). The man in the tail of the Eagle, his face largely obscured by lichen and moss, can also be seen in the lower left corner of Duff's photo on p 43. (The Eagle, whose beak has been destroyed, is lying face up, head toward the bow, in the crate on the port side at the stern of the seiner.) Reid may have been thinking of this eagle from Tanu when he made his Eagle serigraph in 1974 (p 31). There too, "a complete little man" is incarnate in the tail.*

7 *Robert Davidson carved the large ovoid in the right wing of the Raven on Reid's Skidegate pole. This ovoid is clearly visible just above the roofline in Ulli Steltzer's photo on p 126 and again on p 129 in her photo of the horizontal pole.*

8 *Reid's friend Bill Holm, author of* Northwest Coast Indian Art: An Analysis of Form, *was in the audience (and did take an active part in the post-lecture discussion).*

# Haida Means Human Being

What is a human being? We all know the superficial characteristics of this strange species of which we are a part. We are all erect bipeds; we are mammals; our children have an inordinately long period of dependency before we can put them out into the world to fend for themselves. Our two eyes are focussed to the front, giving us depth of vision; we have opposed thumbs on the forepaws we call hands. On the whole we are relatively unspecialized, and for a great many millennia, we apparently made our living by turning over rocks to see what we could find on the underside, scraping out a bare existence from our native environment, which may or may not have been somewhere in Central Africa.

At that time we looked like human beings, but to become what we appeared to be, we first had to invent ourselves. We had to discover all the characteristics that we now consider human. We had to learn to use tools – and then we had to learn to make tools, because the first, unmanufactured ones were inadequate. At the same time, we began to adapt various parts of our anatomy to purposes of our own, including communication. That was the main step along the road to becoming what we are.

Here on the coast, it probably wasn't Eden before the conquest. Nature was generous – endless forests bore a variety of woods for every manufacturing need, and the seas and rivers were rich with a myriad of food resources, supplemented by many land animals and plants – but there must have been high costs to pay. The rich seas were also treacherous. Danger and disaster must have been part of every

*Reid wrote the first draft of this piece while confined to a Vancouver hospital in 1979. At the time, there was some discussion of founding an Institute of Northwest Coast Native Studies, perhaps to be located at the University of British Columbia. No such institution has yet been created, but its mandate and its charter were clearly on Reid's mind while he was writing. Reid revised the essay several times, and it is quoted at length in Doris Shadbolt's book on Reid, but this is its first full publication.*

hunter's day. A wounded sea lion on the other end of the harpoon line would be a formidable opponent.

Much as we now admire the ingenuity of native technology, much of it must have been tedious. Think of the time required to fall a big cedar by burning through its base with a slow controlled fire or chopping it down with a stone blade. The fallers must have spent as much time sharpening as chopping, to say nothing of the days and weeks it took to make the tool before they could begin. And think of the time required to shape the log into the form of a canoe, and to hollow it out by more burning and scraping, then to steam and shape it some more, and finally fit it out. Or perhaps they used the log for house building. That meant hauling it to the beach, towing it probably for days to the village site, wrestling it up onto another beach, and levering it onto upright posts to serve as one of the massive beams. Or they split it into planks, each of which had to be shaped to the required length and thickness with stone or mussel-shell blades. They shredded cedarbark to weave clothing, dug and split spruce roots for hats and baskets. These are some of the thousands of intricate, time-consuming tasks that held together the fabric of material existence.

And there was the general day-to-day discomfort. Over the centuries you can learn to walk in the snow or over barnacled rocks in your bare feet, but it probably never became a pleasant experience. Cedarbark capes may deflect the rain, but in spite of the stimulating effect of that fine, prickly inner surface, they still must have let in a lot of the icy blasts of a November wind howling down from the Gulf of Alaska. The houses were magnificent examples of tribal architecture, but they were also smoky, draughty, crowded and cluttered. Mortality was high – child mortality in particular, judging by the small populations in a very rich environment.

Then there were the social pressures engendered by the apparently compulsive need for people in groups to complicate their lives.

Although different from region to region and group to group, all the coastal societies were rigidly hierarchical, with little mobility between classes. All power and prestige rested with the family heads, who demanded and apparently received the labor and skills of their lesser adherents for their own elevation in rank and advancement in wealth.

Of course, conflicts arose from living in isolated communities in too close contact with relatives and neighbors, exacerbated on the coast by the constant striving of chiefs to better their social standing. Warfare wasn't particularly well organized or extensive, consisting more of sporadic raids than of all-out attacks, but it was a nearly constant activity. So one was never sure that the comparative well-being of today might not give way to violent death or slavery tomorrow. If an inadequate number ventured too far from home, it was never certain whether they would return or become booty for their neighbors down the coast.

Having said all that – and the unappealing list could go on and on – I still believe that tribal society in general, and the Northwest Coast version in particular, probably accommodated the individual better than any system that has succeeded it. No one except slaves (and there is evidence that even they participated to some extent) was excluded from the diverse physical activities of the community – though of course political activities were limited to aristocrats. Everyone had a hand in the harvesting and preserving of food. The best hunters and fishermen, and probably the most skilled preservers and preparers of food, had added status in the communities.

After these seasonal subsistence activities – which seem to have been considered easy, almost holiday time for the people, like a prolonged picnic – came the serious tasks. Here everyone was not only encouraged to display his abilities but required to do so. It would seem that all men practised all the men's trades and arts – boatbuilding, carpentry, tool-, weapon-, utensil- and vessel-making, and so on – as well

as painting and carving ceremonial objects – and that all the women were preparers of food, weavers, basket-makers, and so on. And all were singers, dancers and actors in the ritual dramas which were such a part of the winter ceremonies. Of course, all were not equally skilled. But those who excelled were apparently recognized and rewarded, and the great painters, sculptors, weavers, bards – all with special talents – were cherished by the group. Access to these skills was denied to no one. Every child from his first conscious moment was in intimate contact with the most highly skilled adults in the community, if for no other reason than that he or she was in intimate contact with *every* individual in the community.

With no forced training, the young learned all the wisdom of the group: about the natural environment, how to exploit and live with it, the nature of the materials available from it, the complexities of the social environment, the genealogies of the great families, the myths of their origins, and the use of tools needed to give visible and audible reality to this wealth of symbolism – including, of course, the greatest tools of all, the rich and complex languages of the coast.

I was fortunate enough when I was young to hear some of the old men, the last of their kind, in the full flow of their reverberant oratory. Their deep voices effortlessly released the long, rolling cadences of their languages – Tlingit, Haida, Nishga, Tsimshian, Kwakwala, Salish – until they seemed to echo on the blue dome of the universe itself.

So every child grew up with as complete a knowledge of his world and how to cope with it as he was capable of absorbing. He had the highly developed powers of observation that gave him a better than average chance of finding his way in this world and wresting from it an abundant livelihood. He learned all the complexities of his society and what his place in it was. He had a body of myths and history embodied in the genealogies of his people, which provided him with guideposts and reference points to help determine the course of his

life. And he had a language of sufficient vocabulary and structure to communicate to the rest of his group and to himself all the information necessary to survive culturally, to think his way through his problems and to exercise his imagination creatively, to enrich his own life and that of his community.

In other words, he was a human being: a well-realized product of the unique and marvelous process, going back thousands of years, by which man invented himself. This inventing meant learning to use and make tools, to live together in social groups, to divide labor, to develop unprecedented uses for parts of his amazingly unspecialized anatomy, and to communicate in many different ways – of which the most astounding, unbelievable and magical is by speaking.

The long isolation ended in the eighteenth century, when the first European invaders (or explorers, if you like) arrived.

Thus began another of the seemingly inevitable historic tragedies that have resulted from the impact of an alien superior technology on an indigenous people. It is a drama whose last, pitiful, sordid, apparently senseless act is being played out now in the village reserves of British Columbia and Alaska, and in the slums of their cities and towns, largely unnoticed by the now dominant society. The plot is so familiar that it scarcely bears repeating. A small population over the centuries learned to live in harmony with its environment, like the other living creatures who shared it. They developed technological skills that were little more than sufficient for their existence. They created at the same time complex social systems with their attendant myths and rituals. Artforms – graphic, sculptural, musical, theatrical, poetic – were developed to support, explain and represent these myths. And each intricate cultural structure was firmly held in place by a dense framework of language.

Then the newcomers arrived and began to exploit the new terri-

tory. In this case, the furs of land and sea mammals were the main attraction. These were gathered with the willing or unwilling cooperation of the natives through trade, coercion and bribery. Often at the same time, the women were suborned to become concubines, prostitutes, servants or, occasionally, wives.

The impact was gradual at first. Some few people died from introduced diseases; some social patterns were disrupted; the sea otter population was brought rapidly to the brink of extinction; warfare increased, with bloodier effects on the participants; but new technology and material wealth also produced what we now regard as the flowering of Northwest Coast art. As chiefs from one end of the coast to the other vied with their rivals for ascendancy, wondrous objects, from massive totem poles to delicate goat-horn spoons, were made in enormous quantities. The small portion that survives – perhaps 30,000 items altogether – is sufficient to provide huge collections for many of the world's museums.

That flowering couldn't last for long. Fur traders gave way to gold seekers, followed closely by settlers.

Then came the great smallpox epidemic of 1862, and life as the Northwest Coast natives had known it for thousands of years was effectively over. The population was reduced by two-thirds. Some groups, notably the Haida, lost up to nine-tenths. The missionaries, who for years had been promising fire and brimstone to no effect, finally delivered – and overnight, nearly every survivor became, in name at least, a Christian. The territories of the great families which previously had comprised the whole coastline, its islands, river valleys and estuaries, were reduced to tiny footholds on isolated beaches.

It is an eternal tribute to the toughness and adaptability of the human spirit that they didn't give up easily. With most of their people dead, the social system in disarray, and their institutions under attack

from increasingly powerful forces, most of those who survived remained sane.

Some, notably the Kwakiutl, refused to give in to the pressure. They continued to observe their traditions and to produce the wondrous theatrical devices required for the ceremonials.

And in the north, having decided, whether willingly or not, to embrace the invaders' ways, the people did so with unqualified enthusiasm. Canoe-makers became builders of power fishing boats. The phenomenal wooden cathedrals of Old and New Metlakatla were built with the skills learned from constructing traditional plank and beam houses. Many villagers developed church choirs and brass bands. Men and women began to play an important role in the rapidly expanding fishing industry as boatbuilders, fishermen, carpenters, and as workers in the canneries and oileries that soon dotted the coast.

In most of the inhabited villages, totem poles were cut down. They were sometimes sold to whites, but more often they were burned – and the great plank houses, which had each once housed an extended family, were replaced by single-family frame houses, often with pillared porches and gingerbread trim. Henry Edenshaw of Masset built himself a Victorian mansion that wouldn't have looked out of place in Old Shaughnessy.[1]

There was perhaps at this moment a chance to integrate the survivors of the west coast holocaust with the modern community. But there were too many destructive forces at work. Inadequately treated diseases kept the population more or less constant. As late as the 1920s, the only medical facilities on the Charlottes were embodied in my aunt by marriage, a midwife and practical nurse whose entire pharmacopoeia consisted of some cough syrup and aspirins.[2]

And then British colonialism played its final card: the residential schools. These were large brick edifices, the epitome of the European

institutional building. They were, I think, government financed but exclusively controlled by the dominant missionary church groups – Methodist, Anglican or Catholic.[3] The argument as to whether they were deliberately designed to destroy the old societies forever or misguided attempts by well-intentioned, ethnocentric Britishers to lead their charges to a better life will never be settled. Both motives were probably involved. The result was in any case the same. Those intentions, good and bad, paved a road leading to the hell in which the descendants of these residential scholars now find themselves.

The victims' memories of the system are at odds with one another. Some recall their schooldays as the happiest days of their life, others as just like being in jail. But all agree on one thing: that speaking their own languages was strictly forbidden and severely punished, often by beatings. Most add that they learned little or nothing of value. The girls were taught domestic skills to prepare them for life as homemakers or household servants. The boys were expected to turn into farmers as a result of the experience they gained growing the food required to feed staff and students in the schools. Because the fishing season coincided with school holidays, children often remained at the schools for years on end, completely cut off from their families and homes. When they finally did return, they arrived with considerably less than they had when they left. Their native language and manual skills were gone. Rudimentary English and, at least for the boys, a body of half-learned and useless agricultural knowledge were all they had to show for the years away from home. An amazing number of the women became skilled pastry cooks – the status Victorian culinary achievement – but the rest of the cuisine was distressingly British and infinitely less nutritious than traditional native fare. With the introduction of excessive sugar to the diet, severe dental problems were added to health hazards already present.

Still, there was in each community a core of adults who had

avoided the schools either through age or their parents' refusal to part with them. So the returning refugees were reabsorbed, and if not able to do much more than hang onto some semblance of existence, they could still look to a better future. Alcohol became and remained a problem, but considering the dismal state of their material existence and the almost complete destruction of traditional methods for dealing with stress and anxiety, the wonder isn't that they drank so much but that they didn't drink more.

Between the turn of the century and the Second World War stretched a time of stagnation or decline. The population remained at the same low level in spite of the high birth rate. Disease – especially tuberculosis – continued its ravages. The first generation of European-style houses, often well built in their day, declined for lack of maintenance, and smaller dwellings, virtually shacks, were built instead. Hardly any reserves had electricity, running water or other amenities, and fire was a constant hazard. The old ways were increasingly rejected, yet attempts to join the alternative society were almost completely unsuccessful. As far as I know, my uncle, Percy Gladstone, was the only native university graduate in British Columbia before the war.[4] Discrimination against natives was practised quite openly. They were not permitted to vote in any election, nor to buy liquor legally. Unofficially, they were often refused entry to hotels and restaurants. In Prince Rupert and some other places, natives were required to sit in restricted areas in the local movie houses. The reserve lands and the people were completely under the control of the Department of Indian Affairs, whose officials were all too often former British military officers with a background in colonial administration.

At the end of the war, the beginning of the recent affluence and a general liberalization of the social scene were reflected in the attitude of the ruling majority toward the native people. Those who had

served in the armed services were granted the federal franchise. Provincial voting rights followed. Where native and non-native communities were close enough, integrated schooling was established, and the residential schools were phased out. Health services were vastly improved, and the long decline in population was radically reversed. Band councils were established and, subject to approval by the Department of Indian Affairs, native communities were permitted a degree of self-control. The notion that native people were second-class citizens, wards of the government or the Queen, was no longer so openly stated. Natives could get drunk as legally as anyone else, though they were still more likely to go to jail as a result. Here on the coast, the potlatch was legalized, and the art community, academics and collectors discovered, or rediscovered, native arts. This included Inuit sculpture, historical material from the Northwest Coast, and work of the so-called Coastal Renaissance.

Native participation in the west coast fishery increased dramatically during the war, when Japanese-Canadian and Japanese-American fishermen were exiled and many others were in the armed services. With the improvement in health, the spread of the use of English and elementary literacy, the use of native labor in other basic industries, notably logging and construction, increased. For the native population as for other North Americans, things looked hopeful in the euphoric and affluent time following the war. There was every expectation that within a few years, or at most a couple of generations, they would be equal participants in North American society, and there was some expectation that, if they so desired, they could still retain and practise what remained of their own cultures. And it must be said that many individuals moved easily from their reserves into the outside world, where they or their children often became indistinguishable from the general population.

Within native communities, it soon became apparent that the old

problems would not be so easily solved. The integrated school system, far from encouraging equality between the two societies, points up the fact that native children are completely unprepared to compete adequately in the arcane obstacle course society has designed for the education of its young. Almost without exception, native children find themselves considered failures from the day they are surrendered to the school system. Excessive use of alcohol and more exotic drugs continues to be a much more dominant part of "Indian culture" than any of the older ways. A disproportionate percentage of the jail population is still drawn from the native sector. Attempts to leave the reserve life and move to an urban setting still too often lead to the dreary life and early death of skid road.

The increasing technical sophistication of the fishing industry, with the resulting need for bigger, faster, more expensive boats, led to the exclusion of most of the native fishermen from its more lucrative aspects and effectively ended native boatbuilding and maintenance activities. Most of the canneries on the coast closed, and although they did not perhaps offer ideal conditions of employment, the loss of these jobs was a blow to the economies of many native communities.

The decline in morale among native male populations affected their reliability as workers, undermining the confidence of employers. The Department of Indian Affairs introduced many programs ostensibly intended to alleviate this situation, but far too often they were ill thought out and poorly administered. An intensive housing program was initiated, but the houses were of poor design and second-rate construction and, most telling, were for the most part built by outside contractors. The programs weren't designed to help retrain the village people in skills that would make them more self-sufficient.

Government funding for reserve projects was often lavish but poorly researched and inadequately followed up. Often the money was wasted – either dissipated on unproductive labor or channeled

into the pockets of the shrewder and less scrupulous members of the community. Agencies were set up with the intention of improving aspects of native life, but inexperienced or, all too often, self-seeking personnel were appointed, so that most of the sometimes excessive funding was wasted on administrative costs or used by the administrators themselves to further their own ends.

And then there is the myth that the way out of the current dilemma is through the revival of the old arts and other ceremonial aspects of the old culture.

It can't be denied that a knowledge of where they came from and who they are is invaluable to those wishing to find their way in this world. But this knowledge should be based on fact as far as possible.

Even if a complete record of the past were available, any attempt to recreate their world and themselves as they once were would fail – as all such attempts, wherever tried, have failed. It would serve only to isolate them further from the world as it is – a world which will nevertheless continue to dominate their lives, and with whose tentacles – the schools, courts, police, the health care agencies and so on – they still will have to cope.

The competently made art objects being produced today may give the impression that a cultural revival is actually taking place. But the art movement is largely urban-based, and it can be argued that the whole revival is a result of the intervention of a few academics who originated the totem pole projects for Vancouver and Victoria. Certainly if it hadn't been for them, the Martin/Hunt phenomenon[5] would not have occurred; I would probably still be reading the news at the CBC, and the only objects being created – the only ones showing at least a superficial knowledge of the principles of the old arts – would be those produced by the Seattle tribe, followers of Bill Holm, nearly all of whom are non-native. In the villages, the creative stream would be continuing on its diminishing way to eventual extinction.

The programs aimed at reviving the languages are also, regrettably, almost certain to fail. Even among the most accomplished remaining native speakers, much of the vocabulary is lost, and nearly all of the literature. All the good speakers are old and lack teaching skills, and in any case, the language programs are squeezed into the regular curriculum so as to disrupt it as little as possible.

Then there are the mysterious elders who are supposed to be the repositories of the old culture and wisdom. Well, I sadly fear that the elders of today are not much older than I am, and I remember many of them as friends and drinking companions of my youth. Neither they nor I had much knowledge, culture or wisdom in those days, and we haven't improved much with the years.

So we arrive at the situation as it is today.

I hope that somewhere some young people are actually growing up with enough authentic knowledge of their ancestry to have pride in the true accomplishments of their forebears: their industry, their marvelous ingenuity and skill, their ability to live in comparative harmony with their environment, the richness of their daily lives, their completeness as human beings. I hope that pride in the deeds of their ancestors is creating a desire to emulate them in new and useful ways, and to move out into the world to test the values of their cultures against those of other occupants of this earth.

I hope that's going on somewhere, but I have little evidence that it is. I do have evidence, in hard statistical reports and in too many personal contacts, of failure, apathy, and of lives lived at the minimum level of achievement and interest. Fine, beautiful, potentially brilliant boys and girls who should be the leaders, not only of their own small communities but in the wider world as well, are wandering confused and undirected from meaningless episode to meaningless episode of their meaningless lives.

And always the consuming, dominating, corrosive anger – often repressed with the aid of booze and drugs, and a lifestyle precariously designed so that yesterday exists only in fantasy and there is nothing beyond tomorrow. For to remember is to realize how it used to be, or at least how one imagines it used to be. And to look forward is to know that tomorrow holds no promise of that fabulous education that was going to make one a doctor or a lawyer or a professional of some kind. It holds no promise even of a job or an adequate home in a stable community, or of a family to continue a tradition going back to mythtime. It just holds more of the dreary same.

And then sometimes the anger becomes a tearing, despairing rage – a rage that can very seldom be directed against the enemy, who is after all only a descendant of the enemy anyhow. So it is aimed at whatever is near to hand. Windows in neighbors' houses are broken; buildings in villages are burned by residents of those villages; friends and relatives are beaten or murdered; and far more often than in the general population, the violence turns completely inward, and killer and victim are one in the same.

After most of a lifetime spent on the periphery of the lives of many such people, I have no programs to suggest that would begin to solve the appalling problems existing within our society today. But I do know that if there are such things as aboriginal rights – rights that the first inhabitants of this land can properly insist on having restored, and that we all have an obligation to see restored – they are not primarily land or resources or traplines or fishing rights or any material considerations, but the right of the people to have once again in their lives what the intruding power has taken from them in the last two centuries: their basic humanity.

This should be a purpose to which, in cooperation with the native people, we devote our finest talents in all disciplines.

It needn't be a one-way street. In the process of helping native people attain an equal place in our society, I am sure that the latecomers to this land will begin to realize what riches remain of the cultures their own ancestors tried to destroy – treasures equal in concept, in intellectual and emotional content, and also in technique, to any of European or Asian origin.

*Solitary Raven: The Selected Writings of Bill Reid*

By sharing with the original inhabitants of this continent the things that make up the essence of their own humanity – their legacy from their own original homeland – we and they may feel secure in accepting the priceless gifts that the Northwest Coast peoples left for their descendants – and that they left, as it turns out, for the whole world.

Perhaps by doing so we may all move a little bit along the way to becoming, at last or again, true North Americans – neither displaced aborigines nor immigrant settlers.

I don't know the words in the other languages of the Northwest Coast, but in the Haida language, *Haida* means human being.

As a descendant, in part at least, of the Haida people, I wish for each of us, native or newcomer – or, as so many of us are now, both – that however we say it, we can recognize ourselves someday as Haida.

1 *Henry Edenshaw (1868–1935) was known in Haida as Kihlguulins, a name later given to Reid himself. He was the son of Gwaayang Gwanhlin (Albert Edward Edenshaw) and thus the cousin (mother's brother's son) of the sculptor Daxhiigang (Charles Edenshaw). Old Shaughnessy is the "Victorian mansion" section of Vancouver, the city where Reid was living when he wrote this essay.*

2 *Reid's dates are incorrect here, though his sentiments may not be. There was a hospital in Haida Gwaii, complete with resident doctor, by 1912, but it was built, of course, in the new colonial town, Queen Charlotte City, where its services were far more accessible to the white than to the native population.*

3 *Between 1880 and 1925, the Government of Canada built 16 residential schools for native students in British Columbia. Though built with government funds, all were managed and staffed by missionary agencies. When schools within the province were filled to capacity, students from the coast were shipped to Edmonton and other locations still farther afield.*

4 *Percy Gladstone was apparently the first native person from British Columbia to receive a baccalaureate, but it was given after the war. He earned his B.A. (1949) and M.A. (1959) in economics and political science at the University of British Columbia. Nishga leader Frank Calder had previously (in 1946) earned his licentiate (L.TH.) from the Anglican Theological College attached to the same university.*

5 *Mungo Martin (Naqap'ankam, c. 1881–1962), was a Kwakiutl carver and singer from Fort Rupert. He carved his first pole in 1902, and several of his works now stand in his tribal homeland. In 1949, he began to do restoration carving for the University of British Columbia, and in 1951 moved to Victoria to carve for the Provincial Museum. With his son-in-law Henry Hunt (1923– ) and several grandsons, including Tony Hunt (1942– ), he carved a number of the poles – both replicas and new creations – now standing in Victoria and at other heavily touristed locations in the province. This mania for tourist poles reached its culmination in the late 1950s. Martin and his assistants carved a 128-foot pole, completed in 1956 for the Victoria Times newspaper, and for the British Columbia government, a matching pair of hundred-foot poles to mark the province's centennial celebrations of 1958. One of the latter poles was presented to the Queen of England and raised at Windsor. The other was raised in Vancouver at the Maritime Museum. (Duff 1959, H. Hawthorn 1961, Nuytten 1982 and Stewart 1990 all speak of Martin's work.)*

# Bill Koochin

Whatever else may be said about this troubled century, now entering its final uncertain decades, it has given those interested in the material manifestations of the human experience an opportunity to see at close hand a sweeping representation of manmade objects. Since the fifties, it seems that all that was required of at least the majority of affluent North Americans and Europeans who wished to visit the Jain temples of India or the stone gardens of Japan, or certainly something as accessible as classical Greece or the High Renaissance in Tuscany, was the desire to go.

Even if this were inconvenient, museums of various kinds – art, science and ethnology, either distant or close by, with their travelling or permanent exhibitions – were established or vastly expanded, and the plunder of a myriad treasure troves became the visual playthings of all who bothered to look. And everybody's surrogate eye, the insatiably curious camera, has explored, at least superficially, every corner where man has scratched or scrawled or painted or carved or constructed his imprint on the landscape. So that now, even those parts wrought with greatest care in the elder days of art solely for the perusal of the gods, are only as remote as our coffee tables and television screens, readily seen by the humblest of mortals.

Well, something must have come out of all this.

Certainly the sure knowledge that men of all places and times are much more alike than they're unlike, that such matters as aesthetics, art, excellence and beauty are not the exclusive property of those who happen to have invented words to describe them.

Also, I think that once we describe our ethnocentric, hierarchical ideas of how the world works, we will find that one basic quality

*In 1980, the Burnaby Art Gallery, in Burnaby, BC, mounted an exhibition of bird-shaped carved wooden bowls. These were the work of a French-trained Russian-Canadian artist by the name of Bill Koochin. Reid contributed this statement to the exhibition catalogue. A shorter version of the text (containing no references to Koochin or his work) appeared a decade later, in the* Vancouver Sun *(24 August 1991). It is possible – even probable – that the shorter version is the original: something Reid had written independently in 1980 or earlier and to which – for the purposes of the exhibition catalogue – he added some further remarks on his talented friend.*

unites all the works of mankind that speak to us in human, recognizable voices across the barriers of time, culture and space: the simple quality of being well made.

We may be charmed momentarily by a naïve painting, or shudder from the impact of the old magic of a nail fetish, but it is the elegant line, the subtle curve, the sure precise brushstroke that gives us that sudden aching sense of identity with the distant cousin who first lovingly made it.

Of course, it doesn't start or end there; it is the direction of the line, the expression of the curve, the purpose of the brushstroke that moves or excites us. But without that old, casual mastery of technique, the message is muddied and obscure, or so poor in the shades of meaning that constitute human communication that it becomes senseless or, even worse, boring.

So what, you may rightly ask, has all this high-flown flummery to do with a flock of wooden ducks, geese and chickens? Well, bear with me. The point may be at hand.

In a world where we more and more seek out and admire the finely crafted object, we less and less know how to make it. The old, infinitely precious web which carried the hard-won skills from one generation to the next, which provided the visual and tactile language by which the artists of every age could give expression to their times and to themselves, has become in our time as thin and frayed as our hope of heaven. It may be, as some say, that new skills and other means will give rise to other equally valid expressions. But this doesn't diminish the loss of that which was for so many millennia a cherished and essential part of our humanity. The loss makes even more important those occasional bright segments of that web that still retain their strength and elegance.[1]

One of these is certainly the preserve of Bill Koochin. I don't know by what means this amazing concentration of expertise came to reside

in one individual, whether it all stems from skills brought from old rural Russia by his Doukhobor grandparents, or whether it's just some miraculous facility fine-honed by a lifetime of unremitting practice, or both and more. But here he is, in the full maturity of his career, carver, welder, stonemason, toolmaker, cabinet maker, draftsman, jade carver, modeler, sculptor in stone, bronze, steel and wood, and maker of ducks, chickens and geese.

Of course, as a teacher he has been one of the channels through which the mainstream of sculpture has flowed in our region, a stream which has surfaced more and more often in recent years in the work of young artists. For those truly interested in discovering their roots and learning their trades, he's been an invaluable resource.

As for his work – well, I've myself seen it move through his life for about a quarter of a century now. I missed the early abstractions, but I've seen the horses and cows, the amazing parade of naked ladies, the birds, the bowls, the boxes, the candelabra, a long, quiet flow of unpretentious beings, each a part of a continuous unfolding process. And now this assemblage of fowl, hatched originally from a long dormant ancestral Russian Easter egg but maturing as a joyful, completely personal expression.

If you want, you can dismiss them as well-made exercises in a sort of pseudorustic handicraftsmanship. But twist your viewpoint a few degrees and visualize finding one of these, dust-covered, in an old king's tomb. It would rank as a great discovery and find a place in the collection of some great museum. It would still be the same duck, chicken or goose.

But what the hell. Look at them as you will. Enjoy them for the great good fun they are. Cherish them as beautiful objects. And love them because they represent part of a process that began a long time ago – and that, with any luck and a few more Bill Koochins, may continue for a long time yet.

## NOTE

1  *The sentiments expressed in this paragraph remained important to Reid — so much so that he repeated them verbatim in 1985 in a piece he wrote in praise of his friend and colleague, the master goldsmith Toni Cavelti. (See "The Goldsmith's Art," p 227.)*

*Bill Koochin*

# The Enchanted Forest

*... gradually I became aware of the old island here that flowered once for Dutch sailors' eyes – a fresh, green breast of the new world. Its vanished trees ... had once pandered in whispers to the last and greatest of all human dreams; for a transitory enchanted moment man must have held his breath in the presence of this continent, compelled into an aesthetic contemplation he neither understood nor desired, face to face for the last time in history with something commensurate to his capacity for wonder.*

So wrote Scott Fitzgerald, concerning Long Island, New York, in *The Great Gatsby,* more than half a century ago.[1]

Last month, on another island, almost as remote from Fitzgerald's as possible while still being part of North America, I had the great privilege of feeling something of the sense of wonder of those old Dutch sailors. With some friends, I went ashore at Windy Bay on Lyell Island, which lies off the east coast of Moresby in the southern Queen Charlottes. All my conscious life, because of my kinship with the Haida people and my involvement in their art and history, and because of the austere, remote beauty of the islands themselves, the Charlottes have been my spiritual and occasionally my actual home. But never have I felt the full impact of their magic as I did at Windy Bay.

There is grander scenery on the west coast, wider vistas to the north. But this could be the setting for the Peaceable Kingdom. A fine river empties into the bay through a grassy meadow, an old Haida village site lies at the edge of the forest, marked only by the lush grass that distinguishes the places where the people once lived.

Then there's the forest itself – great old spruces, hemlocks and cedars, some straight and tall, some twisted into incredible baroque

*Windy Bay, on Lyell Island, was once the site of the Haida village of Hlkkyaa Llanagaay, "Merganser Town." This was the mother village of Reid's grandmother's village, Tanu. When he visited the site in 1980, the whole of Lyell Island, including Windy Bay, was under threat of clearcut logging. Reid's plea for a change of policy was published in the Vancouver Sun, 24 October 1980.*

shapes – not a gloomy place at all, so old that there are many open spaces to let in the light, which falls softly on the deep moss that carpets the ground. The game trails along the river are so well worn and the terrain so gentle that even I, who am neither very young nor very strong, could stroll easily for a mile or so along the river. A couple of yearling does didn't even look up as we passed within feet of them, and a black bear went on eating grass, waiting for the salmon that would soon fill the river.

Our time there should have been one of unqualified delight. But we all carried ashore with us the knowledge that the wave of technological assault that had begun on that other island and changed most of the continent, devastating much of it, was lapping at the shores of Windy Bay.

On the other side of the island we had seen the huge swath, miles long and nearly a hillside wide, that marked the rapid advance of the loggers. If present plans are followed, sometime within the next five years they will advance over the hilltop and move down the river valley to the sea. Nothing will remain of the grand old forest but stumps. The moss will be ripped away by the machines and skidded logs, a tangle of branches and other waste will cover the ground, the clear water of the river will be muddied by the unchecked runoff from the bare hills.

In the warm, moist, generous climate of the Charlottes, in fifty years or so the trees will be back, a dense, impenetrable thicket, and in five hundred years, if left alone, Windy Bay perhaps, just perhaps, may be something like it was when we saw it last month.

This is not intended as a diatribe aimed at the most important part of our economy. I'm not opposed to logging, loggers, or the lumber industry. I don't want to see my fellow residents of British Columbia starve in the forest, and as one who's spent many years using beauti-

ful British Columbian wood in my work, I'd be a ridiculous hypocrite if I proposed the end of the tree harvest. But can't we, while we still have a little bit of a last chance, institute true multi-use of the forest, with due regard for its own regeneration, the wildlife it nurtures, and, most important and most neglected, its aesthetic values – that is, the nurture it affords to human life?

At this moment what is happening on the poor old Charlottes resembles a desperate attempt to loot a treasure house before the owners – you and I – realize what's going on and take measures to stop it. This on our famous Misty Isles, home of the fabled Haidas, one of the places in our country still imbued with romance, a world-renowned, unique ecological area.

To my way of thinking, sustained yield in tree farming, as in other farming, should mean bringing at least some of the crop to maturity. We should have fifty-year-old trees, hundred-year-old trees, five-hundred-year-old trees. After all, our great-great-grandchildren may enjoy seeing some big trees in mature forests, and may also find some use for beautiful, clear lumber. They may not feel overjoyed that their ancestors got a little richer by using it all up at once.

And what better place to set aside those five-hundred-year-old trees than the proposed South Moresby Park area, which includes Lyell Island and Windy Bay? Now that control of that particular tree-farm licence is back in local hands, let us hope that enough people within the companies, the government and the population at large will be found with their "capacity for wonder" sufficiently intact to preserve this tiny remnant for the enchantment of all, as a vital memorial to all that's been lost between those old Dutchmen's time and ours, and as a continuing promise for the future.

It may be argued that few will ever set eyes on such a remote spot, but those who still hold to what is left of the "last and greatest of hu-

man dreams" will find their way there, or find solace in the knowledge that it still exists unspoiled. Let's not waste *this* last time in history to save something commensurate to *our* capacity for wonder.

*The Enchanted*
*Forest*                                              NOTE

1 *The quotation is taken from the last page of Fitzgerald's novel, published by Charles*
  *Scribner's Sons, New York, 1925.*

# The Master of the Black Field

In the last years of his life, Wilson Duff's efforts became more and more directed toward trying to uncover the many layers of meaning which he felt sure lay behind the convoluted, complex surface patterns of Northwest Coast art in all its forms – the structure of the myths, the forms of ancient stone artifacts, the significance of masks. He believed, I think, that this whole sweep of creativity expressing the rich cultures of the coastal peoples reached its apogee in the so-called "flat designs" found on carved and painted screens, house fronts, bowls, chests and boxes.

He appears to have considered that the most significant of these designs still existing was found on the sides of a particular bent-corner chest.

I was not closely enough associated with him during this time to have any knowledge or appreciation of his thinking on the meaning of this design. My only role in this investigation, which at times became almost an obsession, was as the intermediary who first brought it to his attention.

This occurred because, like most of the group who brought about the so-called Northwest Coast artistic revival, I acquired my early knowledge of the culture not through contact with the native people but through the writings of the early anthropologists, chiefly Franz Boas. It was in his *Primitive Art* that I first became aware of the existence of this masterpiece whose outstanding qualities were apparent even in the small, inaccurate, unfinished rendering by which it is illustrated there.[1]

When I was charged, along with Wilson and Bill Holm, with selecting material for the *Arts of the Raven* exhibition at the Vancouver

*This piece, probably written in 1980, was published in Donald Abbott's* The World is as Sharp as a Knife: An Anthology in Honour of Wilson Duff *(1981). Recent research by Bill McLennan strongly suggests that at least three 19th-century artists – one Tlingit or Haida, one Nishga or Tsimshian, and a third who may also have been Haida – made blackfield paintings of a very high order. By implication, Reid's essay – the first published appreciation of any of these artists – pays honor to all three, though it condenses them into one.*

Art Gallery in 1967, my first request to the American Museum of Natural History in New York was for this box. It wasn't on display; nobody at the museum had any knowledge of it. Fortunately I had no trouble finding it, completely unprotected, on an open shelf in the grimy attic of the museum which houses so many of the great treasures of the Northwest Coast. Eventually it arrived in Vancouver, a not very large, not particularly well-made box, badly worn, and covered with greasy dirt through long use, not to mention the layers of New York City atmospheric filth.

At the risk of never being allowed near a museum collection again, I must admit that, unknown to the art gallery personnel, I removed a considerable amount of the surface soil, and there, worn and indistinct though parts of it were, was this marvelous design. The next problem was how to draw the attention of the public to this very unimpressive-looking, worn and weathered little wooden box, covered with indistinct patterns. We decided to build it a little room of its own, with a floor space about three metres square and walls about two and a half metres high, and to line these walls with reversed, enlarged photographic images of the sides of the box, each wall reflecting the side of the actual box that it faced. The box itself was, of course, placed in the centre of the enclosure.

The pattern on the box was too indistinct to give a good photographic image, so I made a tracing of the design, transferred it, in reverse, to illustration board, and worked it up in the original colors, black and red. These panels were then photographed and used as outlined above.

The reason for going into all this technical detail is that – although he was intrigued and excited by the box itself – because it was on display during most of its stay in Vancouver and had to be returned to New York immediately afterwards, it was my copy of the box design which Wilson eventually used for his studies. Although harsh and glar-

"Master of the Black Field
N° 1." Bentwood box,
nicknamed *The Final Exam*.
Painted redcedar.
45 × 35 × 36 cm, circa 1865?
[Bought by George
Emmons on the Chilkat
River, Alaska, in the 1880s.]
American Museum of
Natural History (19/1233).
Photograph by Wilson Duff.

ing in texture and color when compared to the original, the strident
poster colors on a white background – instead of old, mellowed paint
on old, soft, dark redcedar – were accurate. I made templates for all
the essential forms to duplicate the wonderful accuracy of the painted
lines found on the box.

Wilson objected to my having rendered the design in reverse,
maintaining that the structure was so delicate that even this change
destroyed something of the intent of the artist. He eventually com-
missioned Hilary Stewart to redraw it the correct way.

That was the end of my participation in the relationship between Wilson and the Master of the Black Field, as we have come to call this great, otherwise anonymous artist, who – judging from the number of examples of his work we find in many collections – experimented time and again with this form before he achieved this masterpiece. I will leave it to someone else, some day, to reconstruct what secrets Wilson found in this magnificent, monumental, challenging work.[2]

First, however, a couple of footnotes. I recently revisited the box on the same shelf in the attic, and pointed out to some of the curatorial staff that it was considered an important piece by Boas, Duff and, for what it was worth, by me. As a result, they decided it deserved a plastic bag to keep off the dust. So in its dark confinement, surrounded by many similar but lesser examples of its kind, it enjoys a kind of distinction. Perhaps because of this, it was chosen by Allen Wardwell for his recent show of Northwest Coast art, *Objects of Bright Pride*.[3] To us who have known and loved it for so long, whether it is relegated again to its attic obscurity or eventually given the permanent setting it deserves, it will always have that powerful inner glow that distinguishes true works of genius.

NOTES

1 *Boas 1927: 276, fig. 287b.*

2 *See, for starters, Duff's essay "Levels of Meaning in Haida Art" (Duff 1996: 172–184). Though it was published only in 1996, this essay was circulated privately in 1972. It gives some further insight into the intense conversations Duff and Reid had been pursuing since the* Arts of the Raven *exhibition in 1967.*

3 *Wardwell 1978 is the catalogue from this exhibition. The title,* Objects of Bright Pride, *was taken from Reid's 1967 essay "The Art: An Appreciation."*

# This Much We Can Understand

Art can never be understood but can only be seen as a kind of magic, the most profound and mysterious of all human activities. Within that magic, one of the deepest mysteries is the art of the Northwest Coast – a unique expression of an illiterate people, resembling no other art-form except perhaps the most sophisticated calligraphy. If it were the product of some great urban civilization, it would still have been an amazing creation, the result of a constant dialogue between a rigidly structured convention and the questing genius of the artists, controlled and amended by a cool, sometimes ironic intellect.

Being what it really was, the work of a handful of seahunters living in tiny communities, it exists as one of the most inexplicably dazzling facets of human creativity. It was made to serve the compulsive need to proclaim the power and prestige of the old aristocrats, a power which might extend in some instances over as many as a hundred individuals; and yet so strong was their conviction of that power that even today it radiates undiminished from the great works of the past, whether they be as exquisitely small as a goat-horn spoon handle or as monumentally large as a totem pole, or if you like, monumentally small or exquisitely large.

It is buried now, that old, powerful magic, under the wrinkled grey curtain of age, beneath the sterile canopy of the museum, the meaningless pile of words of the experts. But it is still there, as strong as ever, a renewing force for all of us if we can learn to use it. It can never give us what it gave those for whom it was created, the sure conviction of their own worth, but it can assure us, through its residual magic, of possibilities still attainable for us and our kind. With a little effort, this much we can understand.

*This short piece, written in 1981, appeared in toto in the form of a quotation, as the epigraph to Martine Reid's essay "Silent Speakers," in the exhibition catalogue* The Spirit Sings *(Toronto, 1987). It was reprinted as a prologue to the exhibition catalogue* All the Gallant Beasts and Monsters *(Buschlen-Mowatt 1992).*

# A New Northwest Coast Art:
# A Dream of the Past
# or a New Awakening?

*Reid delivered this lecture at a conference entitled "Issues and Images: New Directions in Native American Art History," held at Arizona State University, Tempe, in April 1981. The text began life, however, as a lecture called "Traditions of Northwest Coast Indian Art," at the University of British Columbia, Vancouver, on 23 November 1976. It has not appeared before in printed form.*

The first part of this paper is based on a talk I gave at UBC only a couple of years ago, and it's amazing to see how the scene has changed in that short time. I said then that in talking about the historical background of the Northwest Coast Renaissance, what we're really talking about is the transition in Northwest Coast art from the native society, where its function was largely ceremonial, to the present day, when what is made is intended almost exclusively for sale to the non-native community.

Well, this has changed, and today increasing numbers of objects are being created by the native artists to be returned as potlatch gifts, sold or traded items, or contributions to community life.

Putting that aside for the moment, it can safely be said that trade with the newcomers in native art objects began with the first contact and has continued. It didn't, however, assume much importance as long as the culture was more or less intact. In fact, the new wealth derived from the fur trade, combined with new technology acquired from the whites, led to a rapid proliferation of the art within the native population. There was demand enough to absorb the output of the numerous talented, hard-working artists – and apparently that of anybody else who wanted to contribute, judging from the many items, obviously made by untrained hands, that have come down to us.

That ended with the decimation of the population by the plagues, resulting in impoverishment, acculturation, Christianity and all those

other disasters, culminating in the banning of the potlatch, and the virtual extinction of the function of the artist within his own environment. This caused him to turn almost entirely to the outside world to dispose of his product.

There certainly was an economic need to manufacture things for sale, but I think there was also a need for the carvers who survived to continue to carve. It would be interesting if somebody attempted a study of the economics of the native art market in the last century, particularly as it concerned the fine and meticulous workers. In the matter of slate carving, for instance.

When I was in top form, to make one of the involved, multi-figured, twelve-inch slate poles I specialized in for a while took about three weeks of continuous work – say 120 to 150 hours. Assume I was terribly slow (and I don't think I really was), and that someone like Charles Edenshaw, who also made complicated carvings, and better finished than mine, was terribly fast and could do in a week what took me three. The going rate for slate poles was then twenty-five cents an inch, which meant a return of $3.00 for a week's carving, not counting the hundred-mile trip to get the slate and the travelling he did, usually to the mainland, to sell it. Was this then ever an economic endeavor? Or was it merely a kind of self-justification, subsidized almost entirely by the fishing, gathering, and sometimes wage-earning activities of his family? It would be interesting to find out.

It should be noted as well that many of the most intricate and time-consuming things he made, such as all those carved canes, are things he gave away. It's an enigma to me. The only explanation I can offer is that he, and others like him, were artists and had to make art.

Now that the Edenshaw name has come up, we might as well continue with him for a moment, as his career is pertinent to any discussion of Northwest Coast art. He gave up carving because of ill health in 1913 and died in 1920.[1] His excellence as a designer and craftsman

*Solitary Raven:*
*The Selected*
*Writings of*
*Bill Reid*

was not even remotely approached among the Haida until quite recently, and his preeminence as an artist living between the white and native worlds remains, and probably will remain, unsurpassed. He was the last great Haida artist in an old, unbroken tradition, and after him the deterioration of that line was rapid.

From the latter part of the nineteenth century through to the present day, native manufacture of goods for the curio market has proliferated, and most of it has been bad. The carvers were paid next to nothing, which may have impelled them to give as little as possible, but the unerring instinct of the curio dealer – and his modern counterpart, the boutique operator – to unflaggingly seek out items in the worst possible taste and of the worst design, probably played a part.

There were a few flickers of life here and there. The Kwakiutl continued a little clandestine potlatching, which involved some equipment. Willie Seaweed[2] created his masterpieces. Men like Charlie James[3] brought a certain skill and some design sense to the curio items they made. And of course the ladies kept on making beautiful baskets and knitting fine sweaters and generally demonstrating the excellence we all know they possess.

On the Charlottes, there was some adequate slate carving, and a few old men – John Cross, Tom Moody, John Marks, and my grandfather, Charles Gladstone[4] – were making some quite nice bracelets.

But it was pretty bleak. When I first got interested, the only person I knew who was making an attempt to keep the art alive and make a living from it was Ellen Neel, Charlie James's granddaughter, who gained a certain local reputation and a little fame but nearly starved to death doing it. In fact, her early death was probably attributable to overwork and malnutrition.[5]

That brings us to the 1950s, when the big change started and the urban factor began to dominate.

Harry Hawthorn, head of the Department of Anthropology at

UBC, had brought Mungo Martin to Vancouver from Fort Rupert, giving him for the first time since his youth the opportunity to work steadily as a carver. I'd just arrived back from Toronto with my brand-new jewellery-making skills and started exploring the structure of Haida art. That really meant copying old designs from the books which were just then becoming available: Alice Ravenhill's little Provincial Museum pamphlet, Inverarity – the first attempt at a coffee-table publication – and Barbeau, who released in short order *Totem Poles* 1 and 2, *Haida Myths,* and *Haida Carvers.* None of these publications was a great example of scholarship, but they did provide a sufficiently wide selection of photographs of Northwest Coast art, which I and a few others could pore over by the hour and attempt to reproduce – so that eventually we could unlock the secrets of the ovoids, formlines and so on which were later to be codified and described by Bill Holm in his now classic study.

A sad young man named Pat McGuire was drifting back and forth between Vancouver and the Charlottes, carving slate and trying his hand at drawing and painting.[6] And down south in Seattle, Bill Holm was commencing his fantastic career.

These forces, all of which were probably necessary to bring about the current spate of carvers and carvings, for some time operated quite separately from each other.

Mungo went off to Victoria and gave rise to the southern Hunt dynasty by bringing with him as his assistant his son-in-law, Henry Hunt, and Henry's children.

As for me, I rather slowly, but I won't say painfully, because it was not in any way a painful process, found my way, largely through making jewellery, to some kind of understanding of the basic structural forms of Haida art. I got to know Mungo Martin and Bill Holm and was privileged to work with Mungo for a couple of weeks in Victoria. That was my only training in woodcarving – and because my interest

was in Haida art, I didn't learn much from him. I found that Bill was also working on determining the underlying principles of Northwest Coast art, particularly the northern style, which eventually became his very important book. We did, I think, reinforce each other's findings. At least, he and his book have been very helpful to me.

I never really had any students, but people did drop around from time to time to see what I was doing, and the techniques I had learned, particularly for engraving, eventually drifted back to the villages and are now almost universally used. The old techniques – used by Edenshaw, Cross and my grandfather, for instance – have entirely disappeared, and now it's accepted as traditional to do things the way I used to do them.

Pat McGuire also worked alone, far too much so. He undoubtedly had a lot of talent, and he reintroduced into slate carving something it had lacked for many years: the concept of precise work and fine finish. I think he operated too far from the source of his artistic tradition, trying to reinvent forms rather than building on the works of the past, but he was a significant factor. He directly influenced Pat Dixon and the Lightbown boys,[7] who seem in turn to be a dominant influence among the current Masset carvers, who are turning out some quite remarkable pieces.

Quite separate from that group of carvers, because he's somewhat older, is Robert Davidson, who is really one of the more remarkable phenomena of the whole movement. While still a teenager in Masset, with no examples except his father and grandfather – who with all due respect were and are not the world's outstanding artists – he managed to produce slate carvings of considerable craftsmanship and aesthetic value. He lived and worked with me for a year or two in the mid sixties, but he was never a student or apprentice of mine in any way. I showed him a few basic things, but he was always his own man and for the most part found his own way.[8]

At this point, a new and very powerful influence appeared, with the formation of the 'Ksan project in Hazelton. It began, as I understand it, largely as an effort to revive the once flourishing arts and crafts of the Skeena River, as a means of giving the native people in a depressed area an opportunity to improve their living standard and morale. The art, however, was in a terminal state of health, with virtually no resources in the area to be tapped. So instructors were brought in from outside. I was supposed to go but went to Europe instead,[9] so Robert Davidson went – and Doug Cranmer and Bill Holm and Tony Hunt and just about everybody you could mention, including Duane Pasco. They all had their influence, but it seems to me that Pasco was the one that really made the big impression. So we have the peculiar situation of a new Gitksan artform based on the work of a somewhat Cherokee from Seattle.[10] 'Ksan a few years ago seemed to offer some exciting promise but now seems to have stabilized into a few successful commercial careers and a flourishing tourist facility, without much interesting artwork being produced.

With the rebirth of the potlatch, particularly among the Kwakiutl, there has arisen a great need for new regalia, which may bring us back to where it all began.

So what is the state of the art at present? Let's forget about who is Indian and who isn't, and just see what is being made. In Seattle, the tribe is producing at a great rate – Pasco filling commercial commissions, Steve Brown building canoes and doing restorations, Bill Holm finishing his gem-like little Haida house in his backyard and greeting every part of it with lavish ceremonial. Bob Davidson is outside Vancouver, I in the city, Gerry Marks in North Vancouver – long-displaced Haidas continuing to be encouraged in our little games. Joe David and Ron Hamilton are operating close to home on the west coast of Vancouver Island. In Victoria, the lower island clan of the Kwakiutl work away and have exhibitions here and there and run their store.

There are potlatches every year, and lots of paraphernalia is needed for those. The 'Ksan factory ticks along, and an increasing area of the earth continues to be covered with formlines and ovoids. On the Charlottes, young men with a rudimentary knowledge of the trade are actually growing rich grinding out bracelets in silver and gold not only for the tourists but for their fellow Haidas.

So what does it all mean?

Well, it means a pretty good and, more important, enjoyable way of making a living for quite a few young people, and for some not quite so young. It certainly gave status to a group who badly needed it and would never have found it in jobs their educational backgrounds had prepared them for. It demonstrated once and for all that the trouble with Indian education is not the Indians but the system, because, whatever I may say about it, it does require a considerable amount of ability and intelligence and motivation to produce an acceptable object for sale.

Most important perhaps, it has opened a new means of communication between the white and native communities. The native can say through his work, "Look, I'm capable – because I'm a native, not in spite of it – of producing something that you as well as I can recognize has value." And the non-native can respond by admiring, purchasing and cherishing it. All of that is very positive, and I don't for a moment regret my part in bringing it about.

And yet, doubt nags.

Is it, as Wilson Duff used to say, an artform in search of a reason for its own existence? A medium without a message? Is it all form and freedom and very little substance?

It's very easy, and perfectly correct, to say, sure, most of it is. The boys have learned all about ovoids and formlines and primary and secondary and tertiary areas from Bill Holm's handy-dandy, do-it-yourself Indian art book, and they can apply them to anything.[11]

That's okay. It's what we should expect. But I feel that the artists are feeding too much on themselves, losing touch with old forms. And on a deeper level, losing touch with the animals and monsters who inspired those old forms. And most of all, at the very deepest level, in too many cases, they are concealing rather than illuminating the essence of the man who's making the object.

That is the great value of the fine works from the past, that across the decades and enormous cultural gulfs, the artists who made them can still speak to us, not only of their people but of themselves as individuals. They can still display a fragment of common humanity to which we can respond.

That, somewhat updated, is what I said and how I ended a couple of years ago. Since then, something which I suppose was already present has become much more obvious, at least to me. It is the way in which practising their version of the old arts has begun to affect every aspect of the carvers' lives, and almost as directly, the way it has begun to affect the existence of their people, there in their home villages.

I myself was caught up in it sufficiently to return, after a couple of generations away, to Skidegate, to spend nine months carving a pole for the village. This, and the building of the new Band Council House in the form of a traditional structure, brought a need for a big celebration. And this in turn required the making of innumerable button blankets and headgear, and an attempt to relearn old songs and dances.

When this affair was over, all this regalia and learning became surplus, so more occasions were contrived to activate it again. Two or three feasts for various unprecedented reasons took place in the same year.

The unveiling of Robert Davidson's Charles Edenshaw Memorial House in Masset, and later the completion of the interior houseposts,

were accompanied by the closest things to potlatches the Charlottes have known for a hundred years. Other carvers – Joe David and Art Thompson, for instance – have given potlatches. Ron Hamilton plans one for this October, and Bob Davidson is preparing for what promises to be a truly grandiose affair by any standard, to take place in Masset this November. To prepare for this, he's learning as many songs and dances as possible and indoctrinating his family, even attempting to learn the language, and creating a massive pile of potlatch gifts to be distributed – twenty or thirty individually painted drums, dozens of silver bracelets, beautifully made soopolallie spoons. Thousands of hours of painstaking work.

The immediate impulse is to stand up and cheer. People keep trotting out phrases like *Renewal of the Culture! New Pride in Native Heritage! Revival! Revival! Revival!*

I can't quite buy it.

First, I don't think the culture is being revived. The extended family, which was its basis, has just about disappeared. Parents aren't even absorbing the unplanned offspring of their children. I can speak only of the Charlotte Haidas[12] – although friends from other areas tell me it is much the same there – but among them the language is almost gone, hardly anybody knows their family name or crest, and the dances are at best improvisations on old memories.

The graphic and plastic arts could have been reinvented by anyone with the time, interest and ability. All the evidence was there, in the books and the museums. There was no magic about it, and yet we who practise it have become, in the eyes of many of the people, magicians. I've heard many times statements such as "You've given us back our culture" and "We can be proud of being Haida again." A young man said to me, "Gee, if I wasn't a Haida, I wouldn't be anything." But the sad truth is that being a Haida didn't make him anything more

than he was before he realized he was one. He was still unemployed, unskilled, uneducated in any culture, and still alcoholic.

We're not magicians. We're just people who make our living in a peculiar fashion, albeit a very pleasant one, for which we are now admirably recompensed. The pole I carved for Skidegate was intended as a memorial to the Haida of the past, not an attempt to turn the clock back. If the present-day people want to indulge in occasional bouts of pageantry and celebration of their ancestors, that's quite fine, and god knows there's little enough to do in some of those places. But after the celebrations are over, the real world's still there, and the enormous problems it presents to native people are still to be faced. Before they learn Haida, perhaps they should learn English, which is the language they're going to have to live with, and which their kids will have to have if they aren't going to be failures from the day they enter school.

The best way for the current generation on the coast to honor their grandparents and great grandparents would be to emulate their wonderful flexibility and adaptability: the qualities that saw them, when their world lay about them in a shambles, set about building a new one, with Victorian houses complete with gingerbread trim, modern planked fishing boats, as good in their time as any made anywhere, and community halls designed and built by themselves, that still stand and function after a hundred years.

The dominant powers systematically destroyed that initiative. But if any of it remains, I think it's the only hope for the native people.

As for me and my kind, perhaps we should be regarded as what I myself have almost become: another museum exhibit, to be referred to when it seems necessary to reestablish some connection with the past.

I'd like to hear a young man or woman say, "Those old Haidas – or Kwakiutl or Tsimshian or what have you – were really something. Not

through any divine right but because of the things they did." And I'd like to hear them say, "I'm a not inconsiderable somebody too. Not because I'm Haida or something else, but because I've also done a few things."

Many years ago I attended a meeting of the Native Brotherhood in Alert Bay. The CBC was there and wanted to record some native songs, so some of the men sat down in a row and began to beat a rhythm on a piece of plank and sing. The Indian Agent came along about then and shouted at them to stop that foolishness. They knew they weren't supposed to carry on like that, and like obedient children they stopped.

Now the situation has been reversed. And like a kindly, indulgent parent, the dominant society says, "You go right ahead with your quaint game. And not only will we not punish you, but we'll give you a couple of half-hearted cheers and even join in now and then." And again, like good children, they obey.

Let's by all means keep the fun and games, but let's recognize them for what they are and get on with the business of finding a way out of the horrible morass in which the majority of the native people are trapped. I don't think the route follows the dust-covered pathways of the past.

1 *Reid often gave Daxhiigang's (Charles Edenshaw's) death date as 1924 – understandably, since that is what is written on his headstone. But according to Daxhiigang's daughter Florence Davidson, he died at Masset on 10 September 1920 of tuberculosis, and the headstone (which says 12 September 1924) is in error. (Cf Duff n.d.2: 4-1.)*

2 *Willie Seaweed or Sewid (Hiłamas, Kwaxitola, c.1873–1967) was a Nakwoktak headman, carver and storyteller, born in the village of Tigwaxsti (Kequesta) in Nugent Sound. He lived most of his life in the village of Ba'a's (Paas) in Blunden Harbour. Bill Holm has published two fine studies of his work (1974, 1983). His surname, anglicized to "Seaweed," is actually derived from the Kwakwala verb sixw'id, "to paddle."*

3 *Charlie James (Yaqoglas, c.1867–1938), who was born in Port Townsend, Washington, and lost most of one hand at an early age, nevertheless became the preeminent carver of his time in the Kwakiutl community of Fort Rupert. He was the stepfather and teacher of Mungo Martin and the grandfather and teacher of Ellen Neel. (Nuytten 1982 includes a brief biography.)*

4 *John Cross (Ngiislaans, c.1858–1939) was raised in the village of Xayna (on Maude Island, in Skidegate Inlet). Toward the end of the 19th century, he moved to Skidegate Mission, where he made his living largely by fishing and carving. Bill Holm has written a short but useful analysis of his style (pp 192–193 in Abbott 1981). Tom Moody (Gitkun, c.1872–1947) was a Skidegate carver and in later life hereditary headman of the empty village of Tanu. John Marks (Ihldiini, 1882–c.1950) was a Masset carver who spent much of his life in Prince Rupert. Charles Gladstone (1877–1954) of Skidegate trained for a time with his uncle, Daxhiigang (Charles Edenshaw). The famously haphazard and unreliable Marius Barbeau wrote about all four of these carvers and published photos of their works (Barbeau 1957: 104–107, 123–129, 130–135, 199–203).*

5 *Ellen Neel (Qaqaso'las, 1916–1966) was probably the first woman on the Northwest Coast to carve a totem pole. Trained by her grandfather and by her uncle, Mungo Martin, she was reputedly an able carver by the age of twelve. In this respect, she represented to Reid the power and effectiveness of the old, indigenous educational system — yet in the new, colonial world, the only outlet for her skills was the tourist market. She opened a studio and souvenir store in Stanley Park, Vancouver, in 1946. She left this business during the summer of 1949 to repair and restore several poles for UBC but then returned to carving for tourists and filling commercial commissions. One of her poles (originally carved for a shopping*

centre in Edmonton, where it suffered considerable damage) is now in Stanley Park. She died in Vancouver at the age of 49. (Nuytten 1982 includes a brief biography.)

6  Patrick McGuire (1943–1970), a talented, hard-drinking and short-lived Haida carver and painter, worked in Vancouver in the 1960s, chiefly in argillite and watercolor. A good selection of his work is now in the Royal British Columbia Museum.

7  The Skidegate carver Pat Dixon (1938– ) worked with McGuire in Vancouver in the late 1960s. "The Lightbown boys" are Greg Lightbown and his brother Henry of Masset.

8  Stewart 1979b, Thom 1993 and Steltzer & Davidson 1994 are studies of the work of Robert Davidson (1946– ).

9  The 'Ksan Indian Village, now a large exhibition and performance facility near Hazelton, BC, was not officially opened until 1970, but some of its components – including the Kitanmax School of Northwest Coast Indian Art – began operation in 1968, the year that Reid shifted his base temporarily to London.

10 Duane Pasco, a Seattle commercial artist, has frequently adapted or impersonated the idioms of native Northwest Coast art. The Disney-esque, pseudo-Haida illustrations in Eastman & Edwards 1991 (a disappointing collection of Haida language texts dictated in Seattle by Lillian Pettviel) are representative of his work. The suggestion that he might be of Cherokee ancestry – now easily misinterpreted as a slur – began as a relatively friendly and, indeed, protective joke. When Pasco began to teach native students at 'Ksan, questions were inevitably raised about his own affiliations. These were answered with suggestions from his native friends and colleagues that he might be "a little bit something – maybe Cherokee." Underlying the joke is the fact that a craftsman and performer known as Lelooska – billed as an adopted but absentee Kwakwa̱ka'wakw of Cherokee descent with a Nez Perce name – was then working in Seattle, industriously replicating and adapting older artworks from the Northwest Coast. Reid's concern was not with the pedigree of the artist but with the pedigree and genuineness of the art.

11 The concerted misuse of Holm's book by the souvenir trade is documented by J.C.H. King, pp 81–96 in Mauzé 1997.

12 "The Charlotte Haidas" are the Canadian Haida, as distinct from the Kaigani or Alaskan Haida – descendants of the Haida who emigrated from Haida Gwaii to southeastern Alaska in the 18th century

# The Components of the Formline

In his masterful study *Indian Art of the Northwest Coast: An Analysis of Form,* Bill Holm not only recorded the results of his research, which led to the discovery of the principle of the classic northern style of Northwest Coast art, but also provided us with the terms by which we could describe it. Foremost among these terms is "formline," an almost perfect description of the essential ingredient that makes the art of the Northwest Coast aboriginal people the unique thing we recognize it to be.

Since the publication of Holm's book, little more has been written, so far as I can determine, on the nature of formline art, although much of the art itself has been created by the carvers, painters and printmakers of the last two or three decades. As one of these practitioners, I would like to take a somewhat different approach, and perhaps add a little to the understanding of this extraordinary artform.

I find that the concept of the formline, though apparently quite simple, is one that is hard to impart to the uninitiated. This, then, is my attempt to communicate what I have learned about formline art over the past three decades – using Bill Holm's terms where applicable but giving them my own personal interpretation. I hope that it brings further understanding of this unique form of expression to students of all kinds: native students who wish to learn the arts of their ancestors, or those who wish a further appreciation of this art, or museum personnel and collectors who wish to have a further knowledge of the subject.

I think that without an understanding of the principles of the formline, an understanding of the art of the northern Northwest Coast –

*This piece apparently began, about 1980, as a set of notes for a workshop or lecture-demonstration. About 1982, after giving the lecture more than once informally, Reid started to revise the text for publication, but the only extant manuscript breaks off before reaching its conclusion. I imagine that conclusion, if we had it, would hinge on a statement like the one I heard him make in the course of a conversation in 1985: Formline art is art "in which the line that defines the form is the form."*

that is, the art practised by the Tlingit, Haida, Tsimshian and Heiltsuk people – is impossible, and even an appreciation is very difficult. As well, without this understanding, any attempt to recapture the spirit and vitality or even the form of the old art in contemporary efforts is bound to fail. It is extremely unlikely that, without an understanding of the formline, even a careful tracing of a classic design can recapture its dynamic flow and its restrained tensions.

The formline principle is as hard or perhaps harder to describe than it is to discern. And its rediscovery by such people as Bill Holm and myself in the 1940s and 1950s is so recent that most of those who profess to understand it have different ideas of its nature and its distribution. Even Bill Holm, who first used the term and who describes it elegantly, fails, perhaps, because he limited himself strictly to an analysis of the form. I shall try here to provide a definition. It will probably lack considerably in conciseness but may eventually lead to a concise, clean statement.

First, I believe that formline art is the graphic and plastic expression of the mythological iconography practised during historical times – and according to archaeological record, for many centuries before that – by the accomplished male artists of the Tlingit, Tsimshian, Haida and Heiltsuk linguistic groups. And I would state categorically that this system of expression is absolutely unique to them, without any comparable form existing now or (unless new discoveries prove otherwise) having existed at any other time among any other people.

Now, this uniqueness lies not in the matter of bilateral symmetry, nor the depiction of inner as well as outer anatomical details, nor in the use of joint marks or the excessively exaggerated size of some anatomical features, such as heads, eyes, paws and teeth, nor even in the distortion of the image to make it fit the field. All these are characteristics of Northwest Coast art, but all are found to some degree in other forms in other parts of the world. To my way of thinking, the

unique feature of Northwest Coast art is the formline, and for the moment at least we will consider that to mean what Bill Holm calls the primary formline. This, I think, could be described as an image conceived by the artist to consist of a cluster of discreet forms, arranged so as to suggest more or less obviously the creature depicted, and connected together to make a harmonious pattern.

These forms are circumscribed by conventions with a history which we can now only speculate about, but they undoubtedly grew up over a long period of time, and during the period with which we are most familiar – the late eighteenth and nineteenth centuries – they became stabilized, I think, as four recognizable shapes. These in turn, I think, can be shown to have been derived from one essential device which in itself is an expression of a simple universal artistic concept: the depiction of stress or tension and its release.

For purposes of this exploration, however, we shall assume that there are four individual shapes to be considered.

The first and best known of these is the *ovoid*. This can of course be much better illustrated graphically than verbally, and I have done so in the attached illustrations. The ovoid can, however, be said to be essentially an oval form, distorted in such a way that one of the longer boundaries is flattened to make a sort of base. This flattening can be merely a slight variation on the convexity of the opposite boundary, or it can be pushed far enough to make it a straight line, or even, in some cases, a concavity in the outline. It is this distortion of the oval that allows it to become an ovoid, or I should say, an ovoid *shape*. To become an *ovoid*, at least as I understand it, the shape has to be outlined by a variable line, heavy on the convex longer boundary and tapering in both directions through the shorter, more acute curves, and becoming further diminished on the flattened long boundary.

The second shape used as a component of the formline is, as Bill Holm calls it, the *U-shape*. That pretty well describes what it is. Each

OVERLEAF ▶
Demonstration drawings and collages made by Reid and photographed for projection in the lecture hall, circa 1982.

terminal point of the U is relatively thin. Both lines expand as they move toward the base of the U, coming together at their widest point.

*Dog Salmon.* Serigraph. Image 47 cm long, 1974. Original in black and red.

The third necessary component is what I will call the *connective.* I do not believe it is treated in Bill Holm's book, but perhaps I have missed it. In any case, it is a tapered line, starting and ending in a point, with its heaviest part toward the centre. It can be straight on one edge and consequently convex on the other, or it can be concave on one edge and still retain the convex shape on the other. Its purpose is to connect one rounded form to another – whether they be two ovoids or an ovoid and a U-form – and to provide a transitional channel to carry the flow of the design from one segment to another.

The fourth and final element in the design I would call an *extension.* It occurs only where it is necessary to transform the usually rounded shape of a U-form into a point, such as on the tips of feathers. It could be described as being roughly a triangle, connected at both points of its base to some rounded form, and having one straight side and one concave side. There is either a triangular or half-moon shaped separation between it and the rounded form to which it is attached. I think, however, that it can be broken down into even simpler components: i.e., two tapered lines, connected at the apex of the triangle, which is the point farthest removed from the rounded form for which it is an extension.

Rough sketch, ink on acetate, mounted by Reid for direct projection as a 35 mm slide, circa 1980 (enlarged).

[ 177 ]

# The Legacy

"The Legacy" was the
title of an exhibition of
native art first mounted
in 1971 at the British
Columbia Provincial
Museum. The exhibition
travelled for more than a
decade. A catalogue was
finally issued in 1980,
and in 1982 the show was
installed at the UBC
Museum of Anthropology.
At this stage, art critic
Marnie Fleming reviewed
the exhibition for the
Vancouver Art Gallery's
magazine Vanguard.
This is Reid's response to
that review, published in
Vanguard late in 1982 as
"The Legacy Review
Reviewed." Details of the
dispute have ceased to
matter, but the principles
remain. I have abridged
Reid's text with these
in mind, but the elliptical
conclusion is his own.

I had intended to write my own rather scathing review of the *Legacy* show, but my natural penchant for procrastination overrode my good intentions, and now I find it more imperative to reply to Marnie Fleming's published criticism than to write my own.

Miss Fleming's criticism seems to centre on the failure of the planners of this exhibition to provide historical, social and functional settings for the objects displayed, and particularly to relate them in some way to the tragic events resulting from the occupation of the coast by outsiders during the last couple of centuries, and the dreadful circumstances in which so many of the native people find themselves today as a result of that incursion.

I think that – far from supporting this opinion – all but the most obsessed militants in the native communities would resent deeply any attempts to use their arts, past and present, as supports for an aggressive propaganda campaign to air their grievances.

Rather, those who think of them at all look on the old pieces as symbols of the rich lives their ancestors enjoyed, as standards of achievement which they would like to emulate – most by attempting to find places for themselves in the wider community, and a few by continuing the old traditions. In this way of thinking, the arts can be considered weapons, but weapons to destroy prejudice and ignorance with the sharp edges of their own integrity, unassisted and unencumbered by superfluous rhetoric.

This exhibition, rightly or wrongly, is presented as an exhibition of art and therefore should be treated as such. That is, the works should be allowed to make their own statements, to communicate on their own terms. If they have no message for the aware, sensitive, informed

individual of today – no signals strong enough to transcend time, space and cultural differences – then perhaps they are fit only to illustrate some didactic ethnographic treatise or a political polemic or, if you like, a fanciful adventure yarn.

I happen to believe this is an exhibition of art, and in many cases, very high art indeed. This art does employ a different vocabulary from that familiar to most viewers, and therefore some comment on its formal structure is relevant and helpful. Undoubtedly there were terms in the native languages by which the artists of the past identified the different elements of their art, but these have long since been lost and in any case would be meaningless to modern viewers, native or non-native. So we are left with the terms which Bill Holm so brilliantly created to describe these forms, previously unnamed in English, now the common language of all coastal peoples. These terms enable us all to much better appreciate the unique imaginative concepts underlying this great exercise in human creativity.

Of course it would be valuable to have a good background knowledge of these people, their history, their ways of life, their literature – as it is valuable in the appreciation of, for example, the Italian Renaissance, to know the history of those times. But that is not the function of an art exhibit; that is the role of the reference library. And the unfortunate fact of its deficiencies in good material on the Northwest Coast is the library's problem, not that of an exhibition such as this.

Consider the Haida chest. Its importance – to people of our own time, as well as, I firmly believe, to those for whom it was first made – is not so much in how it was fashioned or even in its function. All boxes were made in much the same way. Bent corners are an ingenious device, but once invented, relatively easy to employ, and any simple container would fulfill its function. The very formal elements which caused the chest to be selected for this show are what gave it its importance among the possessions of its original aristocratic owner.

Incidentally, chests like this were not used for food storage but for tasks commensurate with their richness: to contain ceremonial objects, and sometimes eventually as coffins for the highborn dead.

It is ridiculous to assume, because there is no word for *art,* as we use the term, in native languages, that the people of the past had no appreciation of the "formal" elements of their creations, that they had no aesthetic criteria by which to distinguish good work from bad, that they were not moved by excellence and beauty. Without an informed and critical public, the artists could never – in these societies as in any others – have produced the great works they did. This could be considered pure speculation – but I am old enough to have heard very old people, who lived in those times, tell of the ecstasy that would grip an assembly when a great work was first displayed. And they were careful to point out that it was not essentially what the object symbolized – the power and prestige of a chief and his family – but the essential quality of the work itself.

Miss Fleming complains that, in discussing "transitional" works, the curators have used the same "formal analysis" as they did when describing "traditional" objects. Well, why not? The transitional works were made by artists trained in the tradition: professionals who, as expert as these men and women were, lavished the same care and drew inspiration from the same sources, no matter who their patrons were – chiefs of the old order or outsiders of the new, or a new class of insiders. Many of Charles Edenshaw's bracelets were made for use by his own people, and often as engagement presents – a new custom but no less valid for that.

To speak of a "cooperative egalitarian effort" in reference to the Northwest Coast is to display either a complete lack of knowledge of the social structure of the region or else to have such a fixed romantic concept of tribal culture that the facts are obscured. The truth is that few societies were so rigidly hierarchical in their makeup, and the

whole impulse behind the art was the glorification of the dominant members of the societies. These members patronized the best talents, who became in every way individual, professional artists.

The answer to the question, *To whom does the Legacy belong?* is simply this: It belongs to any person who can respond to the essential universal humanity which exists at the core of any true creation of the skill of human hands – the imagination and intelligence of the human mind, the power of the human spirit. These qualities were certainly present in many of the artists of the Northwest Coast, who drew on them to form their creations. Perhaps even some of our present-day efforts have a little of the old universal magic. It would be good to hear if anyone thinks so, and instructive to hear if they don't.

In the meantime, about that unbelievably rotten installation, with its incredibly bad lighting and....

*Solitary Raven:
The Selected
Writings of
Bill Reid*

# Beasts, Monsters and Humans

I

*The first section of this text was written in 1982 as the foreword to George MacDonald's magnum opus,* Haida Monumental Art. *Reid's other contribution to that book was a series of ten highly finished drawings: a man, a woman and eight heraldic animals. He then produced a second set of ten more complex drawings, most of which show multiple figures in action. (This second set of drawings became in turn the basis for another book,* The Raven Steals the Light, *published in 1984.) Reid wrote part 2 of the present text when the two groups of drawings were exhibited at the Equinox Gallery, Vancouver, in January 1983.*

Some day, soon I hope, the native people of the Northwest Coast and members of the strange tribe who inhabit the groves of Academe will overcome the last of the mistrust and suspicion which have always lurked, sometimes hidden, sometimes overt, in their long relationship, and will realize how truly symbiotic it has been. Of course, the academics have always been totally dependent on the raw stuff of native culture to feed their word machines, but only recently have some of the native people begun to realize, as the older generations pass from the scene, taking their verbal recollections irrevocably with them, how dependent they themselves have now become on the words and pictures of the academic community for knowledge of their histories and almost forgotten cultural achievements.

This remarkable volume, assembled over the past two decades by George MacDonald, should provide a strong support for the bridge between the two groups, as well as an eye-opening revelation for the wider community. It is concerned entirely with the Haidas of the Queen Charlotte Islands of the last century, the intricacies of the kinship patterns of the great families, and how they saw themselves as part of a fantastic, but in its own terms logical cosmos, and most of all how this was all expressed in their remarkable architecture, with its perfectly integrated massive carved and painted embellishments, the great totem poles of the Haidas.

Today, where the villages exemplifying this style of life once stood, there are in the two remaining inhabited communities only clusters of sometimes neat and well-built, sometimes run down and untidy, uninteresting little conventional cottages and the inevitable mobile

homes. In the long-abandoned sites, a few corpses of decayed wood which were proud poles and massive house beams lie on or under mossy blankets, soon to be crushed completely by the slow march of the returning forest.

These would become mere memories of memories, images as faint as Atlantis, as remote from us as the lives of those who built and lived in them.

But there were those inspired, dedicated, stubborn, persistent eccentrics who painfully lugged the enormous, cumbersome, glorious pieces of equipment that were the early cameras to those still-remote shores, set them up and recorded what they saw so fully and accurately that today a skilled interpreter – Dr MacDonald in this instance – can reconstruct not only the physical façade of those distant times but also – adding his knowledge of the written records from those days and of the terrain itself – something of the nature of the people who lived there.

We can all find in these amazingly crisp images an immediately comprehensible record of the major accomplishments of the Haidas, who through their genius, ingenuity, dedication and energy, transcended their lack of numbers and their lack of sophisticated technical resources and organization, to make an outstanding contribution to the sum of human achievement.

Of course, when these pictures were made, the great days of the Haidas were already over. The occasional human to be seen was one of a tragically small remnant to survive the destruction of their people. What we see are the ghosts of villages, homes of ghost people. Even the great heraldic beasts, monsters and humans of the totem poles are now ghosts, as are the little figures I've drawn to greet you as you move from village to village in this book.

But what lively, powerful ghosts those old demigods still are – and the Raven at least seems alive, well, and waiting.

*Beasts, Monsters*
*and Humans*

These drawings originated with a commission from the University of British Columbia Press to provide decoration for the chapter headings of George MacDonald's *Haida Monumental Art*. The first idea was to provide miniature crest figures executed in the style of nineteenth-century Haida graphic design, in the traditional red and black colors – in effect, miniatures of the now familiar silkscreen prints. The book, however, is essentially a compilation of photographs, largely from the late nineteenth and early twentieth centuries, long before the advent of color photography. They are photographs of the then nearly or completely deserted, but still intact, Haida villages, with an accompanying text, the whole emerging as a creation in black and white and shades of grey. It therefore seemed more appropriate to use a similar palette for the illustrations. I had previously done some sketches for carved panels employing the shading technique, a European device unknown to the Northwest Coast, and I decided this might be an appropriate way to give some substance to the flat images.

The book is divided into chapters according to the villages. I thought to give the drawings black backgrounds with no borders, so that when they were printed, in quite a small scale, along with the chapter titles on otherwise blank pages, they would appear as if seen through apertures in the paper. What I didn't anticipate – it became obvious as they emerged – is that, because of the monochrome shades of grey and the isolation of the images, they seem, to me at least, to be ghosts of mythological birds, mammals, fish, monsters and humans. In this respect they differ from conventional depictions.

What finally came into being was a group of ten drawings, starting with a Grizzly Bear, then a Beaver, followed by a Wolf, a Frog, a Dogfish, an Eagle, a Killer Whale, a Man, a Woman, and finally the Raven, who seems to me to be much more alive than the others. These im-

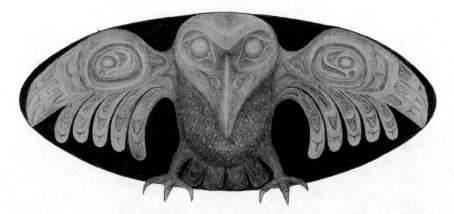

*The Cumshewa Raven* (from the *Haida Villages* series, commissioned for George MacDonald's *Haida Monumental Art*). Graphite on paper. Image 30 cm wide, 1982. Photograph by Kenji Nagai. Douglas Reynolds Gallery, Vancouver.

ages were assigned more or less arbitrarily to the different villages, conforming to the dominant crests where possible, with the humans representing the still inhabited villages, Skidegate and Masset.

I showed this set of drawings to Mrs Nichol,[1] who suggested that I exhibit them in her gallery, and perhaps add some more ambitious attempts in the same mode. These for the most part represent incidents from the myths in which the various creatures play their parts.

The first of the new series to be done shows, in the oval format, the two protagonists in the Bear Mother epic: the Bear Mother in human form and her husband in the form of a grizzly bear. As you can see, she is already pregnant, though for the purposes of the drawing she is carrying only one cub instead of the twins described in most versions of the myth.

The next drawing illustrates the legend of Nanasimgit and his wife, who was kidnapped by whales and later rescued by her husband. Then there is an incident in the Raven legend in which the Raven is swallowed by a whale, pecks his way to freedom, but makes the mistake of biting a fisherman's hook, which tears his upper beak off. Another part of the Raven story, which tells of his discovery of the first men in a clamshell at Rose Spit in the Queen Charlotte Islands, forms the subject of the next drawing, followed by yet another Raven episode, dur-

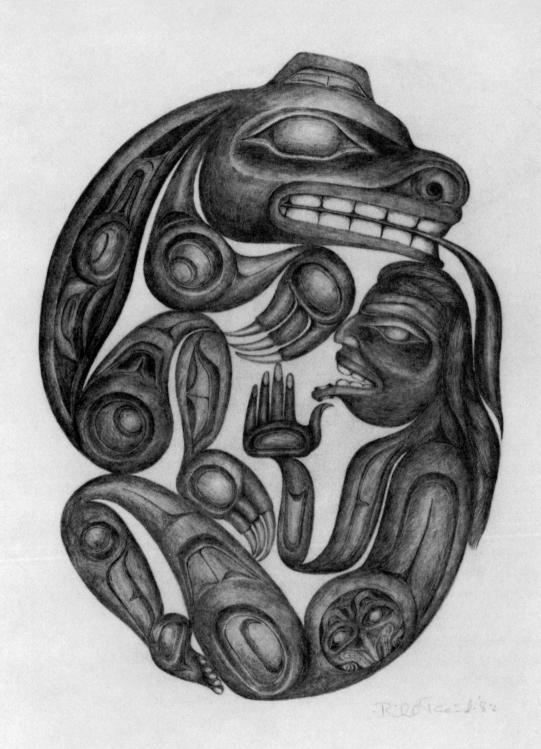

ing which he steals the lakes and streams and salmon from the house of the Beaver. The Sea Wolf, Wasgo, is shown next, having just captured and killed the three whales[2] which constitute his daily diet. Then there is the Raven stealing the light from the old man who kept it in the smallest of innumerable nested boxes in the house where he lived with his daughter, who became mysteriously pregnant with the Raven, and by giving birth to him admitted him into the house so he could carry out his plot. The Raven appears again in the next drawing, this time as the cuckolder of the Halibut Fisherman, who eventually has his revenge and casts the bird, beaten to a pulp, into the sea where he is swallowed by that whale and loses his beak. Then the Eagle appears with a Frog, with whom he is associated in many adventures, and finally the female shaman who derives her power from the Dogfish, shown here in the process of transformation, having both human and dogfish characteristics, with some kind of raptor features thrown in for good measure.

All in all, a good selection of bestiality, adultery, violence, thievery and assault, for those who like that sort of thing.

FACING PAGE:
*The Bear Mother* (from the series *The Raven Steals the Light*). Graphite on paper. Image 34 cm high, 1982. Private collection.

NOTES

1 *Elizabeth Nichol, owner of the Equinox Gallery in Vancouver, was Reid's dealer and agent at the time.*

2 *English has but one common name for all species of whales, where Haida has two. In classical Haida mythology, the whales who kidnap Nanasimgit's wife are killer whales or orcas (sghaana in Haida, Orcinus orca in Latin), while the whale who swallows the Raven, and the whales killed by the Sea Wolf, are toothless or baleen whales (kun in Haida). The toothless whales of the Northwest Coast include the grey whale and several species of rorquals or pouch whales, especially the humpback. In* The Raven Steals the Light, *Reid broke tradition, giving the Sea Wolf a diet of killer whales instead.*

# Curriculum Vitae 2

*This is an excerpt from a panel discussion held at the British Columbia Provincial Museum, 24 April 1983. The moderator was Peter Macnair, the museum's curator of ethnology. The panelists were Bill Reid and Kwakiutl artist Tony Hunt, grandson of Reid's teacher Naqap'ankam (Mungo Martin). This is a transcript of most, though not all, of what Reid said on that occasion. There is a capsule autobiography, then a response to two questions from the audience. The first was a request for his views on the issue of cultural exploitation; the second, a question about "whom the art is for."*

I came to this career quite late in life. I was 28 years old, and that's late to start learning a trade. Yet that's what I set out to do at that advanced age. But my relationship with Victoria is much more intimate than has been suggested. I was born here, to begin with, and most of the influences which were to shape my life were found here.

There was the Victoria Public Library, for one thing. It was one of the great libraries of the country at that time, when this town was very small. It had a wonderful, catholic collection, which I mined for many, many years.

And I suppose the second most influential factor in my life was the collection of the Provincial Museum, where I spent many hours. It was housed at that time in the basement of the Parliament Buildings, and it couldn't be called, by any stretch of the imagination, a display. It was all laid out in fine, old four-square cases, each piece cheek by jowl with the next, with elementary labeling. But it had that wonderful quality which old, traditional museums have. It forced you, if you were really interested, to seek out the exceptional pieces and come back to them time and time again. I still have a vivid memory of individual pieces as they were in that museum at that time. I have an idea that the lighting was unshaded incandescent bulbs hanging from extension cords, but I suppose it was a little bit more sophisticated than that. But you could see, if you looked hard enough, all the wonderful things that this museum contained then, and I spent a lot of time there, looking at those things.

I haven't got a particularly good visual memory, but I can still recall some of those objects. They were to be very influential later on, but at the time I didn't really know what I was looking at. I knew there

was something there, and I suppose the pieces were enhanced, or my feeling for them was, by the fact that the Haida examples came from the ancestral home of my mother, her home islands.

It took a great many years to find out why I was looking at them with that intensity – and that came a lot later, in a different setting. A very unlikely one.

The third thing that happened to me in Victoria – and this was not as beneficial as the others – is that I got involved in the radio business, through a radio station called CFCT.... That was a great radio station. It was a museum piece.... It was established by an elderly gentleman – he was elderly when I knew him; I suppose he was younger at one time – who became a radio station operator by sending his five dollars to the right authorities and buying some second-hand equipment from RCA. And we were too poor to buy tubes for the console, I remember, and we had to go down and buy second-hand tubes for twenty-five cents apiece when the console gave up entirely, and then it would operate only spasmodically, and we'd be in the midst of some, to us, deathless remark, and have to lift the lid of the console and pound on the top of the tubes to find the one that was not operating and hope that it would get back in gear.

You could become a radio announcer at that station by sitting in and radio announcing. You didn't get paid, but you did get a little bit of experience, and eventually it launched me on the most undistinguished career in broadcasting that one could ask for – and so it drove me into the arms of the jewellery business.

I got tired of sitting in a disused broom closet and talking to myself, which was the function I had at the Canadian Broadcasting Corporation, and one sunny afternoon in September in Toronto I was walking by the then brand-new Ryerson Institute of Technology. I suppose there was something that suggested you could learn things there. And I went in and tried to enroll in an engraving course, so I

could emulate my grandfather, who was one of the last in the traditional line of Haida silversmiths.

And particularly so I could emulate John Cross.[1] Up to that time, he really represented Haida art to me, because my mother and aunts had John Cross bracelets. They were the things I was most familiar with, and I thought they constituted the absolute epitome of Haida art, in spite of my familiarity with the material in the museum here.

Well, they didn't have a course in engraving, but they did have one in platinum and diamond jewellery-making, which seemed to be related in some way, so I enrolled in that and spent two years, still working for the CBC. And at the end of that time, I apprenticed to a couple of tough-minded Germans who ran a place called the Platinum Art Company in Toronto. There I got the only real education that I've ever had, I think.

It started the first day I was there. I had spent two years at Ryerson being the apple of everybody's eye, because I was pretty good with my hands. And I was older and able to produce more than my fellow students, who were just out of high school. It was the era of the cocktail ring, where you had great gaudy masses of jewels that just about covered your hand, and the boss had made three of these. He'd put the shanks on, but they were still unfinished. They were just square wire. I had to file them into a tapered, rounded shape. I thought this was pretty chintzy stuff for such an accomplished jeweller as myself, and I went off and spent about four times as long on the first ring as I should have – I learned that later – and took it back to the boss and sat there waiting for an accolade. He didn't look at me. He didn't say anything. He just picked up his saw and cut the shank off and threw it in the scrap. And I began to learn something about the jewellery trade. Three months later, I had learned to file shanks, and I went on from there to become reasonably accomplished at this.

Coming back to the coast, I really no longer had the idea of be-

coming involved in Haida jewellery. My direction had been changed completely. I wanted to become a contemporary jeweller, because I was interested in new architectural designs, new furniture designs, and all that sort of thing. It was really burgeoning then in North America. And I thought that it was a wide-open field: that there wasn't any good jewellery being made anywhere. About two people were making design jewellery, and everybody else was making the same old bow-knots and hearts and flowers that they'd been making for centuries and have continued to make to the present day.

*Solitary Raven: The Selected Writings of Bill Reid*

But when I got back to the coast and saw once again, more or less in their own setting, the Haida designs, I couldn't resist trying my hand at it again. I came back here in 1951, and I started making bracelets, and I went on from there. Using these techniques that I'd learned in the jewellery factory and the school, I was able to add a three-dimensional quality. This was attempted by the old silversmiths and goldsmiths of the Charlottes and other parts of the coast, but because they lacked the technique and the tools and everything else, they were unable to do it.

It was marvelous, you know. It's an absolute miracle that any bracelets were produced at all. I wish I had Charles Edenshaw's tools here with me. I would show you what they were like, because he re-invented, or somebody of his generation reinvented, the whole art of engraving. He had undoubtedly seen engraved pieces, but he hadn't seen anybody engraving. So he conceived of his own method, which was to take a big chunk of steel and sharpen it to a point. And instead of having this lovely ball that we engrave on, the engraver's block, and a nicely developed technique for pushing the graver – all that stuff which has been in use at least since the Greeks – he very painfully held the knife handle with this big chunk of steel and scratched away like this. I assure you that this is absolutely impossible to do. Yet you can look in the museum and see these beautiful, powerful bracelets which

Engraving tools made and
used by Daxhiigang
(Charles Edenshaw),
circa 1870–1880.
Private collection
(*cf* p 108).

he made – which I still think have…. Well, whatever you may add in the way of technique, you still can't get that power and grace of line and the flow of image that Edenshaw achieved.

The jewellery trade is a good thing to learn if you're going to get into the arts and crafts business, or whatever it is we're in, because it's hard work and you learn a lot of techniques. You have to make your own tools. You have to do a certain amount of woodworking. Most of all, you have to learn procedure. Everything has to be done in an orderly fashion to reach the finished product.

When I was asked by Harry Hawthorn to go to UBC and carve the totem poles, it was a great act of faith on his part – because my entire woodworking experience up to that date consisted of ten delightful days spent with Mungo in the carving shed here. I think my instruction consisted of Mungo saying, "Well, I'm going to carve here, so you carve there." And I made a fairly respectable job of the face of the little man held in the lower figure of the pole that's now at the Peace Arch.[2]

And then I went to UBC and carved the poles there, and it was a wonderful experience – a time out of time, as somebody once said. We were on the outskirts of the campus, which was then a farm with trees and a minimum of students. Doug Cranmer from Alert Bay and I spent three and a half years at it. I don't know what Doug felt about it. He was forced to work within the Haida tradition, and he sacrificed his own creative impulse to get the job done – and I'll be eternally grateful to him for doing so – but we managed to build the poles….

I've spent a lot of delightful time with these powerful old images. I hope I've remained true to them and to the spirit of them.

Now I'll show you a few pictures….

This is a mask, representing nothing. It's purely decorative. I haven't made very many masks, and I forget exactly why I did this one. I was in Montreal at the time. Robert Davidson was coming down, and he brought me a piece of alder, and I carved it up. But I have never

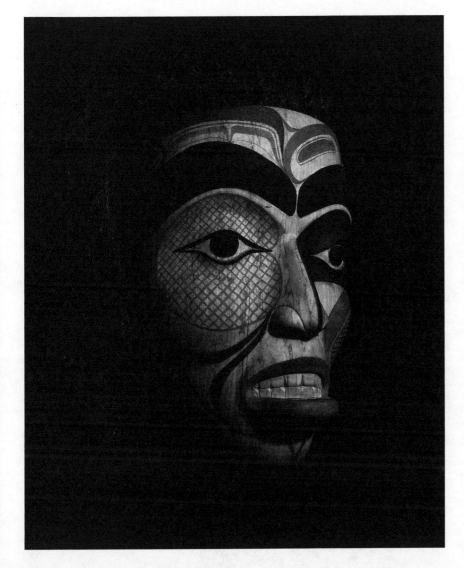

done masks or any other equipment for ceremonial use, because I've never been involved in ceremonies. I'm not a dancer, and my relationship to the culture of my people is in fact a very remote one. So this is a mask for the sake of being a mask, for something to hang on the wall. The face painting is merely a formal design. It represents nothing

*The Nanasimgit Door.*
Designed by Reid, carved
by Reid and Jim Hart.
Yellowcedar. 3 × 1 m, 1981.
Private collection.
Photograph by
Bill McLennan.

FACING PAGE:
*The Milky Way.* Necklace
with detachable brooch.
Yellow gold, white gold and
diamonds. 17 cm diameter,
1969. (There are 70 sheet-
gold pyramids linked by 30
tiny internal hinges. Floating
over these is a second
structure of gold wire. The
substructure and super-
structure together carry
more than 100 diamonds.)
Private collection.
Photographs by Bill
McLennan.

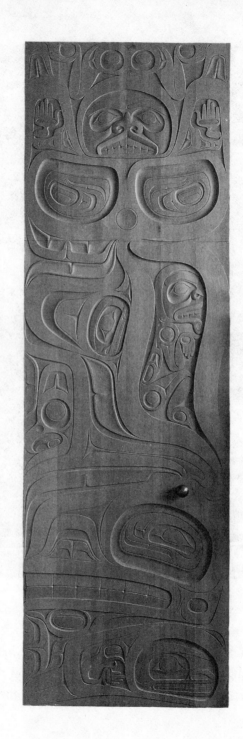

from the tradition. It was an exercise, you could say, in making a mask....[3]

This is a door for a house in West Vancouver. It's a rather obscure design, portraying Nanasimgit and his wife. The wife was captured by a whale, and Nanasimgit went down and rescued her. The door knob is positioned in the spout hole, and the spout hole, of course, is in the top of the head. The killer whale's eye is the big ovoid there below the knob. Toward the bottom of the door is the pectoral fin, which is displaced and rotated. The body is represented by two parallel curved lines flanking the figure of Nanasimgit's wife, who is identifiable as a woman by the labret in her lower lip. The dorsal fin projects toward the left, and the flukes are up at the top, with Nanasimgit peering between them. His hands are projecting from inside the flukes, and his wife is in the body of the whale. In the story, she was never in the whale, and he was never even close. But there comes a point in Northwest Coast design where the formal element takes over and you arrange things so they fit together visually....

Once in a while I stray from the straight and narrow into designs not apparently related to Northwest Coast design. But this necklace was inspired, in a way, by Northwest Coast carving.

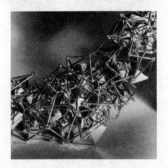

Looking at some of the old Skidegate poles, I notice that their carvers never heard of the law of physics that says that two objects cannot occupy the same space at the same time. They actually contrived to have two objects occupy the same space. In some of the Dogfish poles, the little watchman at the top is almost a part of the dogfish body, and the dorsal fin of the dogfish projects right through his body. Yet he isn't impaled on it. He just happens to have no other place on the pole to go, and so he has to occupy the same space as part of the dogfish.[4]

This is in a sense the same thing. It's really two necklaces, one made out of solid sheets of gold and the other made out of wire. They

intertwine and, I hope, complement each other to become a single object. This doesn't represent in any way anything derived from the Northwest Coast forms, but I would never have been able to conceive this necklace, nor to make it, without having worked in Northwest Coast design....

Haida culture has just about reached the end of its string, I'm afraid. There are strong attempts to bring back something of the feeling of it, but these are based, as I've said many times, on memories of memories. Maybe something new will arise, but the old ways are pretty well gone, particularly in Skidegate, which is the village I've spent most of my time in. I did have a friend when I was younger, Henry Young, who was a great traditional storyteller. He had learned a great many of the legends from his uncle, learning them word for word and having to repeat them exactly. So he was a repository of stories. He didn't speak particularly good English, and I didn't speak any Haida, so communication was slow, but I wish now that I'd spent a lot more time with him than I did. I must admit that for the most part now I go to Barbeau, Swanton, and all those other good Haidas for the stories that are there. I find that it's almost essential to have the story to hang a drawing on, or a work of any kind, because somehow it seems wrong not to have the proper creatures associated with each other in the physical rendering....

Are we involved in exploiting the culture? The question is one which has bothered me ever since I started doing this thing. It doesn't bother me very much most of the time, but it nags. I'm in the business of creating objects, borrowing from the work of my predecessors, with whom I have a very tenuous connection. I'm to all intents and purposes a good WASP Canadian. I look like one, I have the upbringing of one, I've never lived in native surroundings. I've visited a lot, and I know a lot of people and have learned what I can of it. All I can say is

that, a long time ago, the art got a hold of me and possessed me, and I've found it impossible to give up. I won't deny that I've made quite a lot of money out of it from time to time. That's something I hadn't really counted on. I thought that I could retire from the radio business to a little quiet world enclosed by the confines of my jewellery bench. And instead of that, it's taken me out into the public – much more than I would ever have achieved, no matter where I'd gone, in the radio business.

On the positive side, I think I have made a few good pieces. And I think that anything which contributes to the store of the world's well-made objects is not altogether bad. I've been able to combine these marvelous forms with the production of fine metalwork, to which they are exactly suited. By using them, I've been able to bring a richness of texture and form to silver and gold work that has been leached away, for some reason, in the normal work done by silver- and goldsmiths of European origin. And I think that, when done well, the Northwest Coast work not only equals the best of the old European gold- and silversmithing, but because the forms are so powerful and so vital, perhaps it even exceeds that measure.

So I have no regrets.

No: in fact, I regret a great many things that I have done; I would like to have them back and melt them down or run them over with a car or something. But the good things I don't ever regret having done.

I've been working within the tradition and doing it for purely selfish reasons. I love the sensuous quality of the metal, I love the designs, I love seeing something take form. And that's purely for my own benefit. And I have not been the least reluctant to accept the money that came from doing so. It's been a nice way to make a living. It's a lot better than working.

At the same time, it has led me, I think, to a deeper concern for, and perhaps a deeper knowledge of, the people – the descendants of

*Solitary Raven: The Selected Writings of Bill Reid*

the people who made these things. I've been able, in my mind at least, to put myself in the place of those old artists and imagine the impulse behind what they did and how they accomplished it. And through an understanding of them, I have come to realize what has been taken

away from the people, their descendants. I mean this marvelous facility with their hands, the marvelous facility with words, the totality of their culture, in which every one of them participated. Realizing the sad condition that so many of them are in today has impelled me to do what I can – to contribute in my own small way to that totality.

I don't think you can take the design and the art without taking the people as well. And I think when that is done – as it is in a city not too far away from us – you have completely empty images conforming only to the formal aspects of the art, without any feeling or any emotion behind them.[5]

I could go on, but I won't....

I think that great works of the human spirit, great works of creativity, belong to everybody – and that the legacy left us by the old people is as much the legacy of all of you here, and of everybody in British Columbia or everybody in the world, as it is of the descendants of those people directly. This doesn't apply, of course, to pieces that are privately owned. But much of the wealth is now in public institutions and will remain there. And I think it should remain there, so that the descendants of the people who made it can see it in a context where it can be shown properly, and the rest of us can see it as well.

If Lévi-Strauss is right – and I believe he is – that the art of this coast ranks with that of Greece or Egypt or with any of the high artforms of the world – then it deserves to be seen under the same circumstances. I think that all of us can derive inspiration, confidence, reassurance from these artforms.

The great pity is, we are sitting on an enormous treasure house, or

the remains of it, and it is given such minor recognition by the educational authorities, and by people who govern the art world.

It's as though we were living in Egypt and were being concerned only with what's being painted today. We should be devoting much more of our time and trouble to studying and publicizing this art, for all of the people of our community.

*Solitary Raven: The Selected Writings of Bill Reid*

NOTES

1 *For John Cross (Ngiislaans), see note 4, p 171.*

2 *This is the replica of Skedans 1, carved by Martin with Reid's assistance in 1957. It stands near the Peace Arch at Douglas, BC, where the highway from Seattle to Vancouver crosses the international border.*

3 *Three years before he made this mask, Reid was in London to study the British Museum's Northwest Coast Collection. The photos he took are now in the Duff files at MOA (Duff n.d.2: 28-16). There are more photos of masks than of anything else.*

4 *Skidegate poles 13, 23 and 29 are examples. Something similar occurs in poles 21 and 22. For photos of these poles, see MacDonald 1983: 47–54.*

5 *Plenty of ersatz "Indian art" is produced in Victoria, where Reid was giving this talk, and in Vancouver, where he was living. In mentioning "a city not too far away from us," Reid is referring in particular, however, to the "Seattle School": a group of artists generally not of native descent, and for the most part not involved with native communities, but working nonetheless in the native Northwest Coast idiom.*

Reid wrote his "Killer Whale Poem" in 1983 while he was working on his big bronze killer whale sculpture known officially as the Chief of the Undersea World. The sculpture – commissioned for the Vancouver Aquarium by James and Isabelle Graham – was unveiled in June 1984, and the poem – as rendered here by artist and calligrapher Marion Scott – was published by the Aquarium as a poster and in several other formats to commemorate the event. The killer whale figure at the centre, though based on a sketch by Reid, is plainly not his work. (Original in blue and gold.)

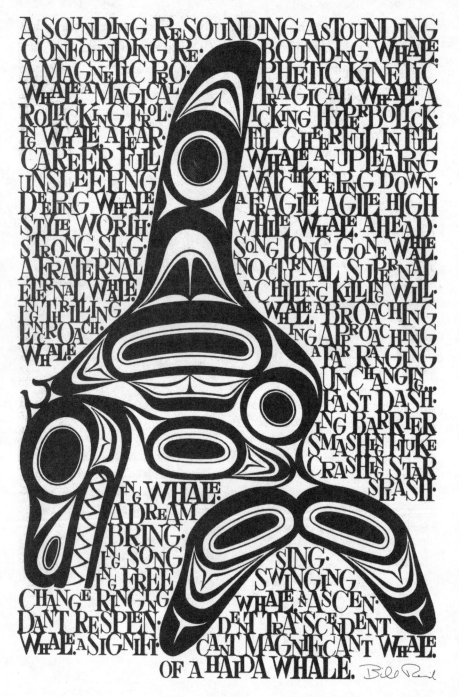

# The Anthropologist and the Article

Of all the subjects involving the relationship between the academic community and the native people of the Northwest Coast, past and present, this may seem to most the least significant and trivial: a bit of gratuitous nitpicking not worth the waste of anybody's time, even mine.

But something that has annoyed me so much for so long must have a significance warranting a few moments' investigation. Herewith, then, I will attempt to create a controversy where previously none existed, and if I accomplish nothing else, at least I can scratch a bit at this persistent little itch.

It is an itch caused by the, to me, peculiar custom which has arisen among ethnologists of omitting the article when referring to the heroic creatures who populate the mythworld of the Northwest Coast and capitalizing their English species designations: Raven, Halibut, Bear, etc., instead of the raven, the halibut, the bear, etc.

This strange practice is also followed in nearly all editions of emasculated, hygienized, colorless versions of already bowdlerized legends intended to give the very young their first lesson in misunderstanding the native people and their cultures – usually with bad illustrations to demonstrate that tribal art should look truly primitive and not all neat and complex and disturbing like those strange, smoldering things safely locked up in museums.

It is difficult to say where or when the first article-dropping occurred. Certainly in west coast anthropological circles it has some distinguished precedents. Swanton and Boas both use the device, and it is probable they were copying older models. So why should I or anybody challenge this time-honored usage? Well, I simply do not believe

*Written in late 1983 and published the following year, in issue 4.2 of the Canadian Ethnography Society's journal* Culture.

that being around for a long time necessarily gives respectability to a basic error. So with history effectively disposed of, let us consider my reasons for abandoning the practice today.

First, to be blunt about it, simply as a piece of diction, it sounds silly, as though the writer had spent too much time conversing only with young children.

Secondly, I have heard a lot of old people, native that is, talking about the mythcreatures, and they either called them by their native names or used the article. Their speech preferences should, I think, command enough respect to be followed by outsiders. Incidentally, some younger natives have copied the white man in this and in many other ways, copying the reflection in a flawed mirror, instead of trying to find the original source. Soon they will become the old people, and I suppose their misinformation will assume the integrity of Holy Writ.

The third and most important reason is also the most difficult to express. It has to do primarily with the origins of the practice, which lie well within the bounds of speculation. The practice may stem from a too literal translation from languages which do not use the article. This may account for Swanton using it in his strange translation into the kind of pidgin, certainly not English, which he used, hardly changing his initial word-by-word renderings. In this case, omitting the article neither adds nor detracts from the rest of his quaint translations, but why do writers, when adapting these writings and those of earlier recorders of myths, retain this peculiar error?

I think it is much more than a mere matter of style. It may have to do with what I have come to think of as the *Brer Rabbit* error or, if you like, the *Winnie the Pooh* fantasy. In these classic stories, which formed an important and, on the whole, I think, positive part of my literary childhood, you will find lots of characters called Chicken, Rabbit, Bear, etc. It may well be that the unfortunate habit of confusing true myths with children's fairy tales, usually in order to exploit them for

the juvenile book market, is responsible. I find these explanations unsatisfactory, but they may be part of the real reason.

The usual excuse given is that removing the article and capitalizing the species somehow enhances the mythological status of the creature referred to. It has even been said that it puts such a being in the same class as God, who needs no modifier, indeed who cannot be modified. Of course the reference is to the good, old Judeo-Christian God, the god of most anthropologists, or at least of their parents. (Notice that as soon as you have to describe even Himself from a position somewhat removed from his special status, you have to use the article, and of course all other gods require it, e.g., the gods of the Aztecs, a god of Olympus, etc.) In any case, whatever He may or may not be, God is not a species of animal.

On the other hand, even classic European monsters seem to deserve the article. For instance, the Minotaur is always the Minotaur, not some mixed-up fellow named Minotaur. Furthermore, the use of the definite article to confer special status has some good precedents, as in "The Stuart" to designate the head of the Stuart clan, and even in regard to animals, as in Kipling's "The Truce of the Bear," where the Bear is treated as an archetype of the species.

Even the use by anthropologists is inconsistent. For instance, in all English versions of the story, Nanatsimget's[1] wife is carried off by a whale. Why then, when referring to the same whale on a totem pole, do they say something like, "The next figure on this pole is Whale"? In the great Northwest Coast epic, the Bear Mother myth, there are many bears, each one having some kind of role analogous to a member of human society: a bear chief, a bear prince, etc., later to become the bear father, bear guards, and so on. And by extrapolation, and probably in the older versions of the myth, they had names, even as their counterparts, and I am sure not one of them was called "Bear."

A well-known Kwakiutl myth begins, "Once there was a Raven

named Hemaskyaso."[2] Personally, I believe it shows much more respect and immediately indicates the extraordinary status of the mythcreatures to designate them with the definite article and, if you like, to capitalize the species name. The Raven *must* be the raven of mythology, not just another bird. In mythtime, the animals were the equals of humans, and the latter are always referred to with the article present: "A man named Nanatsimget"; "A woman was picking berries." If "Raven was flying" or "Bear was walking," why not "Man was fishing" or "Woman went to the beach" or "Human lived in a house"?

On the other hand, dropping the article, particularly the "the," somehow diminishes the great figures of myth, to imagined characters in the quaint folktales of unsophisticated, simple people – if such ever really existed.

That is the source of my annoyance with the practice, and that is where this apparently inconsequential omission begins to seem serious. To me, to use this odd dictional device when referring to *these particular creatures,* in the time-honored accounts by which people identified themselves and related themselves to their environment and their fellow beings, and explained their origins, is an exercise in condescension. For it is a device used *only* when recording the literature of tribal people, completely unsanctioned by any accepted standards of ordinary English usage, and is therefore discriminatory, and no matter how unconscious its use, is ultimately racist.

This is, I realize, pretty strong language to use in reference to the writings of a group of the best-intentioned people, many of whom are good friends and allies in the effort to focus attention on the remarkable achievements of the native peoples of the Northwest Coast. I ask only that they spend a few introspective moments in an attempt to find the real reason for this clumsy aberration from the excellent English they are capable of and normally employ.

If it can be demonstrated that there is some merit in dropping the

article, I may be convinced enough to adopt the practice myself. If my arguments have some validity, I hope at least that some people who write, now or in the future, on Northwest Coast mythology will mend their ways. Probably what will happen is that everyone will continue to follow his or her prejudice.

But please, rightly or wrongly, the title of the piece in the Museum of Anthropology at the University of British Columbia is *The Raven and the First Men*, because I made it and named it.

Indulge me.

*Solitary Raven:
The Selected
Writings of
Bill Reid*

NOTES

1 *Nanatsimget was one of Reid's preferred spellings for the name of this important figure of Tsimshian and Haida myth. The spelling adopted elsewhere in this book, as in* The Raven Steals the Light, *is Nanasimgit. These are both Anglo-Haida variants of the Tsimshian name G̲anaxnox Sm'oogyit, "Spirit-Being Headman."*

2 *Not as well known as Reid may have wished – but it was well enough known in the Reid household. Martine Reid had recorded such a story told in Kwakwala by the Kwiksootainuk mythteller Axu (Mrs Agnes Alfred, c.1885–1995).*

# These Shining Islands

*Reid was in the habit of being asked to write introductions and forewords for other people's books, and those that he produced were for the most part short affairs, but the mandate of the Islands Protection Society – safeguarding the natural environment of Haida Gwaii – was particularly close to Reid's heart. When the society published its anthology* Islands at the Edge *in 1984, the foreword was written by Jacques Cousteau, and Reid contributed this essay which opened the main text.*

A few thousand years ago, a mere tick of the cosmic clock, but quite a respectable time when measured by the rapid pace of a people intent on overtaking their own destiny as soon as possible, the god of a then obscure tribe came up with a rather questionable dictate: "Be fruitful and multiply, and replenish the earth and subdue it."

Fruitful they were, multiplying mightily and industriously subduing as they did so – converting forests into pasture, pasture into desert and all that. In due course they were subdued themselves, but that grand old command was far too useful to discard. It suited the inclinations of the victors just as well as it had those of the vanquished. And when, about four hundred years ago, it was rendered into its finest form, expressed in the resonant English of the King James version – powerful, poetic, unequivocably on the side of the strong and aggressive – the great going forth and, most dramatically, the subduing were approaching full momentum.

The local warlords had begun the process by subduing their immediate neighbors, and later those not so immediate, and so created countries and empires which tried to subdue each other and sometimes succeeded. They certainly subdued the countryside – first of all cutting down the trees to build cities, palaces, churches … and navies.

Some of the ships of these navies – some of the few to survive the bloody neighborhood quarrels which were a more or less constant part of life in those and later times – set out to discover what lay beyond the reaches of the unknown seas. They were sailed by men so foolhardy or courageous, so adventurous or avaricious – take your choice – and so convinced of their own abilities and purpose, that their

exploits are still a source of wonder and admiration, regardless of their methods and motivations.

Everywhere they went they found traces of that old garden from which they had been banished long ago.

Well, the purpose of all this going forth certainly wasn't to go back to anything, and they proceeded to change these demi-paradises into something they could deal with, usually starting by cutting down the trees.

Sometimes they found great cities, the homes of people with cultures as advanced as their own, and sometimes so beautiful they thought they had stumbled into fairyland. So they promptly destroyed them. Sometimes they found beautiful, gentle, generous people, so they made slaves of them and killed them.

Sometimes they found people who weren't so nice, or beautiful, or gentle or generous, but were almost as avaricious and acquisitive as they were themselves. These they dealt with as allies or trading partners until they'd relieved them of the goods they coveted; then they destroyed them and their cultures.

Of course, at the same time, mankind was up to many other things, not all of them so bad. Man, at least a few men, largely through the exploitation of the new wealth from beyond the seas, gained the time and the technology to learn more of the universe and themselves. They developed into artists who looked at the world with fresh eyes and found that the parts of it not yet touched by all this subduing were perhaps the most beautiful, and that even human beings could be beautiful. The writers and philosophers began to wonder if they also might have the capacity to be good and kind, generous and gentle. It even occurred to them that their old god, whose first instructions they had been obeying so assiduously, might have meant some of the other

things he had said about enemies, neighbors, children and fellow humans in general.

Unfortunately he never got around to the creatures great and small with whom we share the earth, or to the land on which we live.

The poets, who'd had such a good time for so long telling of great subduings of this and that, began to sing of peaceful seas and tigers burning bright, of little lambs and other wonders of the nonhuman world. Some people at least came to suspect that the world might have some kind of function other than to be consumed as rapidly as possible for their immediate gratification. They even began to realize that killing all those great and small creatures – either to eat or wear or just for fun, or because they took up some of the room or ate some of the food they wanted for themselves – was neither the most profitable nor the most intelligent way of dealing with them, and might not even be the destiny their god had in mind when he created them.

The realization came too late to do most of the wild animals much good. The wolves had long since gone from Wales and the rest of Europe, along with most of the other wild creatures. What the subduers had done at home, they accomplished with equal efficiency as they made their way around the world.

That tiger who once transformed the night's arboreal gloom with his bright shining now dimly glows in zoos and roadside tourist traps.

The great herds of Africa are gone, their surviving numbers eroded by the pressure of poachers and the harvesting considered necessary to prevent the overpopulation of their steadily shrinking preserves.

In North America, they once told of a hypothetical squirrel who could have made his way from the shores of the Atlantic to the banks of the Mississippi, leaping from branch to branch through the forest without ever touching the ground. They spoke of flocks of birds so dense they obscured the sun with their passing, of rivers and lakes

alive with fish, and of huge herds of bison, deer and pronghorn that swept across the central plains.

Well, the rivers, lakes, shores and ocean depths no longer exactly teem with fish. And, though they have shown an almost unbelievable stubbornness in persisting to survive the guns, traps, snares and ravaged habitats which face them everywhere, the birds are only a remnant of what they once were. Today you can travel coast to coast and if you're lucky you may see a few deer or a half dozen pronghorns. But it's much more likely that the only living animals you'll see are some domestic horses and cattle, seemingly rooted in a geometric landscape.

Even Leviathan, the mightiest creature who ever lived, has almost been swept from myth and history. So few are his numbers that he must call halfway around the world to find another of his own kind with whom to keep his incredible lineage alive. Even this desperate voyage in search of survival too often ends short of its goal, in the sickening blast that tears through the long, smooth muscles, designed to propel him effortlessly around the globe – the only living being whose passage matches the mighty surge of the ocean itself.

Almost everywhere in the world – from the tropical rainforests to the Antarctic, from Lake Baikal to Lake Superior – the effects of the tremendous crushing, consuming, destroying, transforming thrust of energy either have or soon will be felt. It is a wave that started on the smallest continent and spread outwards around the sphere of the planet until it has eventually, inevitably, closed in upon itself. Today the wave reverberates in small, scattered centres of turbulence, lashing with undiminished avarice at the few isolated enclaves it has yet to consume.

One of these is South Moresby in the Queen Charlotte Islands.

For thousands of years the Charlottes lay secure in their isolation, protected by the sea even from the ice that swept south to cover most of the continent. Because of this isolation, these islands gave birth to many unusual, in some cases unique, kinds of animal and plant life. And when, about ten thousand years ago, some newcomers penetrated their isolation, arriving by sea or being coaxed out of a clamshell by the Raven, they too were transformed into a people as unusual and in some ways as unique as their environment: the Haida.

Among their accomplishments were the great Northwest Coast canoes, each ingeniously fashioned from a single cedar tree and ranging in length up to 21 m, as beautiful as any of the wonderful vessels maritime man has ever devised. Possessing the skills needed to build these graceful seagoing boats and with a wonderful sense of design, they filled their lives with one of the most elegant and refined material cultures in the tribal world. They found room for expression in a myriad of objects, ranging from the world-famous totem poles and the beautifully proportioned houses they complemented, to exquisite items of personal adornment, all relating to the complex genealogical patterns which gave structure to their lives. The heraldic art which they developed stands alone among the arts of the world in its concept of the formline, one of the most intellectually refined and aesthetically powerful systems of expression, a feat of the imagination that truly deserves to be called unique.

The Haida as they once were are part of history now. A few survivors of this never very large population still cling to their identity and to some fragments of their culture and their land. The lands of the great families have been claimed, and parts have been transformed, perhaps forever, by the great subduers.... Remember them? They've been up to their old practices here as elsewhere, destroying peoples and cultures, and cutting down the trees, so that now only a few isolated areas remain untouched.

One of these, as I have said already, is South Moresby. In the opinion of many people who know these islands well, if they had to make a choice, conserving only one area of the Charlottes as it was when only the Haida lived there, then South Moresby is the one that they would choose.

Why? First, because of its overwhelming beauty – hundreds of islands, each with a character as distinctive as its name: Hotspring, All Alone Stone, Flowerpot, Tuft, Flatrock, Monument, and many more. And these are just our prosaic English names. The old Haida had much more expressive ways of identifying their intimate environment, such as *Killer Whale with Two Heads* and *Sunshine upon His Breast* and *Red Cod Island*.[1]

Then there is the sea and shore life: fish so numerous that one need never spend more than a few minutes in quest of something delicious for the next meal, and shellfish in profusion. One narrow channel about a kilometre long, Burnaby Narrows, is reputed to contain more protein per square metre of bottom than any other place in the world. Not to mention the birds and mammals of land and sea, an abundance and diversity of life unrivalled on the coast.

Towering above it all, both physically and symbolically, is the forest. Here are the great cedars from which the Haida constructed their material culture, and incredibly huge spruce and hemlock, and a thousand other kinds of plants spread upon the forest floor and clinging to the limbs of trees. In short, it is an unmistakeable part of that old garden, and because it is one of the few pieces remaining, it is incalculably valuable. Not in terms of the subduers' cashflow and balance sheets, or even in the more human context of jobs and wages. There is no dollar-and-cents equivalent with which to measure the sacred.

It may be that few people will ever find their way to these remote shores to witness such a profusion of life in such a concentrated area. When, or if, we should decide that subduing is not the only, or even

the most desirable, way of making our way through the world, these shining islands may be the signposts that point the way to a renewed harmonious relationship with this, the only world we're ever going to have.

Perhaps saving them is a promise and a hope, a being conscious of their continued existence, whether we as individuals ever actually see them or not, so that we may return to a more peaceable kingdom with a full knowledge of its wonders. Without South Moresby and the other places like it, we may forget what we once were and what we can be again, and lose our humanity in a world devoid of the amazing non-humans with whom we have shared it.

I have four grandchildren, three of them growing up in the village of Skidegate on the Queen Charlottes, the fourth a frequent visitor. I would like to think that as they become the Haida of the future – the people who call these beautiful, bountiful islands their home – they and their peers will have more than nostalgic, regretful memories of "how it used to be in the old days" upon which to build their own visions of their past. I would like to know that they can go to at least one sacred place that has not been crushed by the juggernaut of the subduers, and there create the myths of a living culture. There is nowhere more worthy of the care and reverence due the sacred places of the earth than this.

NOTE

1 *In Haida, "Killer Whale with Two Heads" is* Sghaana Qaaji Stins (*the name of a prominent rock on the north coast of Graham Island*). *"Sunshine upon His Breast" is* Qan·gha Xayaa (*a mountain on the west coast of Moresby, shown on English maps as Mount de la Touche*), *and "Red Cod Island" (or Red Rockfish Island) is* Sghan Gwaay (*Anthony Island on English charts, site of the village of* Sghan Gwaay Llanagaay, *or* Ninstints).

# Becoming Haida

I took the opposite route to David Suzuki and backed completely out of broadcasting several years ago. I have since then been making jewellery and various artifacts in the style of my mother's people, the Haidas of the Queen Charlotte Islands. I had hoped by doing this to isolate myself into a nice little world where I could merely play with the concepts of these beautiful designs and turn out finely made objects. I found that a large overburden came with this artform, and I have become more and more involved with the Haida people and the people of the west coast generally, as a result of my involvement in their artforms.

I've spent most of my life with a feeling of identity with the Haida people – always, of course, at a safe distance in some urban location. Recently, however, I have finally had to face up to what it really means to be Haida in the latter part of the twentieth century, and at the last minute I am taking a few steps along the road to becoming one.[1] This came about, of course, because of the recent confrontation on Lyell Island and the emphasis given to the South Moresby area.

I am not a stranger to South Moresby. In fact, I have probably visited the area – and surely have gone ashore there – much more frequently than most of the Haidas who live on the Queen Charlotte Islands. And I have talked about it enough. It's been more than five years since the piece I wrote about Windy Bay was published.[2] I would like here to go on record that I also invented a bear on Lyell Island, and I would like to withdraw that licence which I took with the biological facts of the area. I don't know whether there are bears on Lyell Island or not, but the one I envisioned wasn't there.[3]

Anyhow, the piece on Windy Bay had some small effect on events

In October 1985, the British Columbia Minister for the Environment appointed a Wilderness Advisory Committee "to consider the place of wilderness in a changing society," and to recommend the fate of sixteen disputed areas. One of these was South Moresby in Haida Gwaii. The committee received written submissions over 12 weeks and held public meetings for two weeks. Reid delivered this statement before the committee at its last public session, in Vancouver, on 1 February 1986. The speaker immediately preceding him was his friend the biologist and broadcaster David Suzuki. A portion of Reid's statement was published in Doris Shadbolt's book Bill Reid (1986), and it was she who gave the text its title.

that followed. During that time, I supported the Islands Protection people and helped them with their very successful book.[4] I attended rallies and contributed money and pieces of art to be sold at their functions. And it was all very useful, educational and socially well directed, I suppose, and it did no harm to anyone except the forces of evil. On the whole, it was a not very active but consistent attempt to support plans to preserve South Moresby as a wilderness area.

This effort was directed by the sensibility, the knowledge, the sentiment of a good, middle-class Caucasian immigrant liberal. I thought and spoke about the rather austere beauty of the islands. I compared them not only with the Galapagos but with the medieval and renaissance cities of Europe, extolling the giant conifers as columns and great cathedrals dedicated to worship not only by humans but by all life. I drew comparisons not only to the sacred but to the vain as well. I even called Burnaby Narrows the world's longest sushi bar. I joined in the chorus of wonderment at the abundance of sea, forest and beach. I smiled at the antics of the puffin, his decorated, multicolored beak dripping with prey that is actually impaled on his prickly tongue. I shook my head in disbelief at the stories of the ancient murrelets that come whistling through the islands to bury themselves in their mossy burrows – at night too, just to make the unbelievable seem more impossible.

I wanted South Moresby preserved as a treasure for the whole world, to be enjoyed for its aesthetic value, as a kind of Avalon where we can all go to heal our grievous wounds. I spoke of the spiritual nurture of all people – whether they reached the South Moresby area in person or saw its wonders through the surrogate eye of the camera, or merely felt the satisfaction of knowing that at least one of its beauty spots had been left unspoiled by industrious, industrial man.

Well, that's all worthwhile stuff, and I still believe it makes a good enough case for the rescuing of South Moresby. I would probably still

be supporting the campaign on those grounds if the status quo had been maintained. But along came Miles Richardson Jr, cheerful little Buddy, whom I have known since he was two years old, and his now famous forty days – which proved that, whatever else they had lost, the Haidas could still make pretty good jokes.[5] I joined politely in the laughter, and I waited for the facts and practical wisdom, and the dissention between groups, clans, villages, families, individuals, and the pitiful eagerness to attribute good will to opponents who had never shown any previously – all those factors that should have led to the withering away of resolve and taking the path of resignation in the face of superior, ruthless power.

*Solitary Raven:*
*The Selected*
*Writings of*
*Bill Reid*

We all know what happened instead. Buddy and the brothers and sisters and the glorious nonees and chinees,[6] the old people, took on the forces of darkness and peacefully manipulated them to a standstill. After a century or more, the Haidas came alive again.

I know that it was never intended to attempt land claims but only to call a halt to the logging of Lyell Island so all parties involved or interested could sit down together and arrive at a solution. But the intransigence of people in power forced the Haidas to seek a wider base for the struggle, and the land claim was invoked. That action in turn caused people on both sides to pause and consider while we tried at least to discover what it was that we all meant by that contentious term, "land claims."

It does not mean that the native peoples want to drive all non-natives into the sea. As far as I know there is no sentiment in favor of de-industrializing society. Some people may see the land claims as a way to get rich. But in regard to South Moresby, why should the Haidas – we Haidas – want this particular morsel of wilderness left untouched? Certainly not for the reasons I gave earlier, when I was describing my own attitude. But let's take note that all my earlier comparisons were based on European notions, or in one case on a refer-

ence to Asia. I am sure the Haidas think that places like Windy Bay are beautiful, but I am equally sure that their concepts of beauty are not the same as those of people who view the world through eyes conditioned by European aesthetics. Nor do I think there's a great deal of interest in the individual species of flora and fauna to be found there, no matter how unique. Nor would they think of Burnaby Narrows in terms of an old-time Japanese restaurant.

No. There is, I think – and I can almost begin to feel it myself – a much more direct response, a closer identification with these areas than anything that is filtered through the veil of conditioning which most people carry with them. Those descended from European stock, and probably from Asiatic as well, still feel a slight unease, the tiny remnant of the old looking-over-the-shoulder anxiety of the strangers in a strange land. And in the back of most immigrant minds is the ghost of a thought that they'll return to their real homes some day.

The Haidas have also been in exile, ironically more so than those who displaced them. Once all of Haida Gwaii was theirs. We all know of the plagues that decimated their numbers and caused them to gather together in the two centres of population that endure today. These in effect became tiny islands within the large land mass of the Charlottes, and the people lived within these narrow confines, emerging to go fishing, to visit the cities of the mainland, but hardly ever venturing back to their ancestral sites.

Well, that's all changing now, and the first tentative probes are reaching out to reestablish ties with the old territories, and in places like South Moresby to find links with the past – for it is only in such places as South Moresby that the past can be found intact and unchanged. Every other aspect of Haida culture has been eroded away. The language is almost gone. The songs, stories, the very genealogies that were the threads that made up the fabric of Haida life, are almost forgotten. Even the people's names have been erased from the con-

sciousness of those who should own them, to be replaced by the monosyllables of common English. So we have left only the sea, and a few sacred groves unaltered since the great change that began two centuries ago.

The Haidas never really left South Moresby, or the other areas they once controlled. They only went away for a while. And now they are coming back. As for the other people who claim control of these areas, well, they remind me of a tourist who turned up in Victoria with a couple of fine west coast masks. When asked where he had got them, he said proudly that he had stumbled on an abandoned cabin, and rummaging around, found the masks in a box under the bed. Of course, the cabin wasn't abandoned; the owners were only away for a while, and the tourist, no matter how ignorant and insensitive, was guilty of theft.

The Haidas must have their ancient lands back unviolated if they are to reestablish links with their distinguished past and build on it a new future. If these remnants of their former riches are not returned, it will make the act of theft a conscious one, perpetuated by the people of today, instead of just an accident of history.

Modern methods of logging mean not just cutting trees but murdering the forests – those wonderfully complex organisms which once gone will never return in their ancient form. And in killing the forests, you also kill forever the only authentic link the Haidas still have with their past. You murder once more their symbolic ancestors. That is what I think the land claims are about.

As for what constitutes a Haida – well, Haida only means human being, and as far as I'm concerned, a human being is anyone who respects the needs of his fellow man, and the earth which nurtures and shelters us all. I think we could find room in South Moresby for quite a few Haida no matter what their ethnic background.

*Solitary Raven:*
*The Selected*
*Writings of*
*Bill Reid*

*Becoming Haida*

**1** *In 1985, the Parliament of Canada amended the Indian Act to allow so-called "non-status Indians" to become legal members of Canada's First Nations. Reid, as the child of a Haida mother and a Caucasian colonial father, was Haida as defined by Haida matrilineal tradition but had always been a "non-status Indian" as defined by federal regulations. He took advantage of the 1985 legislation to obtain, in his late sixties, legal status as an aboriginal Canadian at last.*

**2** *"The Enchanted Forest" (p 151).*

**3** *The issue of bears on Lyell Island was raised earlier in the same session, while David Suzuki was being questioned. A member of the committee then alleged that loggers working on Lyell had not sighted a bear in fifteen years. Reid is referring to a black bear he had written about five years earlier (see p 152).*

**4** *The Islands Protection Society's anthology Islands at the Edge (1984) included Reid's essay "These Shining Islands."*

**5** *This is a cryptic reference to the forty-day blockade which halted logging in the Windy Bay watershed on Lyell Island. The campaign was masterminded by Miles Richardson Jr (Nang Qaaji Stins, known as Buddy to close friends), who was then President of the Council of the Haida Nation. Richardson and Reid were close for several reasons. Both were southern (Skidegate) Haidas and both were in professional positions that obliged them to serve as a living bridge between the Haida nation and the outside world. In addition, Richardson's father was hereditary headman of Reid's lineage, the Qqaadasghu Qiighawaay.*

**6** *This is modern colloquial Haida for "grandmothers and grandfathers." In the classical language, the form would be* naanaay at tsinaay.

# Joy is a Well-Made Object

As you can see from the program, I was expected to explore the wonders of the formline, that amazing system which underlies the structure, describes the significance, and dictates the unique, compelling appearance of the arts of the northern part of the Northwest Coast of North America. It is apparent that I don't lack enthusiasm for the subject, and after forty years of exploiting the arts of the Haida people, it is just possible that I may know something about it. But just as I was about to comfortably retell the story of Haida cleverness, and incidentally of mine, something different loomed large on the scene and would not go away.

The event that triggered this change was a strange piece of Canadian legislation which made it possible for some of us to become retroactive Indians.[1] I may appear to be a stoop-shouldered, overweight, pale-skinned, elderly Caucasian, but by decree of her Imperial Majesty the Queen of England and a few other places, including Canada, I have become a stealthy, sometimes noble, sometimes untrustworthy, dark-skinned, black-haired, naked painted savage – or *sauvage,* as we must say in our bilingual country.

Or Haida, as we incorrectly say in Haida Gwaii, known to some as the Queen Charlotte Islands.

This change may not be apparent yet, and may never take place, but it did remind me that part of me at least was legally, as it had long been emotionally, related by blood and feeling to the Haidas, the other people of the Northwest Coast, and to the rest of the original inhabitants of the western hemisphere. And forgive me if I have jumped to conclusions, based on little evidence, that make me the closest thing you will find to a representative of these first peoples in the list

*This is the transcript of a lecture Reid gave at the Centro Cultural de Madrid in 1988, at the opening of an exhibition of Northwest Coast art entitled* El Ojo del Totem. *I do not know who made the transcript and have not found the tape from which it was made. I take it that the tape stopped prematurely, since the typescript ends abruptly in midsentence.*

[ 219 ]

of learned men and women who make up the participants of this conference.

So I am here today to render an account. To whom exactly it should be addressed, I am not quite sure. Certainly it would be best if it could be settled amicably between the original parties concerned, and they could then shake hands and start over again, this time on terms advantageous to both.

But far too many deaths, most of them gratuitously violent, have occurred: too many centuries of suffering on the one side and guilt on the other. Too much unresolved hatred still clouds the unhappy history of the continents.

Let's get something clear at the start. On the Northwest Coast there was little of the dreadful, callous slaughter of the innocents which marked the advance of the Europeans across the continent. As for our hosts' role in the history of the coast, whatever it may have been elsewhere, about the only effects left behind were some rather pretty names for some of our islands: Hernando, Gabriola, Galiano, Valdez, the San Juans, and many more.

There were a few unpleasant incidents, usually ending in defeat of the natives by superior weaponry, but the main effect of that weaponry was to increase the violence of the more or less constant tribal skirmishes.

I'd like to try to assess the effect of the arrival of the Europeans on the people of the coast. Not the people as a whole, or the tribal groups or the cultures as such, but on the lives of the individuals.

It is hard to get a clear picture of life before the invasions, but we can safely say that it was not any Eden. Most communities were governed by a strongly entrenched hierarchy, with a complicated crisscross of hereditary village chiefs, clan chiefs, house chiefs and probably many more, each infringing to some extent on another's territory, and in turn being infringed upon by somebody else.

The universal custom of taking slaves must have made life very uncertain. Apparently anyone caught too far from help was fair game, and unless you were a very important aristocrat whose family could potlatch the stigma away, there was no point in trying to escape. The disgrace of being enslaved could never be overcome, and an escaped slave's life would be lived in solitary exile.

Warfare was not a particularly important activity, being largely restricted to fast raids. But it was a more or less constant occurrence and must have had a disruptive effect on the communities.

As in all tribal societies, the way of life was very conservative, with little room for innovation or creativity. Marriage and other conventions were dictated by custom and arranged by the elders.

It may sound like a pretty reactionary society, and in many ways it was. But it had one big advantage over the larger, more complex systems which replaced tribalism. It accommodated each of its members according to his abilities, not just permitting but requiring all citizens to contribute to the community to the best of their powers.

And by natural contact between people, each became a universal man or woman – within a necessarily small universe. Each learned perfectly the subtleties of a rich and expressive language, adequate to symbolize all the natural elements of his environment, and in its literary version, to retell the myths and the epics of the people. The language was a great tool which served people well in solving the problems of living on a rich but inhospitable, stormy coast.

Manual skills were easily acquired, almost from infancy, from the very best masters of each trade, by observing the activity on everybody's shopfloor: the beach in front of the village.

It was far from passive observation. Children were recruited from the groups who drifted from one end of the beach to the other and were given tasks commensurate with their age and abilities. (Recently I had occasion to put my two-year-old grandson to work gathering

material and found him to be a good, competent workman for at least ten minutes.)

In any case, by the time they were young adults, the talented people of the Northwest Coast had learned that it was abundantly true that joy is a well-made object, equaled only by the joy of making it. Hardly anybody today, native or non-native, knows that joy. And that is a big item in my account book.

Most of the rest of the account is concerned with the other losses suffered since that fateful day when Juan Pérez's sails were sighted off North Island, near the Charlottes.

The most tragic of all is the loss of language, not just Haida – now considered one of the most imperiled native languages in North America, spoken fluently only by a handful of old people. That which was supposed to replace it – this freakish combination of a dozen tongues which we call English – has never become for the native people the useful and entertaining device it should be, and it now seems in almost as much danger as the Haida it supplanted.

Some kind of rough communication still functions. The most abstract, arcane scores of sports never played and never witnessed can be discussed for hours. The reasons for, the preparations, the kinds of substances needed to produce the required results, the people who eat the good shares or the bad, the loves and friendships made and broken, the early, intermediate and late results – all these can be fluently discussed on the day following the last big drunk.

To this unhappy list can and often are added the deaths and injuries from car crashes and the rest of the dreary litany. There are plenty of words for these things, but there are none to provide the tools to begin to eliminate them from the lives of the people. The great-grandsons of the finest woodworkers of tribal times are often incapable of simple repairs to their own houses, and the descendants of those master craftsmen who designed and built the great seagoing Haida canoes are

completely dependent on outside repair shops to keep their fishboats afloat.

In a land where recreational opportunities draw visitors from the whole world, young people have to resort to alcohol and other drugs to make life endurable. How can this have happened? How can people with a past so rich it fascinates all who encounter it have a present so poor that apathy and escape are the corner posts that dominate its apparently inevitable descent into oblivion?

As we all know, early contact stimulated creativity and productivity. Almost everybody grew richer. Using the wealth obtained from the European traders, coastal villages grew into miniature counterparts to the cities of Renaissance Europe, with their own versions of the Medicis and Borgias, while their counterparts on the other side of the world used the golden wealth from their new overseas empires. Then the erosion of the societies between the fearsome grinding stones of efficient weapons, alcohol and disease, culminating in the horror of 1862, when the Haidas lost eighty-five per cent of their number between spring and winter, and the rest of the coast suffered almost as tragically.[2]

The related vultures of the foreigner's law, his religion, his economic system and his armed forces, after waiting for two-thirds of a century to close in, did so then, and everything was changed.

Or was it?

Certainly the great community houses gave way to smaller single-family dwellings; planked fishboats replaced the magnificent Haida canoes, and the songs, dancing and drumming of yesterday's ritual became the dolorous peal of Presbyterian hymns played by the village brass band.

But the spirit of the survivors seems to have endured beyond belief. The houses sprouted gingerbread trim, and the most recent research seems to indicate that the native builders, who had no plans and cer-

tainly no instruction from the white boat owners, actually improved the imported designs. My grandfather was one such man, and though he died in 1954, and built his last boat in 1920, two of his creations are still fishing on the west coast.

But this state of affairs couldn't be allowed to continue. The big artillery was called into play, and aimed at the most vulnerable segment of the society: the children. Parents were coerced into sending their kids to residential schools, where the one lesson was, *It's bad to be Indian.* Speaking their own languages was forbidden, and beatings were the remedy for that and other transgressions.

The school holidays coincided with fishing season, so that families were often segregated for years, sometimes forever.

Disease was still loose among the people – particularly tuberculosis – and most families had at least one member dying in the back room or the T.B. sanitorium.

The Second War brought the natives the vote, and with it improved housing, health care and local education. But the damage had already been done, and even among the more prosperous reserves....

NOTES

1 *Reid's application for aboriginal status, filed as soon as federal law allowed, in 1985, was granted in the spring of 1988.*

2 *Compare pp 113–114. Robert Boyd's recent estimates would put the Haida losses for 1862 alone at 72% and for the century of death (1774–1874) at 89%. But the story, of course, is one that numbers, no matter how accurate, cannot convey.*

# The Raw Material of Chaos

It was late fall or early winter, although you would never know it. The sky was overcast. It was short-sleeve weather, warm, calm, and very peaceful. A small pack of kids, eight or nine years old, were doing what kids have been doing for the last five thousand years in front of this village, coursing their way eagerly along the beach, rattling the gravel and leaving heelprints in the sand, splashing most gratifyingly through streamlets and tidal pools.

Jimmy Hart and I were restoring the totem that decorates the front of the band office. The pack stopped near us and drifted about whispering in their strange secret language, and one of them picked up a tool and began carving a piece of driftwood. We were not very interested in our job, so instead of sending them down to the beach, we distributed our tools among them and put them to work carving small boats. They stayed with us about an hour, and during that time their skills improved at least fivefold; and because they were so involved in their manual tasks, they spoke very freely and unselfconsciously of their lives, ambitions, relationships with their families, and so on. Then they got bored and went off down the beach, as children had been doing for thousands of years.

With one difference. On this long beach, on that warm winter day, Jimmy, the kids and I were the only human beings to be seen. Some evidence of life could be deduced from the electronic flickers seen through the windows of many of the houses, but that was all.

For all the preceding centuries that man has lived on this stretch of coastline, even a hundred years ago, the beach would have been the scene of constant and varied activity. In front of every house, someone would have been building a canoe, or carving a totem pole, or

*Written in 1989. The Rediscovery Program is an outdoor and environmental education program, for native and non-native children, based on aboriginal traditions of contact with the land. It was founded on Haida Gwaii by Thom Henley in 1978 and now operates worldwide. When Henley finally wrote a book about it, ten years after it all began, both Bill Reid and biologist David Suzuki contributed enthusiastic forewords. This is Reid's. The beach he speaks about is, of course, the beach in front of Skidegate on Haida Gwaii, and the Jimmy Hart mentioned in the text is the carver Jim Hart of Masset, who was born in 1952 and worked with Reid on several projects during the 1980s.*

preserving food – occupied with the countless activities necessary to sustaining the rich and colorful lives of the Haida.

The kids would have been a part of the whole scene, used as casual help as their skills permitted, learning something of the knowledge essential to their future lives from the vast talents that their community had to offer. A thousand trips up and down the beach would probably have been sufficient to make each of them a universal man or woman – admittedly of a small universe, but they would have had a working knowledge of all the techniques, developed through the centuries, by which the Haida coped with their environment, as well as complete knowledge of the language and legends of their kind.

Perhaps the descriptions, rooted in myth, of the origins of this universe seem fanciful and inexact compared to the scientific logic we follow. Both give order and structure to the world and its happenings, and if mankind didn't emerge from the Clamshell at the urging of the Raven exactly as described, there's no reason to believe that the land bridge so conveniently appeared and disappeared as in that other story. Who knows? It may be another myth.

The wonderful thing about Rediscovery is that it has enabled all these different truths to exist side by side. It provides for a few more trips up and down the beach, where traditional teaching can still take place, and it helps young people whose private universes seem empty and chaotic to discover there is some order in their lives and in their world. And even if there isn't, some may be inspired to turn the raw material of chaos into structured hope for the future.

# The Goldsmith's Art

From my own unbiased, completely objective interpretation of history, uncolored by my four-decade-long love affair with the goldsmith's art, I offer the proposition that humankind's first truly creative act was to stick a piece of bone through the septum of his nose or hang a bright pebble around her neck, and that the last woman on the last day of the world will put on her favorite earrings for the event.

During the intervening centuries, the rise and fall of empires has been reflected in the glitter of the goldsmith's creations. It's more likely than not that the new ring you just acquired or the antique brooch you inherited from your grandmother contains a few atoms of gold from the sack of Troy mixed with greater percentages from the loot of the New World, along with some virgin metal whose production is helping to fuel the forces of drastic political and social change in the country where it was mined.

Every time the vandals melt down the shiny baubles of our past, the goldsmith puts them together again in a different form.

*In 1991, when the Swiss-Canadian goldsmith Toni Cavelti opened a new shop in Vancouver, he asked his friend Bill Reid to write a few words for a brochure announcing the occasion. Reid spent much of his space repeating things he had said in 1980 in a tribute to Bill Koochin (p 147). Then he went on to a new theme: the art that he and Cavelti shared.*

# The Spirit of Haida Gwaii

*From 1986 to 1990, Reid was occupied with making his largest piece of sculpture, the cast bronze* Spirit of Haida Gwaii, *widely known by its nickname, the Black Canoe. In 1991, as the unveiling date came near, Reid dictated this piece to his wife Martine – an occasion vividly recorded in her afterword. The text did not appear in the journal by which it was commissioned. It was first published as a broadside by the Canadian embassy in Washington, DC, where the sculpture is installed.*

Here we are at last, a long way from Haida Gwaii, not too sure where we are or where we're going, still squabbling and vying for position in the boat, but somehow managing to appear to be heading in some direction; at least the paddles are together, and the man in the middle seems to have some vision of what is to come.

As for the rest, they are superficially more or less what they always were, symbols of another time when the Haidas, all ten thousand of them, knew they were the greatest of all nations.

The Bear, as he sits in the bow of the boat, broad back deflecting any unfamiliar, novel or interesting sensation, eyes firmly and forever fixed on the past, tries to believe that things are still as they were. The Bear Mother, being human, is looking over his shoulder into the future, concerned more with her children than with her legend. After all, they wandered in from another myth, the one about Good Bear and Bad Bear and how they changed, so she has to keep a sharp eye on them.

Next is the Beaver, doughtily paddling away, hardworking if not very imaginative, the compulsory Canadian content, big teeth and scaly tail, perfectly designed for cutting down trees and damming rivers.

And here she is, the Dogfish Woman, still the ranking woman of noble birth, yielding no place to the pretty Bear Mother. In spite of her great cheeks, with gills like monstrous scars, her headdress reflecting the pointed shape of the dogfish head, and her grotesque labret – in spite of all these, the most desirable and fascinating woman from mythtime. More magical than the Mouse Woman, as mysterious as the deep ocean waters which support the sleek, sinuous fish from

whom she derives her power, she stands aloof from the rest, the enormous concentration of her thoughts smoldering smoky dreams behind her inward-looking eyes.

Tucked away in the stern of the boat, still ruled by the same obsession to stay concealed in the night shadows and lightless caves and other pockets of darkness in which she spends her immortality, the Mouse Woman lost her place among the other characters of her own myth, an important part of the Bear Mother story, and barely squeezed in at the opposite end of the boat, under the tail of the Raven. No human, beast or monster has yet seen her in the flesh, so she may or may not look like this. Not so the Raven. There is no doubt what he looks like in this myth-image: exactly the same as he does in his multiple existences as the familiar carrion bird of the northern latitudes of the earth. Of course he is the steersman. So although the boat appears to be heading in a purposeful direction, it can arrive anywhere the Raven's whim dictates.

A culture will be remembered for its warriors, artists, heroes and heroines of all callings, but in order to survive, it needs survivors. And here is our professional survivor, the Ancient Reluctant Conscript: present, if seldom noticed, in all the turbulent histories of men on earth. When our latter-day kings and captains have joined their forebears, he will still be carrying on, stoically obeying orders and performing the tasks allotted to him. But only up to a point. It is also he who finally says, "Enough!" And after the rulers have disappeared into the morass of their own excesses, it is he who builds on the rubble and once more gets the whole thing going.

The Wolf of the Haidas was a completely imaginary creature, perhaps existing over there on the mainland but never seen on Haida Gwaii. Nevertheless he was an important figure in the crest hierarchy. Troublesome, volatile, ferociously playful, he can usually be found with his sharp fangs embedded in someone's anatomy. Here he is vig-

orously chewing on the Eagle's wing, while that proud, imperial, somewhat pompous bird retaliates by attacking the Bear's paws.

That accounts for everybody except the Frog, who sits partially in and partially out of the boat and above the gunwales: the ever-present intermediary between two of the worlds of the Haidas, the land and the sea. So there certainly is no lack of activity in our little boat, but is there any purpose? Is the tall figure who may or may not be the Spirit of Haida Gwaii leading us – for we are all in the same boat – to a sheltered beach beyond the rim of the world, as he seems to be, or is he lost in a dream of his own dreamings? The boat goes on, forever anchored in the same place.

**Afterword**
by Martine Reid

# Afterword:
# The Act of Writing Aloud[1]

We all know that Bill did not call himself a writer but rather a "maker of things." Making things was for him a raison d'être and, as he put it, "so much nicer than working for a living." The act of handwriting, on the contrary, was "hard work" – a real effort which, I think, had to do with his reluctance to leave his beloved workbench. However, when he committed to it, the result was another "well-made" product, reflecting his well-established high aesthetic standard and his love for language.

I write from the point of view of a companion, about the way that Bill could write.

Thinking of Bill's language always brings me back to his omnipresent speaking voice: a voice that draws one back to oral times, when tradition was told and retold. I like to think of his writings as an extension of his storytelling talents. Both his written and his spoken language were such integral parts of himself that it would be difficult for me to dissociate them from one another. For those who have known Bill and heard his mesmerizing voice, it is impossible to read his own words without hearing his voice again. His voice – an "erotic mixture of timbre and language, along with diction"[2] – was a remarkable tool which he learned to use so well during his years as a broadcaster. It was round, warm, seductive, convincing, soft and powerful at the same time, like the intimate crooning of an amorous raven.

Bill did not write the text of "The Spirit of Haida Gwaii" by hand. He conceived it and delivered it in an amazing outburst of creative energy, in the manner in which – all differences of proportion admit-

ted – Mozart is said to have dictated his *Requiem* to Salieri. He "wrote aloud."

*Écoutez!*

Mr Alan Turnus, the editor of *Natural History* magazine in New York, had asked Bill to write 3000 words on his Black Canoe sculpture, to be published to coincide with the unveiling of that monumental work in Washington, D.C., in November 1991. As usual, the deadline had long passed. Bill was customarily reluctant to begin a writing assignment. In addition, handwriting (and typing) had become more difficult with the advance of his Parkinson's disease. His handwriting was fluctuating from bold to normal characters, and from large to infinitesimal scribbles. That was the word he used himself, and in those days it was often difficult even for him to decipher his own script. I, or whoever happened to be around at any time Bill wished to write, became his scribe.

Much nagging on my part had not proven helpful in the case of this request for a piece of writing on the Black Canoe. Until a certain Sunday.

We loved Sundays. For a short while, we made Sundays our own. These were our holidays from the care-givers who, by necessity, progressively invaded our lives. Sundays were times for rare, reclaimed private moments filled with music and total pleasure. They were days to read aloud the poetry of Ezra Pound or T.S. Eliot, or entire chapters of Roark Bradford's *John Henry*, or James Stephens's *Crock of Gold*, to mention a few of Bill's favorites. They were days to be purely creative, beyond the regular routine.

On one such beautiful sunlit Sunday morning, Bill, dressed in his stylish grey linen housecoat and seated so that he was looking out at Tatlow Park from our living room window, said in a firm tone, "Okay. Are you ready?"

With the intuition of a long-term accomplice, I understood that

Bill was about to dictate something. I grabbed a pen and some paper and sat on a sofa against the window, facing him, pen suspended, waiting. Looking quite contemplative and pensive, he stretched out his legs alongside mine, gazing at the tree tops in the park, which were moving gently under a soft breeze. We often spoke about these trees and how they swirled langorously like subsurface seaweed touched by a tidal current. A metallic light gently caressed Bill's face, rippling over his grey mane.

The timbre of his voice, calm and serene, as if it came from the caves where the winds are born, broke the silence: "Here we are at last, a long way from Haida Gwaii...."

Like an entranced shaman in an intense but oddly tranquil and controlled state, Bill dictated to me, in one continuous lyrical flow, the entire text of "The Spirit of Haida Gwaii." It was a genuinely magical experience.

Like a portrait painter who recreates from memory a deeply familiar visage, Bill wrote the portrait of "The Spirit of Haida Gwaii" with that indelible language of his, finding in his mind's eye, with utmost ease, the inner contours and contents of his creation. I realized that I was witnessing something out of the ordinary: the ultimate transformation of his three-dimensional masterpiece into a narrative text infused with his own vision of the world. The creation myth of *The Spirit of Haida Gwaii* was perhaps his own self-portrait.

The flow was rarely broken. At times he asked me to read back paragraphs. My readings seemed to work as rhythmic pulses and helped him think and formulate what was to come next. His mind was so clear, his vision so real, his power of concentration so intense, his language so true to him, that there was never a need for editing. In a way mysterious to me, Bill was describing the sculpture as if he were detached and seeing it for the first time. As for me, I too was seeing it for the first time.

At the end, with a certain sadness and such a mysterious smile, as if he were surprised by his own inspiration, or as if he had just happened to condense his entire life in this recitation, and come to terms with his own destiny, he stopped. Looking fatigued and relieved, he asked in a voice filled with emotion if he had forgotten anybody on the boat. Equally moved, I reported that everybody was on board. The boat was continuing in its mythic journey, "forever anchored in the same place."

*Solitary Raven:*
*The Selected*
*Writings of*
*Bill Reid*

NOTES TO THE AFTERWORD

1 *Roland Barthes introduces the concept of "vocal writing" or "writing aloud" to speak of oral tradition, the art of oratory and rhetoric in* The Pleasure of the Text *(1975).*

2 *Barthes 1975: 66.*

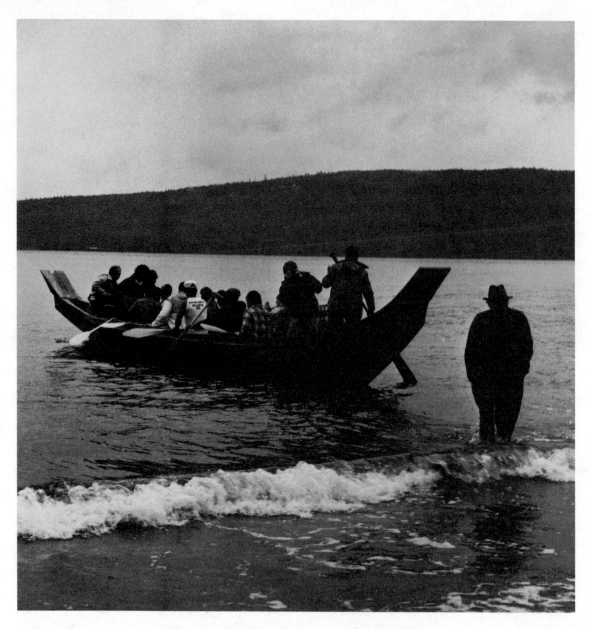

Reid's 15 m dugout, *Loo Taas* ("Wave Eater"), leaving the beach on a test cruise and its maker coming ashore. Skidegate, 10 April 1986. Photograph by Ulli Steltzer.

# Chronology

1920  Born 12 January in Victoria, British Columbia, first child of Sophie
      Gladstone Reid of the Qqaadasghu Qiighawaay (a southern Haida lineage
      of the Raven moiety) and William Ronald Reid, a native of Michigan.
      Returned with his mother to Hyder, Alaska, which was then his parents'
      home.

1921  [age 1]  Birth of sister, Margaret [Peggy] Reid. Returned with mother and
      sister from Hyder, Alaska, to Victoria, BC, where he spent the next five
      years.

1926  [age 6]  Moved with mother and sister to Stewart, BC, just across the line
      from Hyder, Alaska. Here he spent the next seven years. Began crossing the
      border daily, from home in one country to school in another.

1928  [age 8]  Birth of brother, Robert Reid.

1933  [age 13]  Returned again with his mother, sister and brother to Victoria, BC,
      where he spent the next six years. Last direct contact with his father.

1938  [age 18]  Left school after completing one year at Victoria College, Victoria,
      BC (a small junior college which later developed into the University of
      Victoria). Began working without pay as a radio announcer.

1939  [age 19]  Started paid work as a radio announcer, first in Kelowna, BC, then
      in Ontario and Quebec, then in Vancouver.

1942  [age 22]  Death of father.

1943  [age 23]  First visit to Haida Gwaii (the Queen Charlotte Islands) since early
      childhood. Reunited with his Haida grandfather Charles Gladstone.

1944  [age 24]  Conscripted into the Canadian army. Married Mabel "Binkie" van
      Boyen.

1945  [age 25]  Discharged from military service after a year spent entirely in
      training. Moved to Toronto, where he spent the next six years.

1948  [age 28]  Joined Canadian Broadcasting Corporation in Toronto as a radio
      broadcaster and enrolled shortly thereafter at Ryerson Institute of
      Technology, Toronto, as a student of jewellery-making.

1950  [age 30]  Completed goldsmithing studies at Ryerson and began an
      apprenticeship with the Platinum Art Co., Toronto, while continuing to
      work as radio broadcaster for the CBC. Birth of daughter, Amanda Reid,
      in Toronto.

1951    [age 31]  Released prematurely from jewellery-making apprenticeship. Moved to Vancouver, where he worked as a broadcaster for the CBC and made jewellery in his basement workshop. Remained in Vancouver for seventeen years.

1954    [age 34]  Death of Charles Gladstone, for whom Reid composed a eulogy which he broadcast on national radio. Completed a Haida silver bracelet which Gladstone left unfinished at his death. Introduced by Haida carver George Brown to the work of the artist Daxhiigang (Charles Edenshaw), who was Gladstone's uncle and had died in the year of Reid's birth. Joined Wilson Duff of the Provincial Museum and Harry Hawthorn of UBC on an expedition to salvage classical Haida sculpture from villages in southern Haida Gwaii. Given the Haida name *Iihljiwaas.*

1955    [age 35]  With his wife, Binkie, adopted a son, Raymond Cross (born 16 October 1953 to Haida and Nishga parents).

1956    [age 36]  Wrote and recorded the voicetrack for the documentary film *People of the Potlatch,* produced by Daryl Duke, based on a Vancouver Art Gallery exhibition of Northwest Coast art.

1957    [age 37]  Worked for ten days with the Kwakiutl carver Naqap'ankam (Mungo Martin) on a Haida pole for the Provincial Museum in Victoria. Second expedition to salvage classical sculpture from southern Haida Gwaii. First group show, National Gallery of Canada. Separated from first wife (from whom he was divorced in 1959).

1958    [age 38]  Left the CBC on the strength of an invitation from Harry Hawthorn (then head of the University of British Columbia's Department of Anthropology) to create a partial replica of a Haida village on the UBC campus. Exhibited in the Canadian Pavilion, *Exposition universelle et internationale,* Brussels.

1959    [age 39]  Completed first housepole in the UBC Haida village project: a 15 m replica of "Ninstints 12" from Sghan Gwaay Llanagaay.

1960    [age 40]  Brief second marriage to Ella Gunn.

1962    [age 42]  Completed the Haida village project at UBC: two houses and seven poles, produced with the assistance of Nimpkish artist Douglas Cranmer. Established a jewellery studio in Vancouver, first in collaboration with Swiss-Canadian goldsmith Toni Cavelti, and then on his own.

1963    [age 43]  Wrote and recorded the voicetrack for the documentary film *Totem,* produced by Gene Lawrence.

1964    [age 44]  Made small silver chest based on the "Master of the Black Field" box at the American Museum of Natural History.

1965 [age 45] Made a series of eight monochrome drawings for the book *Raven's Cry*, by Christie Harris (Toronto: McClelland & Stewart, 1966).

1966 [age 46] Began collaboration with Wilson Duff, Bill Holm and Doris Shadbolt on the *Arts of the Raven* exhibition, which opened at the Vancouver Art Gallery in 1967. Around this time, he befriended several younger Haida carvers, including Patrick McGuire (d. 1970) and Robert Davidson (who for most of the next two years shared Reid's studio and worked as his assistant).

1967 [age 47] Wrote "The Art: An Appreciation" for the *Arts of the Raven* catalogue. Made his first gold box in the Haida idiom, displayed in the Canadian Pavilion at *Expo '67*, Montreal. (Here, according to Reid, his woodcarving experience and his goldsmithing experience began to fuse.)

1968 [age 48] Completed a large cedar screen, commissioned by the British Columbia Provincial Museum, Victoria. (This was his first large-scale attempt to combine a multitude of mythic narratives in the planar space of a rectangular relief instead of the linear space of a pole.) Moved to London, England, on a fellowship from the Canada Council to study museum collections in Britain and Europe. Worked for a time at the Central School of Design, London.

1969 [age 49] Moved to Montreal and established a jewellery workshop. Completed the gold and diamond necklace known as "The Milky Way." Based in Montreal for the next four years.

1970 [age 50] Completed the alder mask of a distressed woman's face and his first boxwood carving, *The Raven Discovering Mankind in the Clamshell* (both now at the UBC Museum of Anthropology). First experiments with carving in wax and making lost-wax castings. Joined in Montreal by his adopted son. Began work on the poem "Out of the Silence," commissioned by Edmund Carpenter.

1971 [age 51] Publication of *Out of the Silence*: text by Reid, edited by Carpenter, with a suite of photographs by Adélaïde de Ménil. Group show, Art Gallery of Ontario, Toronto.

1973 [age 53] Returned to Vancouver, which remained his home for the next twenty-five years. Designed first of a series of Haida silkscreen prints. Given the Haida name *Kihlguulins*. First diagnosed with Parkinson's disease.

1974 [age 54] Retrospective exhibition at the Vancouver Art Gallery.

1975 [age 55] Dialogue with Bill Holm at Rice University, Houston, taped and published as *Form and Freedom: A Dialogue on Northwest Coast Indian Art*, edited by Edmund Carpenter.

1976     [age 56] Began work on a 17 m (56 ft) housepole for the Band Council office in Skidegate, Haida Gwaii (his mother's village). Received the Canada Council's Molson Award. Lecture at University of British Columbia on "Traditions of Northwest Coast Art." Death of colleague Wilson Duff.

1978     [age 58] Raised the Band Council housepole in Skidegate. Publicly confirmed as owner of the Haida name *Iihljiwaas*, first given to him in 1954.

1979     [age 59] In hospital in Vancouver, wrote the essay "Haida Means Human Being." Awarded the Canadian Conference on the Arts Diplôme d'Honneur. Lecture at University of British Columbia on the classical tradition in Haida art.

1980     [age 60] Large yellowcedar sculpture *The Raven and the First Men* completed under Reid's direction for the UBC Museum of Anthropology [based on the small boxwood carving made in Montreal in 1970]. Retrospective exhibition at the same museum.

1981     [age 61] Marriage to Martine de Widerspach-Thor, whom he had met in Vancouver in 1975. Death (at age 25) of adopted son Raymond Cross. Travelled to France with his bride. Lectured on Northwest Coast art at the "Issues and Images" conference, Tempe, Arizona.

1982     [age 62] Began two cycles of highly sculptural pencil drawings on Haida themes – one commissioned for George MacDonald's *Haida Monumental Art* (1983) and a second which became the basis for *The Raven Steals the Light*, coauthored with Robert Bringhurst (1984).

1983     [age 63] Completed the drawings for *The Raven Steals the Light*. Made the boxwood *Killer Whale*. Began first large bronze sculptures: *Chief of the Undersea World* and *Mythic Messengers*. Began his first Haida dugout canoes.

1984     [age 64] Completed the large bronze *Chief of the Undersea World* for the Vancouver Aquarium [based on the small boxwood *Killer Whale* of 1983]. Completed the 5.5 m (18 ft) redcedar dugout (now at the UBC Museum of Anthropology). Publication of *The Raven Steals the Light*. Lecture on the Northwest Coast canoe, IBM Gallery of Science & Art, New York City.

1985     [age 65] Completed the large bronze *Mythic Messengers* (Teleglobe Building, Burnaby, BC, with a twin casting at Canadian Museum of Civilization, Ottawa). Completed his last large wooden sculpture, *Phyllidula: The Shape of Frogs to Come* (Vancouver Art Gallery). Death of mother. Applied, under the terms of newly amended federal law, for legal status as an Indian. Heavily involved, as fund-raiser and advocate, in the Haida campaign to halt logging in southern Haida Gwaii.

1986 [age 66] Completed the 15 m (50 ft) redcedar dugout, *Loo Taas*. Began work on his largest bronze sculpture, *The Spirit of Haida Gwaii*, commissioned for the Canadian embassy in Washington, DC. Received Saidye Bronfman Award. Retrospective exhibition, UBC Museum of Anthropology. On 1 February, spoke before the Wilderness Advisory Committee on the necessity of preserving South Moresby (the southern portion of Haida Gwaii), and on 27 October, participated personally in a Haida road blockade designed to frustrate further logging on Lyell Island. Publication of Karen Duffek's *Bill Reid: Beyond the Essential Form* and Doris Shadbolt's *Bill Reid*. Given the Haida name *Yaahl Sghwaansing*.

1987 [age 67] Continued campaign for preservation of South Moresby and protest against continued logging of Lyell Island, and to this end interrupted work on the embassy commission, *The Spirit of Haida Gwaii*. Participated as far as his health allowed in the 600-mile voyage of the *Loo Taas*, paddled by a Haida crew from Vancouver to Skidegate, calling at First Nations settlements along the way.

1988 [age 68] City of Vancouver Lifetime Achievement Award. On 13 April, received official status as a Native Canadian. Lecture on Haida art at the Centro Cultural, Madrid, linked with the exhibition *El Ojo del Totem*.

1989 [age 69] Voyage up the Seine in *Loo Taas* to celebrate the opening of an exhibition of his work at the Musée de l'Homme, Paris. Publication of *Le Dit du Corbeau* (French version of *The Raven Steals the Light*) with a preface by Claude Lévi-Strauss.

1990 [age 70] Royal Bank Award.

1991 [age 71] Unveiling of *The Spirit of Haida Gwaii* ("The Black Canoe"), bronze sculpture with black patina, in the chancery courtyard of the Canadian embassy, Washington, DC.

1993 [age 73] Retrospective exhibition, Néprajzi Múzeum, Budapest.

1994 [age 74] Received the National Aboriginal Lifetime Achievement Award, the Royal Architectural Institute of Canada's Allied Arts Medal, and the Order of British Columbia.

1995 [age 75] Moved to the Musqueam Indian Reserve, where his studio had been located for several years.

1996 [age 76] Second casting of *The Spirit of Haida Gwaii* with green patina ("The Jade Canoe") installed at the Vancouver airport.

1997 [age 77] Retrospective exhibition, Canadian Embassy Gallery, Tokyo.

1998 [age 78] Died 13 March at Vancouver. Ashes interred 5 July on the site of his grandmother's village, Tanu, on Tanu Island, Haida Gwaii.

# Bibliography

Abbott, Donald N., ed.

  1981   *The World is as Sharp as a Knife: An Anthology in Honour of Wilson Duff.*
          Victoria, BC: British Columbia Provincial Museum.

Anonymous

  1986   "Meares, Moresby Islands land claims addressed by artist Bill Reid at
          Tofino gathering." Port Alberni, BC: *Ha-Shilth-Sa,* 11 December 1986: 5.

Barbeau, Marius

  [1950]  *Totem Poles.* 2 vols. NMC Bulletin 119. Ottawa: National Museum of
          Canada. [Reissued 1990 with a new foreword by George MacDonald.]

  1953   *Haida Myths Illustrated in Argillite Carvings.* NMC Bulletin 127. Ottawa:
          National Museum of Canada.

  1957   *Haida Carvers in Argillite.* NMC Bulletin 139. Ottawa: National Museum of
          Canada.

Barthes, Roland

  1973   *Le Plaisir du texte.* Paris: Seuil.

  1975   *The Pleasure of the Text,* translated by Richard Miller. New York: Hill &
          Wang. [Translation of Barthes 1973.]

Blackman, Margaret

  1992   *During My Time: Florence Edenshaw Davidson, A Haida Woman.* 2nd ed.
          Seattle: University of Washington Press. [First ed., 1982.]

Boas, Franz

  1927   *Primitive Art.* Oslo: Aschehoug.

Boas, Franz, & George Hunt

  1902–5  *Kwakiutl Texts.* 3 vols. Jesup North Pacific Expedition 3.1–3. New York:
          American Museum of Natural History.

Boyd, Robert

  1999   *The Coming of the Spirit of Pestilence.* Seattle: University of Washington
          Press.

Bringhurst, Robert

  1999   *A Story as Sharp as a Knife: The Classical Haida Mythtellers and Their World.*
          Vancouver: Douglas & McIntyre; Lincoln: University of Nebraska Press.

Bringhurst, Robert, & Ulli Steltzer

  1992   *The Black Canoe: Bill Reid and the Spirit of Haida Gwaii.* 2nd ed.
          Vancouver: Douglas & McIntyre. [First ed., 1991.]

British Columbia. Wilderness Advisory Committee

1986a     *The Wilderness Mosaic: Report of the Wilderness Advisory Committee.* Vancouver.

1986b     *Proceedings at Public Meeting.* 12 vols. [Vancouver.]

Buschlen-Mowatt Fine Art

[1992]     *Bill Reid: All the Gallant Beasts and Monsters.* Exhibition catalogue. Vancouver: Buschlen-Mowatt.

Carlson, Roy L., ed.

[1983]     *Indian Art Traditions of the Northwest Coast.* Burnaby, BC: Archaeology Press, Simon Fraser Unversity.

Clapp, Alan C.

1991     *The Spirit of Haida Gwaii.* Documentary video. Richmond, BC: New Vision Media.

Duff, Wilson

n.d.1     Duff Papers. Royal British Columbia Museum, Victoria.

n.d.2     Duff Papers. Museum of Anthropology Archives, University of British Columbia, Vancouver.

1954a     "A Heritage in Decay: The Totem Art of the Haidas." Ottawa: *Canadian Art* 11.2: 56–59.

1954b     "Preserving the Talking Sticks." Vancouver: *Powell River Digester* 30.6: 10–12.

1955     "Report of the Anthropologist." Victoria, BC: *Provincial Museum of Natural History and Anthropology Report for the Year 1954*: B18–B20.

1957     "Totem Poles Recall Vanished Seafarers." Ottawa: *Crowsnest* 9.3: 22–23.

1959     "Mungo Martin, Carver of the Century." Victoria: *Museum News* 1.1: 3–8. [Reprinted in Abbott 1981: 37–40.]

1964a     "Contributions of Marius Barbeau to West Coast Ethnology." Ottawa: *Anthropologica* 6: 63–96.

1964b     *The Indian History of British Columbia,* vol. 1: The Impact of the White Man. Victoria, BC: British Columbia Provincial Museum.

1974     "Bill Reid: An Act of Vision and an Act of Intuition." In Vancouver Art Gallery, *Bill Reid:* [13–15].

1975     *Images Stone B.C.* Saanichton, BC: Hancock House.

1996     *Bird of Paradox: The Unpublished Writings,* edited by Eugene N. Anderson. Surrey, BC: Hancock House.

Duff, Wilson, et al.

1967     *Arts of the Raven: Masterworks by the Northwest Coast Indian.* Exhibition catalogue. Vancouver: Vancouver Art Gallery.

Duff, Wilson, & Michael Kew

1958    "Anthony Island, a Home of the Haidas." Victoria, BC: *Provincial Museum of Natural History and Anthropology Report for the Year 1957*: C37–C64.

Duffek, Karen

1986    *Bill Reid: Beyond the Essential Form.* Museum Note 19. Vancouver: UBC Museum of Anthropology.

Eastman, Carol, & Elizabeth Edwards, ed.

1991    *Gyaehlingaay: Traditions, Tales and Images of the Kaigani Haida.* Seattle: Burke Museum.

Fleming, Marnie

1982a   "Patrimony and Patronage: The Legacy Reviewed." Vancouver: *Vanguard* 11.5–6: 18–21.

1982b   "*Ms* Fleming Responds." Vancouver: *Vanguard* 11.8–9: 35. [Reply to Reid 1982.]

Fuller, R. Buckminster

1981    *Critical Path.* New York: St Martin's.

Ghandl of the Qayahl Llaanas

2000    *Nine Visits to the Mythworld,* translated by Robert Bringhurst. Vancouver: Douglas & McIntyre; Lincoln: University of Nebraska Press.

Ghiberti, Lorenzo

1947    *I Commentari,* a cura di Ottavio Morisani. Napoli: Ricciardi.

Halpin, Marjorie, et al.

1981    *Celebration of the Raven.* Documentary film. Vancouver: University of British Columbia Museum of Anthropology.

Harris, Christie

1966    *Raven's Cry.* Toronto: McClelland & Stewart.

Hawthorn, Audrey

[1956]  *People of the Potlatch.* Exhibition catalogue. Vancouver: Vancouver Art Gallery. [*Cf* Reid & Duke 1956, which is a film of the same exhibition.]

1964    "Mungo Martin, Artist and Craftsman." Winnipeg: *The Beaver* 295: 18–23.

Hawthorn, Harry B.

1961    "The Artist in Tribal Society: The Northwest Coast." In Smith 1961: 59–70.

Henley, Thom

1996    *Rediscovery: Ancient Pathways, New Directions.* 2nd ed. Edmonton: Lone Pine. [First ed.: Western Canada Wilderness Committee, 1989.]

Holm, Bill

1965    *Northwest Coast Indian Art: An Analysis of Form.* Seattle: University of Washington Press.

1974 "The Art of Willie Seaweed: A Kwakiutl Master." In *The Human Mirror: Material and Spatial Images of Man,* edited by Miles Richardson. Baton Rouge: Louisiana State University Press: 59–90.

1983 *Smoky-Top: The Art and Times of Willie Seaweed.* Seattle: University of Washington Press.

Hoover, Alan

1983 "Charles Edenshaw and the Creation of Human Beings." Scottsdale, Arizona: *American Indian Art* 8.3: 62–67, 80.

1993 "Bill Reid and Robert Davidson: Innovations in Contemporary Haida Art." Scottsdale, Arizona: *American Indian Art* 18.4: 48–55.

1995 "Charles Edenshaw: His Art and Audience." Scottsdale, Arizona: *American Indian Art* 20.3: 44–53.

Hume, Robert M.

1958 *One Hundred Years of British Columbia Art.* Exhibition catalogue. Vancouver: Vancouver Art Gallery.

Iglauer, Edith

1982 "The Myth Maker." Toronto: *Saturday Night* 97.2 (February): 13–24.

Inverarity, Robert Bruce

1950 *Art of the Northwest Coast Indians.* Berkeley: University of California Press.

Islands Protection Society

1984 *Islands at the Edge: Preserving the Queen Charlotte Islands Wilderness.* Vancouver: Douglas & McIntyre; Seattle: University of Washington Press.

Johnston, Moira

1998 "The Raven's Last Journey." Toronto: *Saturday Night* 113.9 (November): 72–84.

Lévi-Strauss, Claude

1974 "Bill Reid." In Vancouver Art Gallery, *Bill Reid:* [7–8].

1984 "Préface." Dans *Le Dit du Corbeau,* par Bill Reid et Robert Bringhurst. Paris: Alpha Bleue: 7–11. [Translated in Reid & Bringhurst 1996: 9–12.]

Long, Jack

1979 *Bill Reid.* Documentary film. Montreal: National Film Board of Canada.

MacDonald, George F.

1983 *Haida Monumental Art.* Vancouver: UBC Press.

McLennan, Bill, & Karen Duffek

in press *The Transforming Image: Painted Arts of the Northwest Coast First Nations.* Vancouver: UBC Press.

Macnair, Peter L., Alan L. Hoover, & Kevin Neary

    1980    *The Legacy: Tradition and Innovation in Northwest Coast Indian Art.*
           Victoria: British Columbia Provincial Museum.

Mauzé, Marie, ed.

    1997    *Present is Past: Some Uses of Tradition in Native Societies.* Lanham,
           Maryland: University Press of America.

Mohr, Merilyn Simonds

    1990    "The Bestiary of Bill Reid." Camden East, Ontario: *Equinox* 53: 76–89.
           [Reprinted in Buschlen-Mowatt 1992.]

Neel, David

    1995    *The Great Canoes: Reviving a Northwest Coast Tradition.* Vancouver:
           Douglas & McIntyre.

Nuytten, Phil

    1982    *The Totem Carvers: Charlie James, Ellen Neel, and Mungo Martin.*
           Vancouver: Panorama.

Ravenhill, Alice

    1944    *A Corner Stone of Canadian Culture: An Outline of the Arts and Crafts of the*
           *Indian Tribes of British Columbia.* Occasional Paper 5. Victoria: British
           Columbia Provincial Museum.

REID, BILL

    1958    "Introduction." In Hume, *One Hundred Years of British Columbia Art.*

    1967    "The Art: An Appreciation." In Duff et al, *Arts of the Raven.* [Reprinted
           1974 in Vancouver Art Gallery, *Bill Reid*: [41–42].]

    1974    "Curriculum Vitae." In Vancouver Art Gallery, *Bill Reid*: [25–28].

    1976a   "Wilson Duff, 1925–1976." Vancouver: *Vanguard* 5.8: 17. [Reprinted as
           "Prologue" in Abbott 1981: 13–14.]

    1976b   "An Interview with Bill Reid," conducted by Lynn Maranda & Robert D.
           Watt. Willowdale, Ontario: *Canadian Collector* 11.3: 34–37.

    1977    Radio interview. *Arts National*, CBC FM, 12 July 1977. Acoustic tape, CBC
           Radio Archives, Toronto. [Dub in the MOA Archives, UBC, Vancouver.]

    1980a   "Whatever else may be said...." Untitled statement, in *Bill Koochin.*
           Exhibition catalogue. Burnaby, BC: Burnaby Art Gallery: 2–3.

    1980b   "The Enchanted Forest." *Vancouver Sun*, 24 October 1980: 5.

    1980c   "The Haida Legend of the Raven and the First Humans." Museum
           Note 8. Vancouver: UBC Museum of Anthropology.

    1981    "The Box Painting by the 'Master of the Black Field.'" In Abbott, *The
           World is as Sharp as a Knife*: 300–301.

1982 "The Legacy Review Reviewed." Vancouver: *Vanguard* 11.8–9: 34–35. [Reply to Fleming 1982a; *cf* Fleming 1982b.]

1983a "Foreword." In MacDonald, *Haida Monumental Art*: [viii].

1983b "These drawings originated...." Untitled statement in the gallery leaflet *Bill Reid–Drawings*. Vancouver: Equinox Gallery.

1984a "Killer Whale Poem." Poster. Vancouver: Vancouver Aquarium Marine Science Centre.

1984b "The Anthropologist and the Article." London, Ontario: *Culture* 4.2: 63–65.

1984c "These Shining Islands." In Islands Protection Society, *Islands at the Edge*: 23–30.

1986 Statement to the Committee. In British Columbia, Wilderness Advisory Committee, *Proceedings*, vol. 12: 37–46.

1991a "A Master Artist on Mastery in Art." *Vancouver Sun*, 24 August 1991: D4.

1991b "The Spirit of Haida Gwaii." Broadside. Washington, DC: Canadian Embassy.

1994 "The Spirit of Haida Gwaii: The Jade Canoe." Leaflet. [Vancouver: UBC Museum of Anthropology.] [Text reprinted from Reid 1991b.]

1995 "Nobody comes around...." Untitled statement on canoe building, in Neel 1995: 23. [This appears to be a paraphrase instead of a verbatim transcript of an interview.]

1996 "Foreword." In *Toni Cavelti: A Jeweller's Life,* by Max Wyman. Vancouver: Douglas & McIntyre.

REID, BILL, & Robert Bringhurst

1984 *The Raven Steals the Light.* Vancouver: Douglas & McIntyre; Seattle: University of Washington Press.

1996 *The Raven Steals the Light,* 2nd ed., with a preface by Claude Lévi-Strauss. Vancouver: Douglas & McIntyre; Seattle: University of Washington Press.

REID, BILL, & Daryl Duke

1956 *People of the Potlatch.* Documentary film. [Vancouver]: CBC Television. [*Cf* A. Hawthorn 1956, which is the catalogue of the same exhibition.]

REID, BILL, & Bill Holm

1975 *Form and Freedom: A Dialogue on Northwest Coast Indian Art.* Houston: Institute for the Arts, Rice University. [Reissued as Reid & Holm 1978.]

1978 *Indian Art of the Northwest Coast: A Dialogue on Craftsmanship and Aesthetics.* Vancouver: Douglas & McIntyre; Seattle: University of Washington Press. [Reissue of Reid & Holm 1975.]

REID, BILL, & Gene Lawrence.

1963    *Totem*. Documentary film. [Vancouver]: CBC Television.

REID, BILL, & Adélaïde de Ménil

1971    *Out of the Silence*. New York: Outerbridge *&* Dienstfrey; Harper *&* Row;
        Toronto: New Press; Fitzhenry & Whiteside.

Reid, Martine

1987    "Silent Speakers." In *The Spirit Sings: Artistic Traditions of Canada's First
        Peoples*, by Julie D. Harrison et al. Toronto: McClelland *&* Stewart:
        201–236.

1989    "Le Courage de l'art." Dans *Des Symboles et leurs doubles*, par Claude Lévi-
        Strauss et al. Paris: Plon: 219–252.

Reid, Martine, & Daisy Sewid Smith

in press    *Paddling to Where I Stand: The Memoirs of Mrs Agnes Alfred,
            a Kwiksootainuk Noblewoman*. Vancouver: UBC Press.

Schuster, Carl, & Edmund Carpenter

1986–88    *Materials for the Study of Social Symbolism in Ancient and Tribal Art*. 3 vols
           in 12 parts. New York: Rock Foundation.

Shadbolt, Doris

1987    "The Well-Made Object." Toronto: *Canadian Collector* 22.1: 14–19.

1998    *Bill Reid*. 2nd ed. Vancouver: Douglas *&* McIntyre. [First ed., 1986.]

Smith, Marian W., ed.

1961    *The Artist in Tribal Society*. New York: Free Press of Glencoe.

Steltzer, Ulli, & Robert Davidson

1994    *Eagle Transforming: The Art of Robert Davidson*. Vancouver: Douglas *&*
        McIntyre.

Stewart, Hilary

1979a    *Looking at Indian Art of the Northwest Coast*. Vancouver: Douglas *&*
         McIntyre.

1979b    *Robert Davidson: Haida Printmaker*. Vancouver: Douglas *&* McIntyre.

1990    *Totem Poles*. Vancouver: Douglas *&* McIntyre.

Suttles, Wayne

1983    "Productivity and Its Constraints: A Coast Salish Case." In Carlson,
        *Indian Art Traditions of the Northwest Coast*: 67–87.

Swanton, John Reed

1905a    *Contributions to the Ethnology of the Haida*. Jesup North Pacific Expedition
         5.1. New York: American Museum of Natural History.

1905b    *Haida Texts and Myths: Skidegate Dialect*. BAE Bulletin 29. Washington,
         DC: Bureau of American Ethnology.

1908        *Haida Texts: Masset Dialect.* Jesup North Pacific Expedition 10.2. New York: American Museum of Natural History.

Tennant, Paul

1990        *Aboriginal Peoples and Politics: The Indian Land Question in British Columbia, 1849–1989.* Vancouver: UBC Press.

Thom, Ian M., ed.

1993        *Robert Davidson: Eagle of the Dawn.* Vancouver: Douglas & McIntyre.

Tully, James

1995        *Strange Multiplicity: Constitutionalism in an Age of Diversity.* Cambridge: Cambridge University Press.

Vancouver Art Gallery

1974a       *Profile: Bill Reid.* Documentary film. Vancouver: VAG.

1974b       *Bill Reid.* Exhibition catalogue. Vancouver: VAG.

Vastokas, Joan

1975        "Bill Reid and the Native Renaissance." Toronto: *Artscanada* 198/199: 12–21. [Reprinted in *Stones, Bones and Skin: Ritual and Shamanic Art*, edited by Anne Trueblood Brodzky et al. Toronto: Society for Art Publications, 1977: 158–167.]

Wardwell, Allen

1978        *Objects of Bright Pride: Northwest Coast Indian Art from the American Museum of Natural History.* New York: Center for Inter-American Relations.

Webb, Phyllis

1982        "A Correspondence." In *Talking.* Montreal: Quadrant: 129–149.

[Weeks, Clifford W.]

[1970]      *'Ksan.* Hazelton, BC: 'Ksan Association.

Westman, Marja de Jong

1984        "Bill Reid's Killer Whale." Vancouver: *Waters* 7: 21–28.

Wisnicki, Nina

1989        *I Called Her Lootaas.* Documentary film, narrated by Bill Reid. Vancouver: William Reid Ltd & CBC.

*This book is set in*
Monotype Dante
*roman and italic.*
*Giovanni Mardersteig*
*designed the type in*
*Verona during the*
*Second World War.*
*Punches for the first*
*( foundry) version were*
*cut by hand in steel*
*by Charles Malin in the*
*rue de la Glacière, Paris,*
*between 1947 and 1952.*

The captions are composed
in *Haarlemmer Sans*.
Frank Blokland created this
type in The Hague in 1997
to complement his digital
revival of Haarlemmer, a
serifed metal type designed
by Jan van Krimpen and first
cut by hand in steel in 1938
by P. H. Rädisch.